WIFREDO LAM AND HIS CONTEMPORARIES 1938–1952

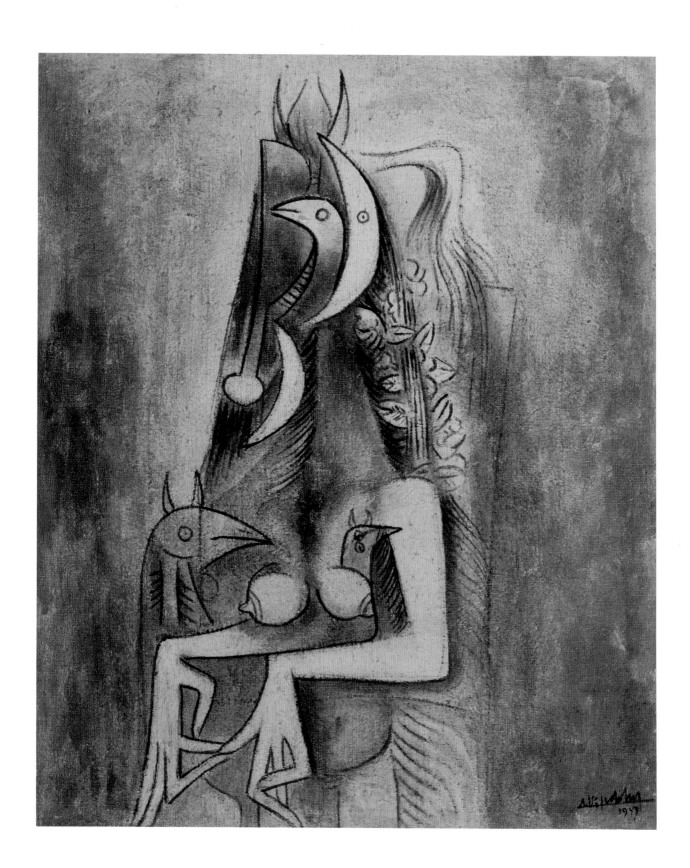

WIFREDO LAM
AND HIS CONTEMPORARIES 1938-1952

Foreword by
KINSHASHA HOLMAN CONWILL

Introduction by
JACQUES LEENHARDT

With essays by
GIULIO V. BLANC
JULIA P. HERZBERG
and
LOWERY STOKES SIMS
guest curators
of the exhibition

MARIA R. BALDERRAMA
Editor

THE STUDIO MUSEUM IN HARLEM
1992

Distributed by Harry N. Abrams, Inc., New York

Cover:
Wifredo Lam
Pasos miméticos. 1951
Oil on canvas
46 x 56″ (117 x 142 cm)
Daniel B. and Marcia G. Kraft
cat. no. 49

Frontispiece:
Wifredo Lam
Personage. 1947
Oil on burlap
43⅛ x 36″ (109.5 x 91.4 cm)
Santa Barbara Museum of Art
cat. no. 42

WIFREDO LAM AND HIS CONTEMPORARIES
1938–1952
The Studio Museum in Harlem, New York
December 6, 1992–April 11, 1993

LIBRARY OF CONGRESS CATALOGING-IN-PUBLICATION DATA

Wifredo Lam and His Contemporaries 1938–1952
Foreword by Kinshasha Holman Conwill
Introduction by Jacques Leenhardt
Essays by Giulio V. Blanc, Julia P. Herzberg, and Lowery Stokes Sims.
 p. cm.

Catalog of an exhibition organized by The Studio Museum in Harlem

Includes chronology and selected bibliography

Library of Congress Catalog Card Number 92-62642
ISBN 0-942949-08-0 (The Studio Museum in Harlem, paperbound)
ISBN 0-8109-2548-6 (Abrams)

Published by The Studio Museum in Harlem, 144 West 125th Street,
New York, N.Y. 10027

Distributed by Harry N. Abrams, Incorporated, New York
A Times Mirror Company

Printed in the United States of America

Dedication

This catalogue is published on the occasion of the exhibition "Wifredo Lam and His Contemporaries, 1938–1952," organized by The Studio Museum in Harlem.

"Wifredo Lam and His Contemporaries, 1938–1952" is supported in part by grants from the National Endowment for the Arts, the National Endowment for the Humanities, and the Rockefeller Foundation. The Studio Museum also gratefully acknowledges the support of Mel and Meg Knyper for their support of this exhibition.

Additional support has come from The Studio Museum in Harlem's 25th Anniversary Fund, which has been established to support the year's special exhibitions, programs, and publications.

American Express Company is the lead corporate sponsor of The Studio Museum in Harlem's 25th Anniversary.

The 25th Anniversary Fund is also supported by a leadership grant from the William Randolph Hearst Foundation and a grant from IBM.

"Wifredo Lam and His Contemporaries, 1938–1952" is the inaugural exhibition of the Museum's 25th Anniversary Year.

Operation of the Museum's facility is supported in part with public funds provided through the New York City Department of Cultural Affairs.

Wifredo Lam and His Contemporaries, 1938–1952 is published in honor of the following Studio Museum in Harlem benefactors:

Director's Circle

Marilynn A. Davis
Reginald F. Lewis
Mr. & Mrs. Joel Motley
Patricia T. & David V. Smalley

Patrons

Enid Adams
Gregory T. Anderson
Anonymous
Mr. & Mrs. Armand P. Arman
Gayle & Charles Atkins
Jacqueline & Clarence Avant
Jean Bach
Raphael Bernstein
Bill Blass
Jacqueline Bradley & Clarence Otis, Jr.
Sherry Bronfman
Peggy Cooper Cafritz
Drs. Mary & George Campbell
Kenneth Strong Campbell
Dr. and Mrs. Sidney Clyman
Camille & Bill Cosby
Evelyn Cunningham
Norma Jean Darden
Selma Ertegun
Alfred Feinman
Susan & Louis Ganz
Sandra Grymes
Agnes Gund & Daniel Shapiro
Gene Hovis
Charles E. Inniss
Collette & Bernard King
George Knox
Marjorie D. Kogan
Nancy Lane
Gabriella de Ferrari & Raymond J. Learsy
Mr. & Mrs. J. Bruce Llewellyn

Arthur Loeb
Delores E. Mack
Henry McGee, III
Mr. & Mrs. Richard McKenzie
Mrs. G. G. Michelson
Mr. & Mrs. Parker Montgomery
New York Coalition of 100 Black Women
Mr. & Mrs. Beverly Peer
Mr. & Mrs. Charles Rangel
David Rockefeller
Cynthia & Nathan E. Saint-Armand
Bobby Short
Suzanne Randolph & Charles Shorter
Dr. Meredith Sirmans
Robert Solomon
Ute Stebich
Isabel & Donald Stewart
Mr. & Mrs. Wilbert Tatum
Franklin A. Thomas
Mr. & Mrs. Major E. Thomas
Mrs. Irene Wheeler
Mr. & Mrs. John Hay Whitney
Mr. and Mrs. Dave H. Williams
Oprah Winfrey

Donors

Linda Allston-Shaw
Peg Alston
Benny Andrews
Andrew Athy, Jr.
Coral Aubert
Ruth Ellington Boatwright
Edward Bradley
Lovetta Brooks
Janet & Ron Carter
Mr. & Mrs. Kenneth Chenault
Joseph Cicio
Kinshasha & Houston Conwill

Peggy & Gordon Davis
Terry Dintenfass
Jerome P. Dunlevy
Marquita Pool Eckert
Myra & Ed Finkelstein
Ann & James Harithas
Lovette Harper
Mariella A. Holman
Lena Horne
Arlene Howard
Bertina Carter Hunter
Renee C. Hunter
Rick Johnson
Harley Jones
Willa M. Jones
Vernon Jordan
J. Trevor Lindo, M.D.
Mary Ann Madden
Jane S. Murray
Corine Pettey
Eric D. Robertson
Marsha E. Simms
Marti Stevens
Nancy & Donald Todd
Robert F. Van Lierop, Esq.
Eudora Ward
Michelle Morris Weston
E. T. Williams, Jr.
Michael R. Winston, Esq.

Contents

Acknowledgments

An undertaking of this magnitude is only possible with the help of many individuals and institutions. First and foremost, our deepest thanks go to our three guest curators, Giulio V. Blanc and Julia P. Herzberg, independent curators, and Lowery Stokes Sims, Associate Curator of 20th Century Art, The Metropolitan Museum of Art. Their scholarship and commitment made the exhibition possible, and their insightful essays add significantly to the art historical record. We also extend special thanks to Jacques Leenhardt, Président de l'Association Internationale des Critiques d'Art, for his insightful introduction to the catalogue.

We are very grateful for the generous support of the exhibition and its programs provided by the National Endowment for the Arts, The Rockefeller Foundation, and the National Endowment for the Humanities. Additional support for the exhibition's programs was provided by the New York Community Trust, The New York Times Company Foundation, and The Fan Fox and Leslie R. Samuels Foundation, Inc. This exhibition and all of the programs of the Studio Museum's 25th Anniversary Year were made possible, in part, by the generous support of the American Express Company, the lead corporate sponsor.

Here at the Studio Museum in Harlem we extend our warmest thanks to Maria R. Balderrama, Project Coordinator of this exhibition, whose diligence and judgment in expediting numerous aspects of the exhibition and whose diplomacy and skill in locating and securing loans were invaluable; to Jon Hutton, Senior Registrar, whose expertise, ingenuity, and dedication to this enterprise and all the details of its logistics were critical; to Patricia Cruz, Deputy Director for Programs, whose coordination, fundraising, and administrative activities and development of an impressive and comprehensive set of interpretive programs and materials immensely enriched the project; to George Calderaro, Public Relations Manager, for his excellent promotion of all aspects of the exhibition and its programs; and to Sharon F. Patton, former Chief Curator, and Naomi Nelson, former Director of Education, for their assistance in the preliminary planning of the exhibition and its programs. I am also grateful to the Board of Trustees and the entire staff of the Museum for their steadfast support and encouragement.

Many colleagues in the field cooperated in numerous ways in the realization of the exhibition, including in Germany, Mrs. Helena H. Benitez; in Paris, for the Wifredo Lam catalogue raisonné project, Yveline Hemsi and Agnès De Poortère; Philippe Cazeau, Mme Thessa Herold, and Mme Françoise Thésée; at the Musée National d'Art Moderne, Centre Georges Pompidou, Paris, Mr. Germain Viatte, Director, and Mme Vivianne Tarenne; in Mexico, Mr. Armando Colina; and in Peru, Jorge C. Gruenberg and Ms. Lika Mutal.

For their assistance in facilitating this exhibition in the United States we are most grateful to the following individuals and institutions: at the French Cultural Services in New York, Mme Annie Cohen-Solal, and Mr. Jacques Soulillou; at Arnold Herstand & Co., Scott Cook; at Christie's Latin American Department, Elizabeth G. Palmer, Vice President, Vivian Pfeiffer, and Silvia Coxe; at Galerie Lelong, Mary Sabattino, Director; at Mary-Anne Martin Fine Art, New York, Mary-Anne Martin, Director; Pierre Matisse Foundation, New York; at The Metropolitan Museum of Art, William S. Lieberman, Chairman, 20th Century Art Department; at The Museum of Modern Art, New York, in the Department of Painting and Sculpture, Cora Rosevear, Associate Curator, and Susan Bates, Loan Assistant, and in the Department of Drawings, Magdalena Dabrowski, Curator; at the Schomburg Center for Research in Black Culture, Miriam Jimenez-Román, Research Coordinator, and Diana Lachatanere, Division Head—Archives; and in Sotheby's Latin American Department, August Uribe, Director, Alberto M. Barral, Senior Manager, and Isabella Hutchinson, the former Assistant Vice President; Anne Horton; Gam Klutier; Rosa and Manolo Valdés; and Richard S. Zeisler; and in Connecticut, Sharon Schultz Simpson; at Yale University Art Gallery, New Haven, Mary Gardner Neill, Director. In Miami, at M. Gutierrez Fine Arts, Miami, Marta Gutierrez must be especially acknowledged for her assistance with many loans; and we also thank Mr. and Mrs. Ramón Cernuda; Mr. and Mrs. Carlos de la Cruz; Luis Lastra; Brian A. Dursum, Director, at the Lowe Art Museum, University of Miami; in Houston, Nancy L. Swallow, Associate Registrar at The Menil Collection; at the Indianapolis Museum of Art, Theresa Harley-Wilson, Associate Registrar; and in Providence, Diane Johnson, Director, David Winton Bell Gallery, Brown University.

For their collaboration in the joint education program, we thank at the Americas Society, Fatima Bercht, Director, Department of Visual Arts; Elizabeth Beim, Director, Development Department, and Dr. Charles Merewether, curator of the Society's 1992 retrospective of works on paper by Wifredo

Lam. We also thank the members of the Advisory Committee for this exhibition: Dore Ashton, Dr. Jack Flam, Dr. Verna Gillis, Susana Torruella Leval, Juan A. Martínez, Dr. John Kuo Wei Tchen, Dr. Robert Farris Thompson, and Barbara Webb. For their collaboration in our programming, we also extend our gratitude to Joanne Cossa, Managing Director, Symphony Space; Dr. Vishakha N. Desai, Director of the Gallery at the Asia Society; and Nilda Peraza, former Director of the Museum of Contemporary Hispanic Art, for her initial support of this exhibition project.

We owe our gratitude to Leon Auerbach for his fine design of this publication, and to Jessica Altholz for editing it. We are grateful to J. R. Saunders of Saunders Design, New York, for his design of the exhibition. Finally, we extend our most sincere thanks to all the lenders to the exhibition who are listed elsewhere—and to Madame Lou Laurin-Lam. Without their support and cooperation this exhibition would not have been possible.

Kinshasha Holman Conwill
Director

Foreword

KINSHASHA HOLMAN CONWILL
Director
The Studio Museum in Harlem

Listen:
 from my distant island
 from my watchful island
I call out to you: Ho!
 And your voices answer me
 and this is the meaning of their reply:
"The day is bright and clear." And it is true:
even in the midst of storm and night
for us the day is bright and clear.[1]

From the tiny island of Martinique, the poet Aimé Césaire, a leading voice of the *Negritude* movement, proclaimed a new moment for peoples of the African Diaspora, a moment of hope and promise, of the possibility of shaping new realities and building them through cultural expression. The Afro-Cuban artist Wifredo Lam, who was briefly detained in Césaire's homeland and met the poet there on his way back to Cuba during World War II, was a major progenitor of the movement of artists of the "Third World" from the margins of the art world to its center stage. In a career that spanned six decades, Lam left an indelible mark on his field and its creators from Cuba to Spain, from France to the United States. Colleague, friend, collaborator, and contemporary of giants in the international arena of arts and letters—Picasso, Breton, Césaire, Gorky, Cabrera, Guillén, to name a few—Lam was both a man of the world and the proud product of a rich ancestry that embodied Old and New World cultures.

This publication and the exhibition which it accompanies concentrate on Lam's career between the pivotal years of 1938 and 1952, covering the period when the artist was between the ages of thirty-six and fifty, the years he synthesized his formal and conceptual ideas into a unique personal style. After his early years in his native Cuba, Lam lived first in Spain and then in France. World events—the Spanish Civil War, and then World War II—forced Lam's return to his homeland and a reencounter with its African-based culture and spiritual life, particularly Santería, and also with the land itself. Lam synthesized the lessons of Cubism and Surrealism with the complex beliefs and practices of Afro-Cubanism that he learned from his mother and godmother and from the philosophy of his Chinese-born father to create a style, iconography, and vision that are all his own.

Lam's work is presented here in the context of his Cuban contemporaries—Cundo Bermúdez, Mario Carreño, Carlos Enríquez, and Amelia Peláez—members of the New York School—Robert Motherwell and Jackson Pollock—and members of the CoBrA group—Karel Appel and Asger Jorn. The work is reappraised on formal grounds and in a cross-cultural analysis that seeks to assess Afro-Cubanism as a vital artistic expression and to demonstrate the connections and cross-fertilization that happened between European modernism and the art and expression of Latin America, particularly its African-based aspects. The African-American painter Herbert Gentry, who knew Lam in Paris and enjoyed a thirty-year friendship with him, said that Lam "forged the link between African sensibility and European tradition."[2]

It is particularly significant for us at The Studio Museum in Harlem to present this exhibition as part of the celebration of our twenty-fifth year as an institution dedicated to the art of Black America and the African Diaspora. The power, innovation, and imagination of the art of Wifredo Lam proclaim Césaire's "bright and clear" day. Lam's work and being embody the realization of a fertile encounter of the Old and the New World, and this exhibition marks the quincentennial of a more painful encounter of those worlds, transforming it on some level to a cause for celebration.

1. Aimé Césaire, from "Pour saluer le Tiers-Monde," *Negritude: Black Poetry from Africa and the Caribbean*, edited and translated from the French by Norman R. Shapiro (London: October House, 1970), p. 83.
2. Herbert Gentry, "Wifredo Lam," *Black Art an International Quarterly*, vol. 4, no. 4, 1981, p. 4.

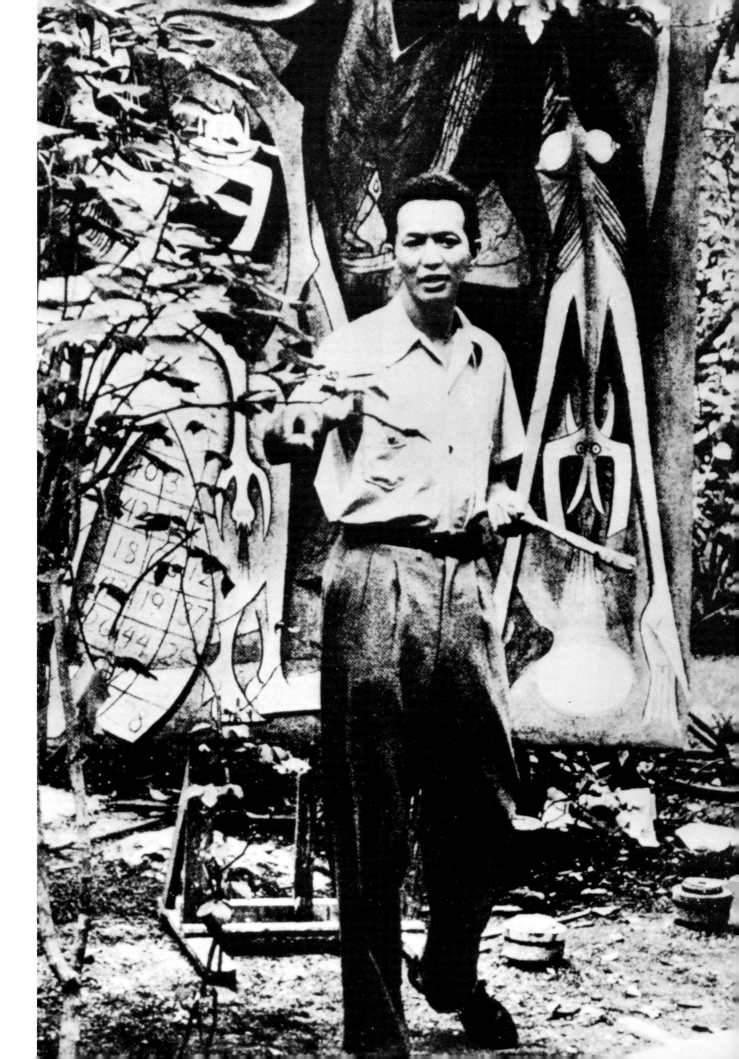

Introduction

JACQUES LEENHARDT
Président de L'Association Internationale
des Critiques d'Art

Among the artists who were working at mid-century, Wifredo Lam is perhaps the most distinctly contemporary. This is not because he profited from a close association with such seminal figures in the art world as Picasso and Breton, or because he belonged to a particularly talented generation. Lam is the most contemporary because of his repudiation of the exclusivity of the artistic canons of the western tradition, a repudiation that would revolutionize art in the latter half of the twentieth century. Lam began making art at a time when the world's eyes were suddenly opened to the wealth of cultural diversity in the so-called "Third World," a wealth that had previously either been neglected or seen exclusively from a folkloric or ethnographic perspective. Lam proceeded to mold this new consciousness into a highly accomplished art form, which cut all ties to the past, revising tactical or epistemological ruptures and reestablishing geographic and aesthetic boundaries.

It was no coincidence that these developments occurred in the wake of the Second World War. Until that time, certain concepts and aesthetic canons had dominated cultural and political spheres in the western world. During the first decade of this century, artists had begun to challenge the fundamental assumptions concerning the status of established modes of artistic expression. Artists—Marcel Duchamp, for example—began to postulate a critique of museological practice, of means of figuration, and of the decorative aspect of art. This critique challenged the very basis of established notions of art and served as the basis for a continually developing innovative approach to art. Yet at the very same time that art was being rebuilt on the basis of a new definition, it seemed that its energy was giving out. In the wake of the trauma of the First World War, the only feasible approaches seemed to have led either to a continuation of the analytic mentality of Cubism—which had prevailed before the war—or to a "return to order" through the adoption of various figural styles in a realistic or neoclassical manner.

Although he was trained in the academic tradition in Havana, Lam would eventually find himself dissatisfied with that approach to painting. Like other young artists he met, first in Spain and later in France, Lam wanted to be free of the aesthetic shackles of academicism. He glimpsed the way out of this dilemma when he encountered the work of Picasso.

This event was certainly essential to Lam's artistic development, given the affinities that existed between the two artists (they met in Paris in 1938) and the experiences they shared—the Spanish Civil War and their mutual origins in Cuba. Lam, however, did not let himself be influenced aesthetically by the already-famous Picasso for long. In fact, the concurrent influence of Matisse on Lam's work of 1936–40 is evident, particularly the sensitive decorativeness seen in pictures such as *La Fenêtre* of 1936 and *La Table blanche* of 1938. These works also manifest an interplay between the background and the motifs in the foreground. But this too was only a stage.

Beginning in those years, Lam was obsessed with the themes of women and women with children. The female figure, which appears consistently in his oeuvre throughout his career, becomes increasingly hieratic. We are reminded of Picasso's work of the Cubist era, and of *Guernica* as well. During this period, melancholy commingles with iconic impenetrability, as if Lam were seeking to surpass the merely anecdotal and transient elements in figuration.

This development culminated in the very formal "portraits" of 1940—*Femme au fond rouge* and *Femme sur fond vert*, for example—which invite comparison with the work of another of Lam's contemporaries, Alberto Giacometti. Like Lam, Giacometti was searching for the expression of truth in the human visage. Unlike Lam, who created an absolute image, a universal, Giacometti explored the singularity of the individual, captured in his irreducible uniqueness. Thus, there is a hesitant, exploratory quality to Giacometti's hand, as if he were grasping at a truth that eluded even his own observations. As draftsmen, Lam and Giacometti both sought to depict an existence that had been brutalized, displaced, and destroyed in a period when war and social upheaval left little chance of survival.

However, these two artists employed different artistic means. Giacometti destroyed the false truths of figuration by excessive drawing; Lam did so by paring down to the essence of figuration. Whereas one obsessively accumulated lines in the secret hope of eventually discovering the truth of a particular face, the other eliminated all traces of whatever would dissolve the humanity of a face in the fortuitous expression of individuality. This is why Lam returned to the idea of the mask. His was not a reappraisal of the

Wifredo Lam in his garden with the work **Belial, empereur des mouches** (completed in 1948). Havana. 1947

research that had inspired Picasso in his Cubist period. Far from it. In Lam's paintings, the hieratic pose that transforms the face into a mask reveals a quest for essence, not merely form. Beyond the strokes that seem to resemble mimetic figuration, Lam was in search of a truth that is not readily apparent. In a society dedicated to the cult of the individual, and to the unbridled quest for self-identity—that is, all that distinguishes an individual and thus separates him from others—Lam proposed a generic figuration. It was humanity as a whole that had to be shown, not individual human beings, if the word *humanity* was to have any meaning.

After having arrived at this point in his thinking—which was further enhanced by his encounter in Spain with Carl Einstein, the premier aesthetician of African statuary—Lam was forced to flee the German invaders of France, and in 1941 he traveled to the Caribbean. Following his extended sojourn in Europe, from 1923 to 1941, Lam's return to Cuba was the catalyst for a new awareness of Afro-Cuban traditions. This awareness reflected ideas that had already percolated in France, not only in Cubism but also in Surrealist circles, which had questioned not only the nature of form but also form's metaphysical nature. This contact and the sensibility that came to him from his Chinese origins contributed to the maturation of Lam's new outlook.

Lam discovered, or rediscovered, a country that was the amalgam of many peoples and cultures and religions. The singularity of the European sensibility now seemed far removed within his new milieu, which was steeped in African traditions. In Cuba, Lam renewed his acquaintances with Surrealist cohort Pierre Mabille and with Pierre Loeb, who had organized Lam's first gallery exhibition in Paris in 1938. He also corresponded with André Breton, who was temporarily in exile in New York City. There was an intense exchange, most of which has been lost. Most importantly, Lam began to paint again, after the painful displacement and wandering that had taken him from Paris to Marseilles, then to Martinique, and finally home.

Home, however, was now a very different place: Cuba was in danger of losing sight of her African essence. Despite the efforts and interest of artists and intellectuals such as Lydia Cabrera and Fernando Ortíz, African culture was trivialized in the service of the tourist industry and its attendant social problems. Lam found a comparable Afro-Antillean sensibility in Haiti, which he visited in 1945–46 in the company of André Breton. This archaic essence rose in him when he attended vodun ceremonies together with Breton and Pierre Mabille. It would continue to call him, like a melody from the deepest recesses of his being, even later, when he had returned to Europe and when, after 1952, he made subsequent trips to South American countries such as Mexico and Venezuela.

It was the power of this primordial force—with recurring motifs of bird talons and ceremonial knives—that he then began painting, reuniting what the evolution of morality and philosophy in the west had torn asunder. The mythical figures, monsters, and montages he composed portrayed in a single figure a fragmented sense of belonging. He had begun to conceive this mode of depiction while participating in the *cadavre exquis* with his Surrealist friends during the long wait to leave Marseilles in 1941.

Lam's anthropology—for one must read his work as the knowing and spontaneous construction of a vision of Man—draws from all the sources that converge in his own biological and cultural heritage. His drawing, which is the stabilizing element in all his painting, worked to hold together all the elements. From *Belial, empereur des mouches* of 1948 to *Tropique du capricorne* of 1963, Lam's figurations became more distilled, purer; the narrative of myth persisted, now concentrated in an enduring image. The solitary figures of the 1940s were gone. After *The Jungle* of 1942, Lam cast the isolated individual into mysterious and violent narratives. Increasingly, his painting had a reductive quality, composed of fewer but incisive lines and a closely related palette of monochromatic earth tones such as light ochers and burnt umbers. He seemed to be searching for an essence, as in a dream whose colors are not true to life. From the earth arose a suggestion of the past, of eternity, and the stylized forms of the figures attest to the primordial nature of the earth.

By the same gesture with which he restrained his painting from succumbing to the seduction of color—so as not to be misled by the nonessential beauty of the world or by a facile denunciation of the ills of the world—Lam further downplayed the importance of pictorial elements by imposing on them a certain sparseness.

In time, there was less and less paint on his canvases. The canvas itself began to assume an unprecedented prominence in his work. Lam was not just depicting the abstract space on which western art had built its systems of representation; now by exploring the materiality of the canvas itself, and deliberately diminishing the sizing, the painting became the *Materia prima*—the arena, the terrain—on which symbols appeared and disappeared. Then began his prodigious struggle with the drawn line, laden with enigmatic representations. After *The Jungle*, which still presented a figurative and presumably real space, Lam abandoned the western tradition and yet did not stop being a figurative painter. This is what marked Lam so definitely as a contemporary painter. He departed from what was being done in New York or Paris but continued in the spirit of what has always and everywhere been thought, felt, and done in painting.

Even though he took great care with his artmaking, Lam never went in the direction of featuring the autonomy of color or form that characterized the art of the 1950s. However attached he was to the dreams and images of the unconscious, he never fully conspired with the Surrealists in their disdain of "painting." Furthermore, whatever his political sentiments, he never denounced anything in his paintings.

Wifredo Lam was involved in more universal struggles, and it is for this reason that his manner of allying himself with various factions in the contemporary art scene was different. He was not part of any movement. His work is a distinctively individual manifestation, which reflects his singular capacity to express the rupture taking place in western art, which he, like Matta, probably experienced more keenly than others, because he came from a split Euro-Latino-American background. This culture viewed the west from a double perspective, recognizing itself and yet not finding itself there, because its essential nourishment came from elsewhere—from African, Indian, or Caribbean sources. Wifredo Lam embodied a multiplicity of races. He was to bring to the contemporary world, which has been in the process of discovering itself as one planet, the first art that truly dealt with the humanity of Man, beyond the differences that society imposes.

*Translated from the French by Nancy Festinger
and Lowery Stokes Sims*

Wifredo Lam
La Cortina. 1942
Courtesy M. Gutierrez Fine Arts, Miami
cat. no. 12

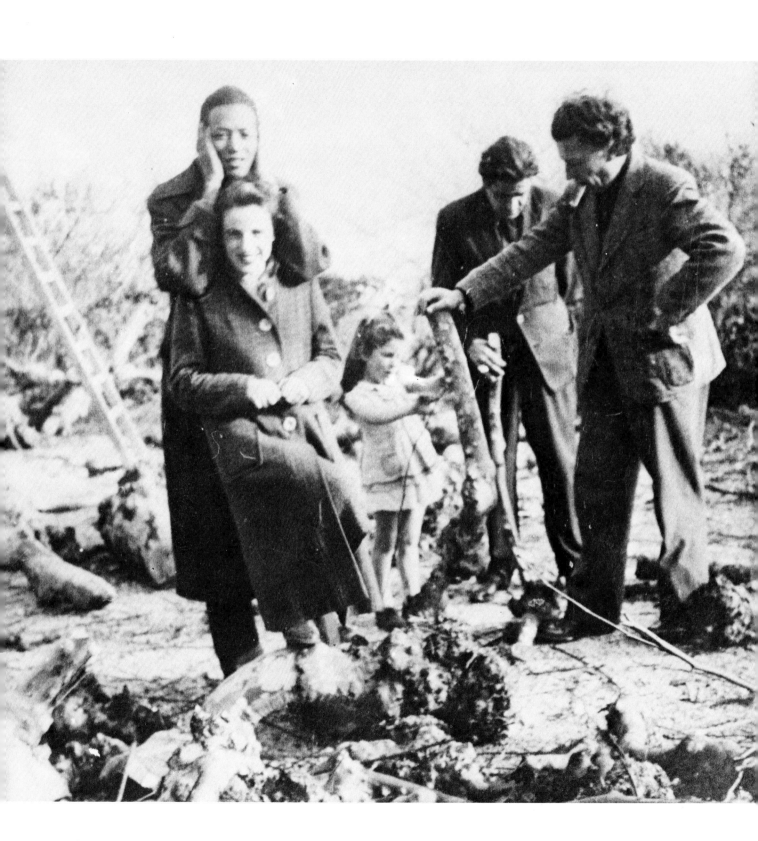

Wifredo Lam: From Spain Back to Cuba

LOWERY STOKES SIMS
Associate Curator, 20th Century Art
at The Metropolitan Museum of Art

The arrests, raids, searchings were continuing without pause; practically everyone we know . . . was in jail by this time. The police were even boarding French ships . . . seized suspected "Trotskyites." . . . We had managed to get our passports in order. . . . There was a train that was due to leave for Port Bou at half-past seven in the evening. . . . I got down to the station at about seven to find that the train had already gone . . . at ten to seven. . . . There was another train early the following morning. Next morning my wife slipped out of the hotel successfully. The train was about an hour late in starting. . . . In the end we crossed the frontier without incident. . . . With every mile you went northward France grew greener and softer. . . . Now, after poor Spain, even Paris seemed gay and prosperous.[1]

This passage is from George Orwell's memoir of the Spanish Civil War, which was published in April of 1938, just as the Cuban-born artist Wifredo Lam, then thirty-six years old, was making similar preparations for his own journey via Port Bou and was facing even more intense perils. Lam arrived at the Gare d'Orsay in Paris on May 22, 1938. The timing was fortuitous, as Catalonia, one of the last surviving Republic strongholds, was fast succumbing to the insurgency of the Nationalist forces. Two months earlier, Barcelona had been bombarded by Mussolini's air force, and in April the electrical power had been cut off.[2]

Lam had been a committed Republican since he joined the party in 1932.[3] He put his artistic talent in the service of the Republican cause by producing propaganda posters, and he was drafted to fight in the defense of Madrid in 1936, when the Civil War broke out. This period in time is preserved in two photographs: one is of Lam and two male companions standing in front of a truck, probably at the munitions factory where he worked for the Fifth Regiment, and the other shows Lam and his then-current companion Balbina Barrera holding rifles in front of a barricade. Lam captured the spirit and drama of the moment in his 1936 gouache titled *The Spanish Civil War* (fig. 1). Lam conveys the confusion of street fighting at close range, presenting the bodies of dead partisans in the foreground, over whom weeping women prostrate themselves.

In late 1937 or early 1938, Lam was incapacitated during the fighting. He was either poisoned by toxic gas or stricken by an intestinal ailment. He was transferred to a hospital in Barcelona, where he managed to paint a backdrop for one of the theatrical performances that were staged to raise the morale of two individuals who were to influence the course of his future—a German research associate in neurobiology named Helena Holzer, with whom he shared his life for the next twelve years, and Manuel Hugué, a Catalan artist known as Manolo, who gave Lam a letter of introduction to Pablo Picasso in Paris.[4]

In the midst of, and in spite of, these dramatic events, Lam's art was undergoing a crucial synthesis and change that continued his evolution from academic painting to modernism, which had begun some thirteen years earlier when he first arrived in Madrid from Cuba. Lam initially studied academic painting with Fernando Sotomayor at the Prado, and he had

Wifredo Lam, Helena Holzer Lam, Aube and André Breton, and Oscar Dominguez. Marseilles. 1941

his first lessons in modern art at Academia Libre in the Paseo Alhambra in Madrid. From 1924 until about 1929, he spent a great deal of time in the small town of Cuenca, nestled in the mountains approximately 150 kilometers southeast of Madrid. The portraits of farmers (fig. 2), gentry, and postcard-like views of Spain he executed at this time reveal his retention of a sturdy realist style, and his salon decorations are an unlikely excursion into an ornate orientalizing symbolist mode (fig. 3). Around 1934, after briefly experimenting with biomorphic imagery (fig. 4) and with a type of Surrealist narrative that was no doubt influenced by the Surrealist currents in the Madrileño art scene between 1924 and 1936,[5] Lam launched into a prolific production of still lifes, interiors, landscapes, cityscapes, and portraits in which form is simplified, at times into separate window-like segments. The bright colors and elaborate decorative details in those works reveal at least an interest in the work of Matisse and quite possibly the direct influence of the work of Joaquin Torres García (fig. 5).[6]

These characteristics also exist in the aforementioned *Spanish Civil War*, in which various elements of the composition are compartmentalized into individual elements. Lam compressed the various and numerous figures into a tightly woven composition, in which all the elements seem to exist on the same plane. This tendency culminated about 1935–36, at which time there was another shift in his work, precipitated by his viewing of an exhibition of Picasso's work that opened in Barcelona (January 13–28, 1936), traveled to Bilbao (February 1936), and finally was shown in Madrid (May 1936), where Lam saw it. Lam noted that the Picasso exhibition was "not only a revelation but . . . a shock."[7] The impact of Picasso on Lam had political as well as artistic implications. In a gesture of solidarity with the Republican cause, Picasso had accepted the honorific post of director of the Prado at the onset of the Civil War. It is well known that Picasso continued to support the Republican cause from Paris, and in 1937, he created *Guernica*—undisputedly one of his masterpieces—as a protest to the savage bombing of the town of Guernica by the Italian allies of the Nationalist forces.

Lam's transition from a Matisse phase to one informed by Cubism is seen by comparing two beautiful gouaches from 1936, both of a mixed-race couple (figs. 6 and 7), most likely Lam and Balbina Barrera,

captured in an intimate moment. In the first version of the composition, the woman sits at the feet of the man, affording us an unimpeded view of her ivory back and luxurious red hair. In the second version, she stands slightly above him, assuming a more aggressive air; her face has taken on a masklike aspect that resembles Picasso's work of around 1906–07. Lam's pictures of 1937 and 1938 show an adaptation of Cubist forms, specifically those of analytic Cubism. There is some question as to which works from 1938 were done in Spain and which were made in Paris. Among a group of works from 1938, there are certain compositions that are imbued with an intense emotionality that conveys the anguish and urgency of this time in Lam's life. Couples are engaged in intimate exchanges, during which one or the other may awaken distraught from a nightmarish sleep (fig. 8). In other compositions, women gesticulate in anguish and despair, clutching their children to them in desperation. These compositions equal Picasso's *Guernica* in intensity, but Lam was painting them in Spain, in the midst of the fighting. A number of mother-and-child compositions from 1938—and also 1939, such as *Mother and Child* (cat. no. 4)—show the child lying across the mother's lap, very like the dead Christ in a Pietà. It may not be farfetched to see in these works Lam's belated anguish over the death of his first wife, Eva, and son Wifredo in 1931, a grieving that was momentarily diverted by the exciting political activities that began soon afterward. There are also the paintings that have figures with featureless oval heads, such as *Personnage assis* (cat. no. 3), who sit cross-legged; some, as in *Deux personnages* (cat. no. 1), also have their arms crossed and appear to be in a contemplative state of mind. María Lluïsa Borrás has reported that friends of Lam from that period in Spain have asserted that such featureless figures appeared in Lam's work before he went to Paris.[8] These compositions, and a related group from 1939, are sometimes set in interior spaces marked by dramatic shifts of perspective as the corners of the room and the ceiling and the wall meet at odd angles. As the spatial reading was thus flattened, Lam also striated the individual planes of the architecture in alternating vertical and horizontal directions to distinguish one from the other, as can be seen in *Deux personnages*. We can therefore conclude that the works begun in Paris in the spring of 1938, after the hiatus while Lam was fighting in the defense

of Madrid in 1938, show a much more "Africanized" character. His figures are now defined with strong angular outlines that clearly articulate the planes of the body parts—breasts, collarbones, and shoulder blades are often summarized in a zig-zag motion, approximating the formal synthesis of human anatomy seen in African art styles such as that of the Dogon of Mali. Faces are masklike; often, an eye is an oval with parallel lines, a nose is defined by two parallel lines perpendicular to the lines of the eyebrows (fig. 9).[9] The mouth is also two parallel lines. One is reminded of the so-called Goli masks of the Baule of the Ivory Coast, and occasionally an elongation of the nose and mouth planes into a snout evokes the style of the Basongye in Zaire.

By the time Lam was painting these works, he had met Picasso. Armed with the letter from Manolo Hugué, he had gained entry to Picasso's house and studio, where he received an unusually attentive welcome. Lam later reminisced about that meeting:

> I set out on foot on the rue de la Boétie, where lived the artist I so admired. A uniformed chauffeur greeted me . . . and said, "You can give him your letter personally at 4 this afternoon at rue des Grands Augustins." I then walked about aimlessly on the rue du Faubourg Saint Honoré. There were so many art galleries, and I went into Galerie des Beaux Arts, where there was a retrospective exhibition of a French artist. . . . A little while later I saw a small man enter . . . with a woman. I realized that they were Picasso and Dora Maar, but I preferred not to introduce myself. . . . At 4 in the afternoon I was in front of the door to his studio at the same time as someone else who was about my age. I didn't dare open my mouth because my command of French was not strong. This other man, who later became one of my best friends was Michel Leiris. . . . After greeting me Picasso led me to a room where there were African sculptures. I was especially attracted to one—a head of a horse. . . . Picasso moved the furniture and the sculpture . . . seemed to be alive. "What

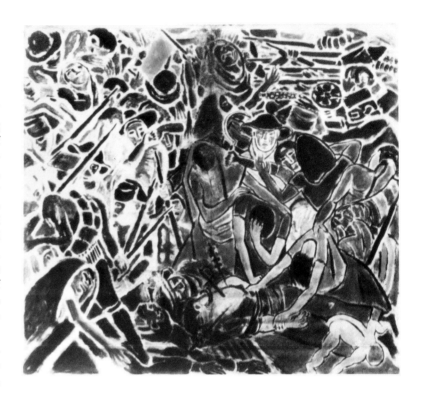

> a beautiful sculpture!" he said . . . and added: "You should be proud!" "Why?" I asked. "Because this sculpture was made by an African and you have African blood." And then he said to Michel Leiris, "Teach Lam about African art."[10]

While it is not the purpose of this essay to examine the relationship between Picasso and Lam, it is important to note that out of their first exchange, a myth about Picasso's influence on Lam was generated. Pierre Mabille has pointed out that Lam had already seen African art in Madrid.[11] In addition, Lam was grounded in the Africanized Santería religion of Cuba, having been trained in its beliefs and rituals by his godmother, Mantonica Wilson, when he was a child in Cuba.[12] The mantle of benign progenitor that has been conferred by Lam scholars on Picasso (and later on Lydia Cabrera) misses the point of these connections. Picasso (and Cabrera) merely served as catalysts to Lam's search for a personal interpretation of modernist syntax. As a descendant of peoples who were displaced in the diaspora and discouraged—officially—from following the practices of their forefathers if they aspired to access to the mainstream, Lam, along with others of his generation, found encouragement in the embrace of their despised cultures by European artists and intellectuals. In turn—and this is key to the rela-

1
Wifredo Lam
The Spanish Civil War. ca. 1936
Gouache on paper
83 x 93" (210.8 x 236.2 cm)
Col. Angel and Magaly Capriles

tionship of Lam, Picasso, and Breton—Africanized intellectuals and artists lent an air of authenticity to the pervasive primitivizing that characterized much of the modernist enterprise. In 1945, André Breton wrote that in Lam, Picasso found a confirmation of his own artistic mission, "the only affirmation he could have, that of a man who had reached a similar stage to his own, taking the opposite path."[13] The assumption is that Picasso and Lam started at opposite ends of an artistic spectrum framed by Europe and modern art on one end and Africa and tribal art on the other, but this is a misconception. Lam was never a tribal artist; he had come to a modernist style in much the same way as any artist of his generation. Lam's distinctive achievement is the fusion of Cubist and Surrealist stylistic strategies with referents from Santería, a traditional African-based religion with which he was intimately acquainted as an "insider," as opposed to Picasso's engagement of African and Oceanic art as an "outsider."

Throughout 1939, Lam continued to elaborate on the figural compositions that he created in 1938. The female figures now appear more preoccupied with vamping for the artist; they are seen in a number of coquettish poses, that of the *Woman Holding Her Hair* (cat. no. 5), for example. Of special interest is a series of still-life compositions variously featuring fish on a platter, fruit, an artist's palette, drapery, and a variety of utensils on a side table with a drawer (fig. 10). These works demonstrate a particularly adroit fusion of Matisse's linear shorthand and Cubist spatial interplay. Toward the end of 1939 and into 1940, the masked figures acquire more decorative surfaces with floral motifs replacing eyes and mouths becoming open circles with teeth inside, features that also emphasize Lam's occasional impulse toward the horrific. The overall surrounding space becomes more decorative as well, demonstrating that the influence of Matisse persisted even in this Picassoesque moment. Color and line alternate rather than exist to define one another, thus establishing a more open-ended dynamic interaction between figure and ground as seen in synthetic Cubism. Finally, a group of figures with crescent- and oval-shaped heads and anatomical parts that shift this way and that on the central axis of the figure appears in the work, evincing a brand of Cubism that is Lam's own. The figures possess enlarged hands and feet of exceptional articulation and

expressiveness, characteristics that will persist in Lam's work, as in *La Cortina* of 1942 (cat. no. 12), for example. Some of these gouaches were exhibited at Pierre Loeb's Galerie Pierre in 1938. Klaus Perls exhibited more of them (sent from Paris by Perls's mother, who at the time had a gallery on rue du Dragon) the following year in his gallery in New York, along with drawings by Picasso that Perls had in stock at the time.[14]

Through Picasso and Dora Maar, Lam met several other personalities on the Parisian art scene—Tristan Tzara, André Breton, and presumably through him, members of the Surrealist group, including Oscar Dominguez, who came from the Canary Islands, Victor Brauner, and Max Ernst. Those friendships were important for Lam during the months following the outbreak of World War II. Lam left Paris in June of 1940 and went to Bordeaux and then to Marseilles, where he caught up with Breton and other intellectuals, writers, and artists who were seeking to leave France. Lam gave up the studio he had established at rue Armand-Moisant. Before his departure, he had himself photographed with his paintings (fig. 11) and then deposited them with Picasso for safekeeping. These paintings stayed with Picasso until after the war, when Lam returned to claim them in 1946.

The Catalan writer Sebastiá Gasch, who met Lam in Paris, provides a riveting description of Paris at the time of the arrival of the German troops. He and Lam had ventured out onto the Avenue du Maine:

> The streets of Paris had become scenes of horror; instead of trying to help one another, all those fugitives seemed to feel nothing but mutual hatred, each one intent on getting away even if it were over his neighbor's dead body.
>
> A band of louts who had somehow commandeered a furniture lorry were attacking the crowd mercilessly, laughing like madmen. They drove the lorry as if it were an army tank and roared with sarcastic laughter at the plight of a panic-stricken couple who did not know where to put their little children.
>
> Along the broad central roadway of the Boulevard Raspail came a pitiful mob of people, advancing almost at random like an army of automatons.

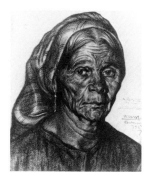

2
Wifredo Lam
Portrait of a Peasant. 1927
Pencil on paper
23⅝ x 19⅝" (60 x 50 cm)
Private Collection

3
Wifredo Lam
Indio con balio. ca. 1927
Oil on canvas
44⅛ x 35⅝" (60 x 50 cm)
Private Collection

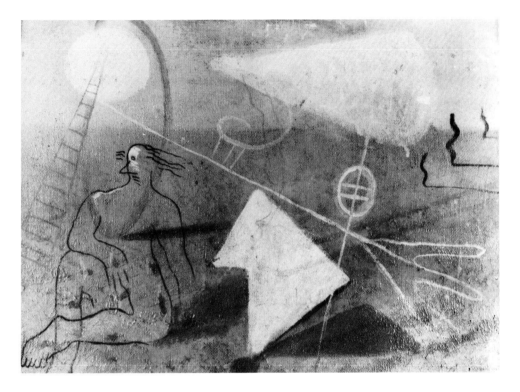

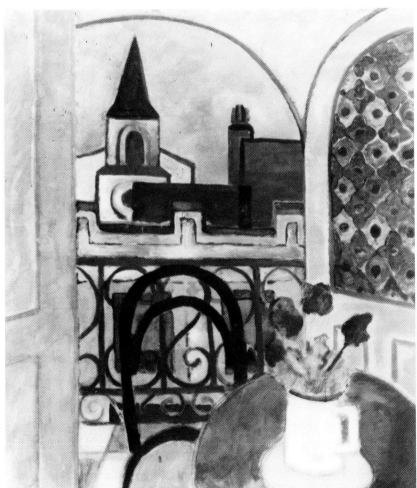

4
Wifredo Lam
Untitled. 1935
Oil on cardboard
Private Collection

5
Wifredo Lam
The Window. 1936
Gouache on paper
38⅛ x 29⅞″ (97 x 76 cm)
Private Collection

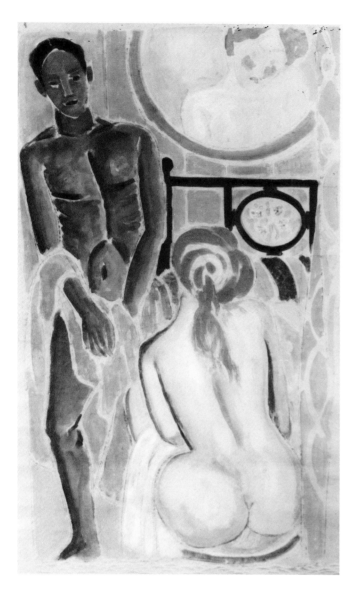

6
Wifredo Lam
The Couple. 1936
Gouache on paper
50¾ x 30⅜″ (129 x 77 cm)
Private Collection

7
Wifredo Lam
The Couple. 1936
Gouache on paper
50⅜ x 32⅛″ (128 x 81.5 cm)
Private Collection

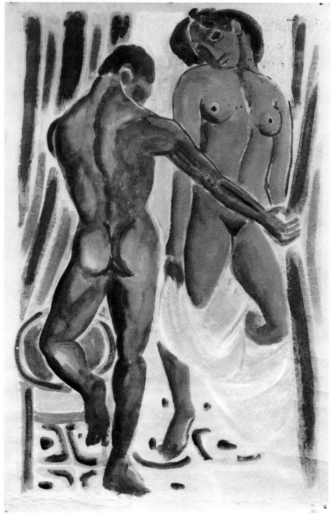

A heterogeneous group of tattered soldiers, Jews who went to the Café du Dôme for coffee every day, and pariahs of various kinds emerging from the sewers were pretending to help the poor people, who were frenziedly piling their worthless possessions onto battered lorries, muttering hoarsely: "They say they'll burn the soles off the feet of anyone they catch alive."

Some children crying with fear, others stamping on the ground in their impatience to be off; a group of half-dressed women were muttering almost unintelligibly among themselves talking of the "horrible tortures" awaiting any-body who was foolish [enough] to remain in Paris. . . . After sleeping for eight hours . . . I was awakened by a knock on the door of my room in a hotel in the rue de Chevert . . . "Ils sont là!" I was told . . . by the only maid who had not aban-doned the hotel. . . . I hastily put some clothes on and almost flew downstairs. In the hall I found two Catalans . . . hur-riedly burning papers, documents and books. . . . They were accompanied by Wifredo Lam, and he and I then saw that German flags had already been hoisted: over the Military School, on top of the Eiffel Tower. . . . Wifredo Lam was preparing for his journey to Bordeaux. He got there after walking almost all the way and then he went on to Marseilles.[15]

In Marseilles, Breton and several Surrealist cohorts found lodging in the Villa Bel-Air (figs. 12 and 13). Although Marseilles was outside the direct domi-nation of the Vichy regime, it was—as Spain had been three years previously—a hotbed of intrigue and deception. Because of their Surrealist reputations, they were all under suspicion. They whiled away the time drawing *cadavres exquis* and producing other types of collaborative artworks. Varian Fry noted that at this time Breton

made collections of insects, pieces of broken china polished by the sea, and

old magazines; he talked magnificently and always entertainingly about every-thing and everybody, and held Surrealist reunions on Sunday afternoons . . . [when] . . . the other Surrealists came: Oscar Dominguez . . . who was living in a nearby villa with his fat and elderly but rich French mistress; Benjamin Péret, the French poet whose verses sometimes read as though they had been copied down from the walls of public toilets; Wilfredo [*sic*] Lam, the tragic-masked Cuban Negro who was one of the very few pupils Picasso ever took; Victor Brauner, the one-eyed Rumanian painter whose women and cats all have one eye; and many others. Then Breton would get out his collection of old magazines, colored paper, pastel chalks; scissors and pastepots, and everyone would make montages, draw, or cut out paper dolls.[16]

In the midst of these diversions, Breton and Lam col-laborated on the publication of Breton's poem *Fata Morgana*, with drawings by Lam. These drawings and related studies, which had been dispersed among several of Lam's acquaintances, provide crucial stylistic information about the final stages of Lam's transition before the signature imagery he produced in Cuba between 1941 and 1947.

Although the drawings done in Marseilles in 1940 and 1941 are collectively know as the *Fata Morgana* suite, only about three of the drawings served as the direct inspiration for the *Fata Morgana* illustrations (cat. no. 7; figs. 14 and 15).[17] More importantly, they provide a record—in some instances, a daily one—of the development of Lam's signature imagery, which heretofore was thought not to have begun until his return to Cuba in 1941. That year, the development of the "*femme cheval*," the horse-headed female who achieves a meld of the protagonist of Picasso's 1935 graphic *Minatouramachy* suite and the possessed devotee of Santería ceremony, was advanced. What is clear from these drawings is that the type originates from a variation of a helmet-headed and horned entity that at this point is more bull-like than horselike. That these images are transitional is indicated by the defined horned heads that appeared beginning with

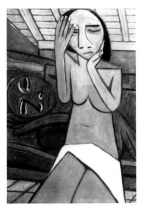

8
Wifredo Lam
Le Réveil. 1938
Gouache on paper
41⅜ x 29½" (105 x 75 cm)
Private Collection

the 1940 drawing *Hector, Andromache and Their Son Astyanax* (cat. no. 6). Picassoesque elements include eyes in vertical alignment and multiple facial features that seem to indicate the presence of many characters. However, Lam was also beginning to present the distinctive visual punning that is unique to his work—the bulbous chins that evoke both the fruits of the Caribbean and male sexual organs, and fruit that refers to female fertility merging with the male sexual organ that conspires in the act of procreation. Although Lam demonstrates a particularly elaborate decorative sense in these drawings, more ferocious elements occasionally emerge, for example in the drawings in which the hands and arms, festooned like medieval clubs, strongly evoke the anguish and brutality of the works of 1938 (see cat. no. 6). This ferocity is also evident in the terrified figures that curve around to clutch themselves, their eyes wide open in terror. Several stunned-looking female figures, some holding children, appear in incredulous hand-to-cheek-and-chin poses. In other instances, the volumes of one figure intrude into those of another, or else simply carve out chunks of space.

The ingenue, if you will, of this group of female incarnations is the long-haired woman who serves as the inspiration for the figure in the opening plate in *Fata Morgana* (cat. no. 7). Her stare, enhanced by the horizontality of her brows, is particularly intense, indicating that her immediate inspiration was probably Helena Holzer. In the 1940 drawing, her hair is bedecked with stars, as if she were a fairy princess. In *Fata Morgana*, that stellar embellishment proliferates with additional floral motifs. Later in the book, she reappears as part of an impressive composite being, looking out to the right, seemingly unperturbed as a host of grasping, crawling creatures and an anguished profile gyrate around her like the ghastly apparitions that torment the hapless sinners in Hieronymus Bosch's *Garden of Earthly Delights*—a painting in the Prado in Madrid, a museum Lam frequented during his Spanish years. This profile recurs in a 1943 drawing that Lam made in Cuba and dedicated to Lydia Cabrera. Finally, the figure's probable identity becomes clear when compared with one of a series of portraits Lam did of "H.H." (cat. no. 30) later in the 1940s, in which the horizontal brow and long hair have a provocative likeness to those in the *Fata Morgana* drawing.

By early 1941, the dates that Lam was inscribing on his drawings indicate that he was producing up to four or five drawings a day. His virtuoso line was now creating more fantastical and numerous permutations of the human form. Several of these compositions became the bases for later works: One of the *femme cheval* drawings from 1940 is the source for *Symbiose* of 1942; a horned, double-faced incarnation of February 13, 1941, with thumb-articulated feet, served as the basis for *Figure zoomorphique* of 1942; and finally the horseshoe-headed family grouping of 1941 is the source of the interlocking heads in *Malembo, Diety of the Crossroads* of 1943.[18] The stylistic changes seen in the Marseille drawings as a whole were certainly propelled by Lam's participation in Surrealist drawing such as the aforementioned *cadavres exquis*, and in other collaborative drawings, such as the one he made with Jacques Herold and André Breton (cat. no. 8) and also the so-called *Jeu de Marseilles*, a deck of fanciful playing cards, to which he contributed several designs. These exercises contributed to intensified psychic energy that occurs in Lam's drawings of 1940 and 1941. Indeed, the images of "Alice" and "Lautreamont" from *Jeu de Marseilles* (figs. 16 and 17) and the 1943 *Hermès* demonstrate an interest in the occult that has long been debated as a key element of Lam's mature work of the 1940s.[19] This connection was more fully developed in *Belial, empereur des mouches* of 1948 and in Lam's contribution to the 1947 Surrealist exhibition at the Galerie Maeght, an "altar" based on the image of the *Chevelure de Falmer*, a reference taken from Lautreamont's *Les Chants de Maldoror*. But at this moment in Lam's career, the underlying Cubist influence still persisted, and Lam continued to refine what was already a unique and personal version of that style throughout the next few years.

Lam's allegiance to what is tantamount to a synthetic Cubist style seems a bit anachronistic in view of concurrent events in the Parisian art world of 1938 to 1940. The postwar generation personalities were making their presences felt. Bram van Velde was painting bright Fauve-colored canvases with Cubistic divisionism that predict the work of the CoBrA artists. Asger Jorn—the future instigator of that group—had gone to Paris with the intention of studying with Kandinsky but ended up working in the studio of Fernand Léger. His paintings, rendered in a textural expressive

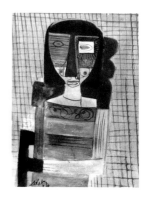

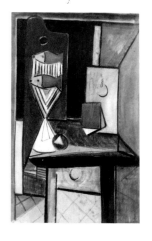

9
Wifredo Lam
Jeune fille au fond carré. 1939
Oil on maroufle paper
24 x 18⅛" (61 x 46 cm)
Private Collection

10
Wifredo Lam
Coin d'atelier (La Table). 1938
Tempera on paper
38⅝ x 25¼" (98 x 64 cm)
Private Collection

11
Lam with his paintings in his Studio at 8, rue Armand Moisant. Paris, 1940

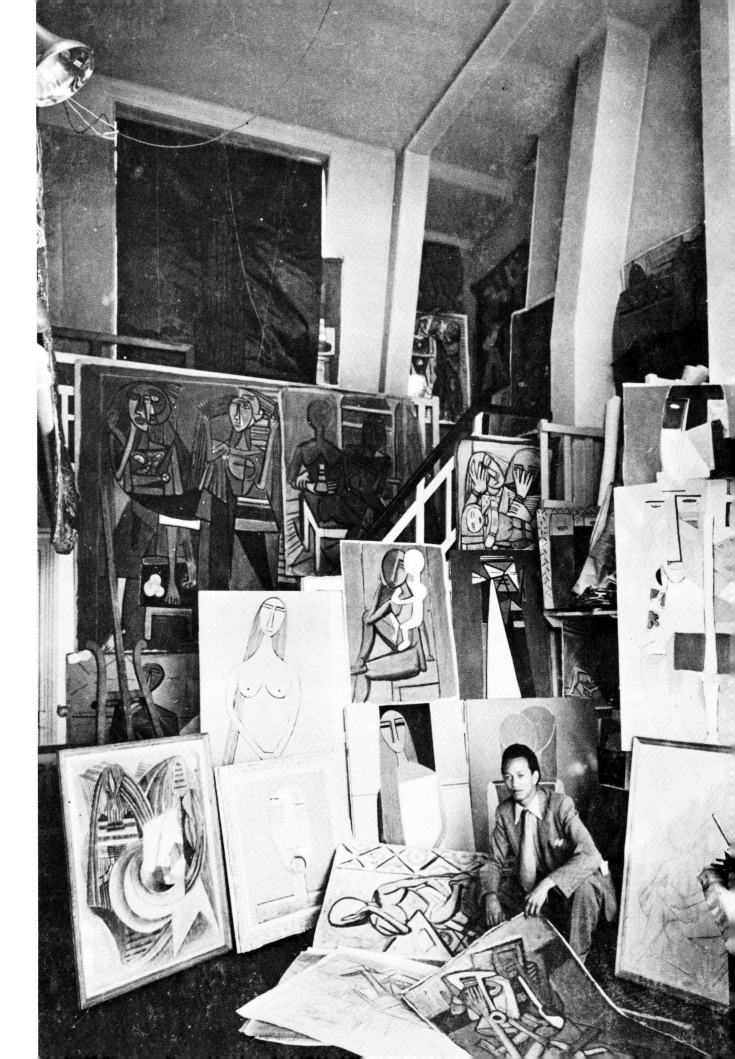

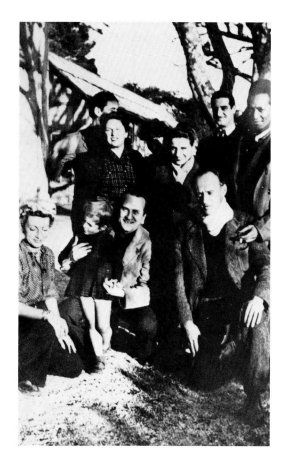

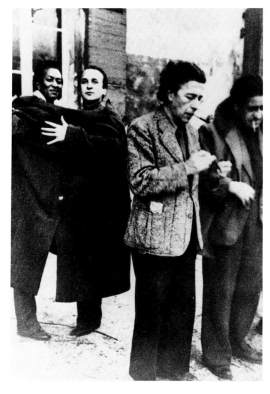

style, already manifested an appreciation of children's art. Other artists, such as Otto Freundlich and Maria Helena Vieira da Silva, were painting their respective notions of expressionistic geometric abstraction, and the late Orphist works of Robert Delauney, along with Kandinsky's most recent pristine and mechanistic non-objective pictures, were shown in 1937 at the Jeu de Paume.[20]

Even Surrealism was undergoing changes that prelude its next incarnation in the New World. Writing in *Minotaure* in May of 1939, André Breton summarized the most recent tendencies in Surrealist painting, noting a return to automatism and heralding the emergence of newer techniques for harvesting "found" imagery, including *decalcomania*, a staining and smudging process that had been devised by Oscar Dominguez, and *fumage*, the smoking and charring of paper and canvas, originated by Wolfgang Paalen. Breton further noted the contributions of the newest Surrealists including Victor Brauner, the American Gordon Onslow Ford, Esteban Francis, Matta, and Kurt Seligmann.[21] These artists, particularly Onslow Ford and Matta, would provide a crucial link between European and American Surrealism as the group dispersed into exile at the onset of World War II.

In the case of Lam, it is clear that the African-based formal sources of Cubism were the major attraction in his artistic exploration. That European artists had already glimpsed the power of this art and had identified it as a central element of modernism was compatible with Lam's own modernist ambition. Cubism, along with Surrealist methods, allowed Lam to give a cultural edge to this widespread modernist mode. Cubism was the most compatible springboard for his evolution into an artist of significant reality, but Lam transformed it into an instrument of cultural revolution. As John Yau has pointed out, after Lam arrived at a definitive point of self-realization in his art during the early 1940s, his relationship with Picasso changed, and "he began demanding parity. He did so by re-appropriating the African gods Picasso first appropriated in 1907, and restoring them to their rightful domain."[22]

Securing passage from Marseilles was a game of chance, but at last, on March 24, 1941, Lam and Helena Holzer set sail from Marseilles to Martinique. They were on the same boat with Breton, Victor Serge, Benjamin Péret, and Claude Lévi-Strauss, who in 1955 published his memoirs of the trip, in which he noted, "In addition to its human load, the boat was carrying some kind of clandestine cargo. Both in the

12
J. Lamba, J. Hérold, H. Gomez, V. Brauner, O. Dominguez, Helena Holzer, Wifredo Lam. Villa Bel-Air, Marseilles. 1941

13
Wifredo Lam, J. Hérold, A. Breton, and O. Dominguez in front of Villa Bel-Air, Marseilles. ca. 1941
United States Holocaust Memorial Museum

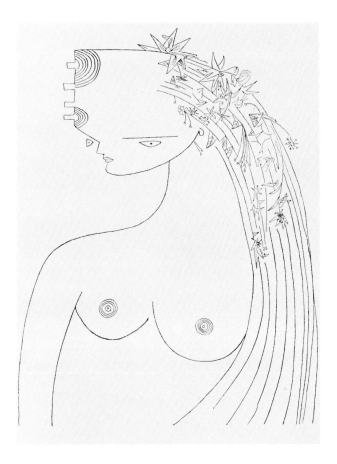

Mediterranean and along the west coast of Africa, we spent a fantastic amount of time dodging into various ports, apparently to escape inspection by the British navy. . . . Because of the heat, which became more intense as we approached the tropics, it was impossible to remain below, and the deck was gradually turned into dining-room, bedroom, day-nursery, wash-house and solarium."[23] Lévi-Strauss went on at great length to describe the hardships that were exacerbated by the lack of sufficient sanitary arrangements, and he expressed the all-around relief when, at the end of April, the lighthouse at Fort-de-France was sighted, with its promise of baths and other comforts. But this respite was not to be had; instead, to their consternation, a number of passengers were herded off to lodgings in a former leperatorium at Le Lazaret, where they awaited their fate.[24] They were soon joined by André Masson, who arrived on a second ship. Breton was able to secure a pass to go to town by day, and there he met local Martinicans, including the poet-politician Aimé Césaire,[25] who was engaged in intellectual warfare with the local Vichy regime in the journal called *Tropiques* that he was publishing at the time. An important venue of Surrealist thought and anti-colonialist polemic, *Tropiques* also sought to define a recuperated pride in self on the part of black Caribbeans. The jour-

nal published one of the first lengthy analyses of Lam's work, which was written by Pierre Mabille.[26] At the end of May, Lam finally secured passage to Cuba—first through St. Thomas in the Virgin Islands and then the Dominican Republic—arriving in Havana in July of 1941. Victor Serge, who traveled to the Virgin Islands with Lam, dedicated his poem *Mer des Caraïbes*, written on St. Thomas in June of 1941, to Lam. In it, he laments for the vanquished races of the Caribbean and evokes the image of European colonizers as centaurs—half-man, half-woman, and thus the inverse of the *femme cheval*—hunting runaway slaves in the bush. It is in that bush, *el monte*, that Lam would reclaim the heritage preserved by thousands of rebellious Africans in the New World.[27]

Lam later described his reaction to returning to Cuba: "Because I had left everything behind in Paris, I told myself I was at point zero."[28] And from that point, as he was entering his fortieth year, Lam was poised to come fully into his own artistically and to create the most significant works of his life.

14
Wifredo Lam
1941 illustration for André Breton's
Fata Morgana, published in
Buenos Aires in 1942
The Museum of Modern Art
Library

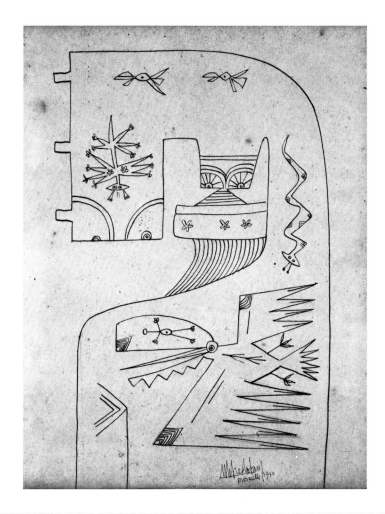

15
Wifredo Lam
1941 illustration for André Breton's
Fata Morgana, published in
Buenos Aires in 1942
The Museum of Modern Art
Library

Wifredo Lam
Preparatory drawing for André
Breton's **Fata Morgana.**
1940–41
cat. no. 7

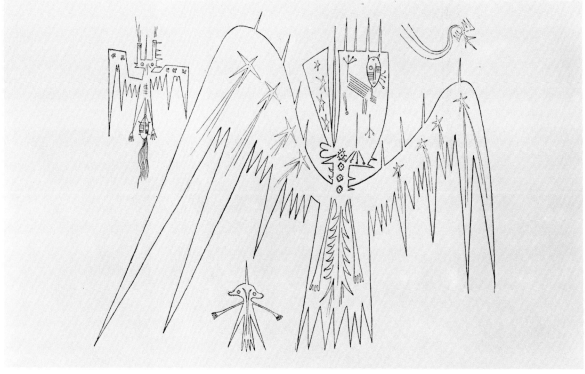

Footnotes

NOTE: I wish to thank Lou Laurin-Lam for her friendship and support of my research on Lam's work, sustained during eleven years of innumerable kindnesses and invaluable help. Thanks also to her associates, most particularly Yveline Hemsi. Maria Balderrama, coordinator of the exhibition *Wifredo Lam and His Contemporaries, 1938–1952*, was most helpful in proving information and being generally supportive. I also wish to acknowledge the assistance of Clara Sujo of CDS Gallery in New York and Fabrice de Kerchove, former summer intern in the 20th Century Art Department at The Metropolitan Museum of Art, for their assistance in completing this essay. I have also benefited from conversations with my co-curators, especially Julia P. Herzberg, who has generously helped to clarify dates and has shared with me the reminiscences of Helena Holzer Benitez about this period.

1. George Orwell, *Homage to Catalonia*, intro. Julian Symonds (London: Penguin Books, 1989), pp. 181–86.

2. Gabriel Jackson, *The Spanish Republic and the Civil War, 1931–39* (Princeton: Princeton University Press, 1972).

3. Like many individuals in the often-confusing configuration of politics in Spain during the 1930s, Lam also joined several other organizations in Madrid such as Estudiantes Universitarios Latino Americanos, Organización Anti-fascista, and one other that is designated only as the FUHA.

4. Sculptor Emanuel, or Manuel, Martínez Hugué was born in 1876 and according to Daniel-Henry Kahnweiler was "the abandoned son of a Spanish general. . . . [He] . . . had a precarious youth in Barcelona . . . [and] . . . became one of the closest companions of Picasso, nine years his junior" (Daniel-Henry Kahnweiler in an introduction to the exhibition brochure *Manolo*, Galerie Chalette, New York, October 7–November 2, 1957). Kahnweiler met Manolo in Paris in 1910, where he was known for his forthright dislike of Cubism—although his friend Picasso was its main agent—his wit, and appreciation for pranks. It was he, however, who handled the arrangements with the police in the aftermath of Casegemas's suicide and then took the dead man's mistress for his own. See John Richardson with the collaboration of Marilyn McCully, *A Life of Picasso. Volume I, 1881–1906* (New York: Random House, 1991), p. 181. Manolo's art, characterized by what Kahnweiler calls a "mediterranean classicism," is steeped in the lessons of Maillol, who was a friend and neighbor of his in Roussillon, and Gauguin, with its broadly defined simple classicizing form. He fought in the Spanish Civil War and died on November 17, 1945, just as the Second World War had ended. It is interesting to note that Manolo lived near the Caldas de Montbuy Spa, located 35 km from Barcelona, where Lam recuperated before emigrating to Spain.

5. See Lucía García de Carpi, *La pintura surrealista española (1924–1926)* (Madrid: Ediciones ISTMO, [1984]).

6. María Lluïsa Borrás in conversation with the author, Lou Lam, and Yveline Hemsi on September 19, 1989, attributed this character of Lam's work at this time to the presence of the Uruguayan modernist Joaquin Torres García, who spent time in Madrid between 1932 and 1934, giving workshops and exhibiting his art. (Notes transcribed by Yveline Hemsi.)

7. Max-Pol Fouchet, *Wifredo Lam*, preface by Pierre Gaudibert (Paris: Editions Cercle d'art, 1989), p. 112.

8. Borrás in conversation with Lou Lam, Yveline Hemsi, and the author on September 19, 1989. (Notes transcribed by Yveline Hemsi.)

9. Valerie Fletcher used the designation "coffee bean" to describe this stylization of the eye. See Valerie Fletcher, "Wifredo Lam," in Valerie Fletcher, with essays by Olivier Debroise, Adolfo M. Maslach, Lowery S. Sims, and Octavio Paz, *Crossroads of Modernism, Four Latin American Pioneers: Diego Rivera, Joaquin Torres García, Wifredo Lam, Matta* (Washington, D.C.: Hirshhorn Museum and Sculpture Garden, in association with the Smithsonian Institution Press, 1992), p. 171.

10. Wifredo Lam, "Mon amitié avec Picasso, 1938," *Wifredo Lam, 1902–1982. Paris: Editions Amis du Musée d'art moderne de la ville de Paris*, exh. cat. (1982), p. 13. (Translation by the author.)

11. Pierre Mabille, "La manigua," *Cuadernos americanos*, 1944. Extracted in *Exposicion Antologica: "Homenaje à Wifredo Lam, 1902–1982"* (Madrid: Museo Nacional de Arte Contemporaneo, [1982]), p. 67.

12. Fouchet, pp. 48–49.

13. André Breton, *Le Surréalisme et la peinture. suivi des "Genèse et perspectives artistiques du surréalism" et "Fragments inedits"* (New York: Brentano's, 1945), pp. 181–83.

14. This information was conveyed to me in a conversation with Klaus Perls in 1989. On July 10, 1992, Julia P. Herzberg told me an interesting episode to this story that was related to her by Helena Holzer Benitez, which brings the Lam-Perls connection full circle. At the outset of the war, Mrs. Perls and Holzer were detained in an internment camp. Mrs. Perls was then able to ransom herself and Holzer, and from there Holzer was able to go to Marseilles to meet with Lam again.

15. Sebastiá Gasch, *Wifredo Lam à Paris* (Barcelona: Galería Joan Prats), pp. 44–46.

16. Varian Fry, *Surrender on Demand* (New York: Random House), pp. 115, 117–18. The description of Lam's relationship with Picasso in this extract is a common one, but it is misleading.

17. The largest concentration of these drawings is a group of thirty-six that are currently in the collection of Dr. Gerald Millstein of Fort Lauderdale, Florida. Another belonged to Sara Sluger of Argentina, who met Lam in Paris. I wish to thank Clara Sujo for her help in identifying the works from the Sluger collection.

18. Lam double-dated several drawings done in 1939 with the notation "Marseilles, 1940." From photographic images and xeroxes of these works, which were formerly in the collection of Sara Sluger, there does not seem to be any indication of further embellishment of the imagery to justify this double-dating. Until all the Marseilles drawings are reunited, it will be impossible to discern Lam's purpose.

19. See André Breton, "Le Jeu de Marseilles," *VVV*, nos. 2–3 (March, 1943), pp. 88–90. For a discussion of occult and alchemical aspects in Lam's art, see Marta García Barrio-Garsd, *Wifredo Lam: dessins, gouaches, peintures, 1938–50* (Paris: Galerie Albert Loeb, 1987), n.p.

20. See *Paris/Paris, 1937–1957* (Paris: Centre Georges Pompidou, 1981), and *Cobra, 1945–1951* (Paris: Musée d'Art Moderne de la Ville de Paris, 1982).

21. André Breton, "Des tendences le plus recentes de la peinture surréaliste," *Minotaure*, nos. 12–13 (1939), pp. 16–21.

22. John Yau, "Please Wait by the Coatroom: Wifredo Lam in The Museum of Modern Art," *Arts Magazine* (December, 1988), p. 59.

23. Claude Lévi-Strauss, *Tristes Tropiques*, translated by John and Doreen Weightman (New York: Atheneum, 1973), p. 25.

24. Ibid., pp. 26–28.

25. See André Breton, "A Great Black Poet," *What is Surrealism: Selected Writings*, edited and introduced by Franklin Rosemont (New York: Monad Press for the Anchor Foundation, Inc., 1978), pp. 230–36.

26. Pierre Mabille, "La Jungle," *Tropiques: Revue Trimestrielle*, no. 12 (January, 1945); reprinted by Editions Jean-Michel Place, 1978, pp. 173–87.

27. Victor Serge, "Mer des Caraïbes," *Exposición antológica: "Homenaje a Wifredo Lam, 1902–1982,"* p. 43.

28. Fouchet, p. 187.

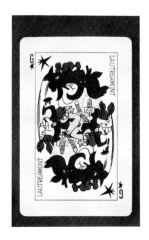

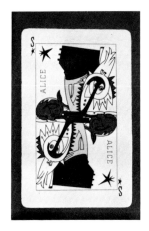

16 and 17
"Alice" and "Lautreamont" Playing cards for **Le Jeu de Marseilles**, designed by Lam in 1941
The Museum of Modern Art Library

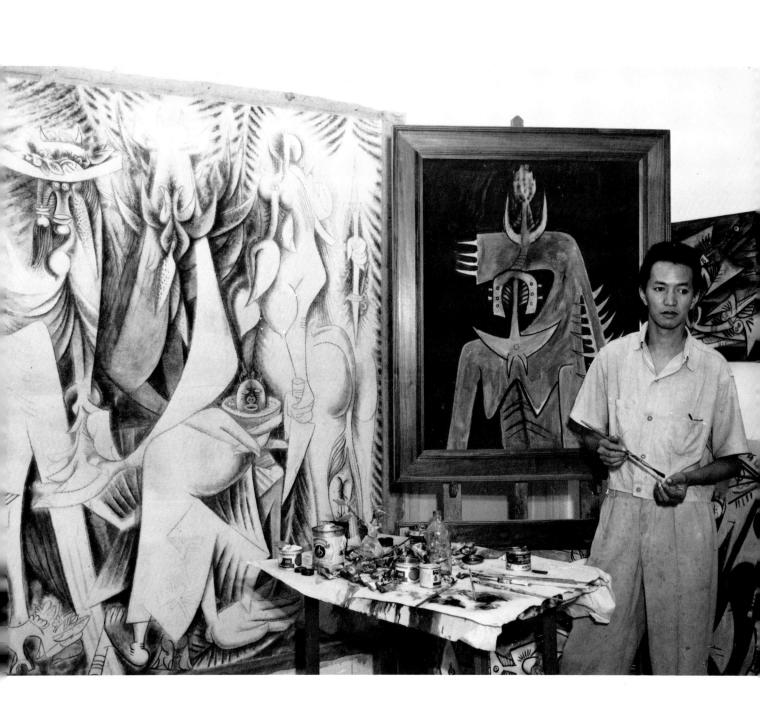

Wifredo Lam: The Development of a Style and World View, The Havana Years, 1941–1952

JULIA P. HERZBERG
Art Historian and Independent Curator

Lam's Havana period spans a decade, beginning with the artist's return to his native country in midsummer 1941 and ending with his return to Paris in early 1952. Lam's first year-and-a-half back in Havana represents a benchmark in his development. Although we have a small body of work dating from 1941, it is clear that the artist began to hit a new stride in 1942, a year in which he was very prolific.[1] That year marks a major stylistic and conceptual leap ahead in the artist's rapid evolution. Lam sent some fifty gouaches—only part of his production—to New York for his first one-person exhibition at the Pierre Matisse Gallery late that fall.[2] Remarkable for their inventiveness, these gouaches announce new formal and thematic directions. They are characterized by the presence of a hybrid figure that combines human, animal, and vegetal elements. Despite infinite variations, this hybrid became the single most important image in Lam's subsequent oeuvre. Its imaginative form, Surrealist in genesis and Cubist in construction, represents a significant departure from the earlier figural compositions of his Paris period (see Lowery S. Sims). In such works as *Oubli* (fig. 1), *La Chanteuse des poissons* (fig. 2), and *Nu dans la nature* (cat. no. 10), Lam progressed from a simply rendered figure to a more complicated hybrid, and then to an anthropomorphic figure merged with landscape.

Lam was born and raised in the rural sugar-farming province of Las Villas in the village of Sagua La Grande. His parents came from culturally diverse backgrounds. His father, Lam Yam, was Chinese and practiced ancestor worship; he transcribed the writings of Confucius and Lao Tse.[3] His mother, Ana Serafina Lam, was predominantly Congolese and inherited her traditional Afro-Cuban beliefs from her mother, who had been brought to Cuba as a slave from the Congo and set free when she married a Cuban mulatto.[4] Lam lived in the Chinese neighborhood in Sagua La Grande, which was only a stone's throw from where the majority of Afro-Cubans lived.[5] Although the artist was exposed to his father's teaching and practices, it was his mother's cultural and religious beliefs that were central to his formation. When Lam was growing up, he was surrounded by many people who had arrived in Sagua La Grande in 1880, during the last migration of slaves, to work on the sugar plantations. It was still common then to hear African dialects spoken.[6] Afro-Cubans in Sagua La Grande, as well as those living on other parts of the island, practiced their traditional religions and at the same time considered themselves Catholics. They did not see any conflict in going to church and attending ceremonies honoring the *orishas* on the same day. In this syncretistic belief system, African deities are coidentified with Catholic saints.[7] Bascom found that "members of Santería cults regard themselves as Catholics. All informants, without exception, stated unqualifiedly that they were Catholics, yet they stressed the importance of those very elements of their faith and ritual which set it apart from that of the Catholic Church."[8]

Lam's spiritual guide was his godmother, Mantonica Wilson, who was a *lucumí* priestess commonly known as a *santera*. Mantonica Wilson was a priestess of Changó, the Yoruba thunder god, who was her tutelar deity. Anyone who came to her for guidance would indirectly receive the guidance of Changó through her. She brought Lam under the guidance of Changó.[9] Although the young Lam was a devotee, he was not an initiate,[10] which in the Santería religion is a priest or priestess. In order to receive spiritual guidance and thus be considered a godson or goddaughter of a priestess, a devotee does not have to become an initiate.[11] In connection with her role as spiritual guide, Mantonica Wilson gave Lam a gift of an amulet consecrated under Changó's patronage. The amulet, exhibited here for the first time (cat. no. 113), must have been very dear to the artist; he kept it throughout his life. This good-luck charm has two ribbons and four leaves.[12] Changó's colors are red and white. The original colors of Lam's amulet have changed over the years from a deep red to a lighter shade and from white to pale green.[13]

Leiris has written that as a youth, Lam observed purification ceremonies in which guinea hens were passed over an adherent's body to rid it of its maladies.[14] We do not know if Lam was involved with *lucumí* practices after he moved to Havana as a youth in 1914. It seems likely, however, that since he lived with his mother's relatives, he continued observing syncretistic practices, in both the *lucumí* religion and Catholicism. After Lam moved to Europe in 1923, he apparently chose not to practice any formal religion.[15] This personal choice did not interfere with the artist's desire to embrace in his subsequent art both the cultural and religious beliefs inherent in Afro-Cuban life. Stories of Sagua La Grande peppered the artist's con-

Wifredo Lam in his studio with the works **Le Présent éternel** (1945) and **Figure** (1947). Havana. 1947

versations throughout his life, when he was in the company of Picasso and friends in Paris during the late 1930s and years later, when Lam and his biographer, Max-Pol Fouchet, were in Cuba during the late 1960s.[16] Lam never forgot the stories about the *chicherekú*, the long-toothed gnomes who lived in his back yard, or the *guije*, the spirits who lived in the river next to his house.[17] When he returned to Havana in mid-1941, he was again reminded of the sounds of the Afro-Cuban drums and the sights of the ceremonial dances and street corners strewn with grains of corn and dead cocks adorned with strands of beads.[18]

Lam's years in Havana during World War II were a time of redefinition. A close examination of the artist's new handwriting demonstrates that he explored several formal and thematic directions at once. Directing his aesthetic explorations to the reconfiguration of the human form, Lam experimented principally with either a seated or standing figure.[19] Within these traditional categories of poses, he devised seemingly infinite variations. The group of fourteen gouaches that Pierre Matisse selected from the fifty that Lam sent for his first New York show in November of 1942[20] provides a basis for examination of the sources for and evolution of the inventive images Lam developed that year.

The first of the gouaches, *La Langue maternelle* (fig. 3) is based on a small Marseilles drawing dated February 25, 1941, that has a mother and child as its subject (fig. 4).[21] The gouache, larger in scale and more fully resolved than the small drawing, continues the iconographic innovations of the Marseilles drawings and anticipates the more fully resolved images developed in the gouaches, thereby assuming a pivotal role in the artist's development. The gouache includes two notable images, the quadrilateral heads and the phallus-appendage, both of which are seminal in Lam's emerging vocabulary and recur in subsequent work of the 1940s. In the process of remaking traditional mother-and-child figures into Surrealist hybrids, Lam created angular heads inspired by Picasso and African art. The mother's head juts out in the form of a long triangle with knoblike elements at the end, and the child's head takes the shape of a rectangle with a line down the center. Beginning in 1942, variations of these two shapes first made explicit in the Marseilles drawings can be seen throughout Lam's oeuvre, in *L'Homme à la vague* (cat. no. 16),

for example. This motif reappears in later works, such as *Figure* of 1947 (cat. no. 43), *Zambezia, Zambezia* of 1950 (see Sims, "Myths and Primitivism," fig. 9) and *Femme magique* of 1951 (cat. no. 52).

Starting with *La Langue maternelle*, the phallus-appendage becomes a standard iconographic element. Its appearance at the chin of the maternal figure provides a visual jolt. Dislocating the phallus from its normal physiological placement is typically Surrealist. It is also conceivable that the artist was inspired by African works of art such as the Dogon lidded box (fig. 6) that was in the Musée de L'Homme when Lam was living in Paris. On that box is a female torso whose head has an erect protuberance, probably a lip labret, at the chin line. That protuberance might have been misinterpreted by Lam as a phallus and thus appropriated for two Surrealist objectives, the first, to jolt normal visual associations and the second, to bring an African presence into his work.

In addition to *La Langue maternelle*, *Oubli* and *La Femme sable* (fig. 5) are also among the fourteen gouaches exhibited at the Pierre Matisse Gallery in 1942. Both works continue the formal directions begun in the earlier Paris figural works. Anatomies are simply drawn with heavy black outlines. The multicolored lines defining the physiognomic features suggest the volumetric dimensions of African sculpture. Whereas *Oubli* continues the flattened spatial construction of the Paris figures, *La Femme sable* tentatively experiments with multiple viewpoints.

In Lam's re-formed female figures, female anatomical parts are mixed with zoological features. In *Les Yeux de la grille* (cat. no. 14) and *Figure* (cat. no. 9), for example, bodies are rendered naturalistically, and the faces are composed of both human and equine features. The impetus for Lam's use of the human-horse face and the woman-horse figure comes from the influence of Picasso, Surrealism, and Afro-Cubanism.[22] In reconfiguring the human form, the image of the horse was of singular importance. The horse motif appears for the first time in the Marseilles drawings, most notably in *Fata Morgana* (fig. 7), in which the horse's head with its splayed-open mouth and dagger-pointed tongue recalls similar features of a horse in Picasso's *Guernica*.[23] In Lam's drawing, the horse's head abuts the central figure's head in a manner that resembles the Surrealist method, in which different artists add one element to another to create a collective drawing.

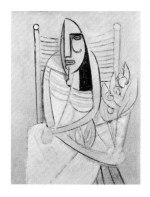

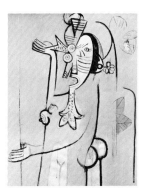

1
Wifredo Lam
Oubli. 1939
Tempera on paper
41½ x 33″ (105.4 x 83.8 cm)
Pierre Matisse Gallery Archives

2
Wifredo Lam
La Chanteuse des poissons. 1942
Gouache on paper
41½ x 33″ (105.4 x 83.8 cm)
Pierre Matisse Gallery Archives

An interesting study of circa 1942 (cat. no. 20), which was previously unknown, illustrates the artist's concerns with merging elements of the human and animal species. In this untitled work, documented here for the first time, the horse's head is still attached to the female figure, in a manner reminiscent of the additive figuration of the *Fata Morgana* drawing. The study, nevertheless, is a somewhat more advanced exploration in which Lam seems to be moving toward substituting a horse's head for a human's head. Most likely Lam first developed the group of hybrid figures whose physiognomies are composed of both human and equine features as noted above in *Figure*. These were followed by the single figures with woman-horse anatomies. Two important examples in this exhibition demonstrate these iconographic and conceptual changes—*Les Yeux de la grille* (cat. no. 14) and *Déesse avec feuillage* (cat. no. 13).[24] In an attempt to move beyond a mere appropriation of Picasso's animals forms, Lam fused diverse zoological elements within one human figure, including the horse's snout, pointed ears, mane, buttock, and tail. The resulting amalgams are articulated in a fully developed Cubist space of multiple viewpoints and overlapping forms.

Surrealism freed Lam from traditional representation and opened up the possibilities for subversion of the naturalistic that results in endless surprise and delight. In this regard Lam was deeply influenced by Breton's insistence that painting, like language, must refuse to copy nature. Lam consciously chose to express himself in a Surrealist-based visual vocabulary. This choice would bring him into a new alliance with a group of artists living in New York who, in searching for new aesthetic imperatives, followed a variety of directions rooted in Surrealist practices. Their visual language of biomorphic imagery was consonant with Lam's vision of a world in which the human, animal, and plant kingdoms are united. This vision also grew out of an Afro-Cuban world view, which the artist inherited from his family.[25] The horse motif should be understood in the context of Afro-Cuban culture, in which it resonates with meaning. Its presence alludes to an important religious phenomenon, the process of being possessed. In sacred ceremonies the practicant, who is referred to as the "horse" (*caballo*), goes into a trance, at which time he or she is overcome by both the personality and characteristics of the particular deity who is being

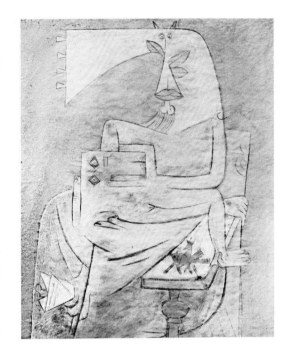

3
Wifredo Lam
La Langue maternelle. 1942
Gouache on paper
42 x 34½" (106.7 x 87.6 cm)
Pierre Matisse Gallery Archives

honored during that ceremony. The spiritual possession that has occurred in such ceremonies is understood as an exchange of life force (*ashé*) between practicant and deity. This transformation is commonly described as one in which the deity/saint comes down to mount his horse, "*bajarle el santo*."[26] (In Spanish *santo* means saint; in the Afro-Cuban context *santo* refers to either a Catholic saint or Afro-Cuban deity.) By infusing a Surrealist aesthetic with references to Afro-Cubanism, Lam established a special territory for himself in which he claims a personal and collective identity.

In his formal and thematic explorations regarding the reconfiguring of the human figure, Lam used two additional subjects, figures with offerings and figures merged with leaves. Among the works in which these two themes are represented are *L'Esprit du matin* (fig. 8) and *Ta propre vie* (fig. 9). Both works were exhibited in Lam's first show in 1942 and were titled by André Breton, who recognized the artist's references to Afro-Cuban beliefs.[27] In *L'Esprit du matin*, a hybrid holds a bird in one hand and an unidentifiable plantlike object in the other. Motifs of birds and plants depicted in many of these works recur in later paintings. Lam did not paint pictures in which the specifics of ceremonial rituals are illustrated in a narra-

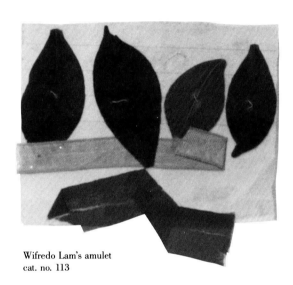

Wifredo Lam's amulet
cat. no. 113

4
Wifredo Lam
Untitled drawing (February 25,
1941) for **Fata Morgana** series
Pencil and pen with black ink on
paper
8⅝ x 6⅝″ (22 x 16.8 cm)
Vassar College Art Gallery

5
Wifredo Lam
La Femme sable. 1942
Gouache on paper
41½ x 33″ (105.4 x 83.8 cm)
Pierre Matisse Gallery Archives

tive manner. Rather, he created Surrealist melanges in which the motifs impart a significance that is greater than that connected with Surrealist ideas through their allusion to traditional Afro-Cuban celebrations. Afro-Cubans who have maintained their ancestral beliefs uphold the practice of making offerings to their *orishas* (deities). Offerings of animals (*ebó*) and plants (*adimu*) are thought of as gifts that honor, propitiate, and commemorate the divinities and that dispose them to offer gifts in return.[28] When animals are sacrificed, it is believed that the invisible life force (*ashé*) passes from one living creature to another. In that exchange, each creature is strengthened, and the union between the living, the ancestors, and the deities is perpetuated.[29]

Lam's works of 1942 demonstrate his rapid progression in the merging of the figure and landscape. In such works as *Déesse avec feuillage*, *Les Yeux de la grille*, and *Ta propre vie*, the hybrid is surrounded by clusters of leaves. These works are among the first explorations that attempt a union between the anthropomorphic hybrid and nature. Further integration occurs in *Femme* (cat. no. 11). The iconographic features of *Femme* are very similar to an untitled gouache, although the latter is not surrounded by foliage of any kind (cat. no. 15).[30] Basing my judgment on formal analysis, I posit that these two works were executed sometime between early October and early December, the period immediately after the fifty gouaches left Cuba for New York and before the last series of Jungle pictures was begun.[31] In *Femme* and in the untitled work, together with a small group of other works, elements are carried over from earlier works such as *L'Esprit du matin*, for example, while they also anticipate the subsequent series of Jungle pictures. Among the common characteristics shared by *Femme* and the untitled gouache are the composite multiple-headed images combined with a horse-snout and an elliptically shaped African-like mask with scarification marks. In both the hybrids' anatomies are rendered in a similar fashion, although the untitled work is executed in profile. In the untitled work, the papaya-shaped breasts appear on the side of the body under the arm, allowing for a full range of simultaneous viewpoints. *Femme* has similarly disjointed features; the hybrid's torso is executed from a frontal view, while the buttock is wrenched into a three-quarter rear view. In addition, the mane that flows over the side of the buttock appears to start at the waistline. Such is the

nature of the Surrealist liberties Lam employed to evoke the inner states lying beneath the surface of consciousness.

Both works are the antecedents for four pictures whose titles relate them to the theme of the jungle: *The Jungle (Personage with Scissors)* (fig. 10),[32] *Le Bruit* (fig. 11), *Nu dans la nature* (cat. no. 10), and *Lumière dans la forêt*. The untitled gouache, especially, is the model for *The Jungle*; there are a number of parallels between them. In both works, the figure is a composite of two figures, one superimposed over the other. The deftly treated Cubist overlay and the simultaneous viewpoints suggest the physical and psychic convergence that takes place between the deity and devotee during spiritual possession. Each of the two figures holds a pair of scissors in one hand and plant-like forms in the outstretched palm of the other. However, unlike the three-quarter hybrid in the untitled work, who is depicted without any vegetation, *The Jungle (Personage with Scissors)* has a full standing figure whose limbs actually merge with dense vegetation—the trunks of the palm trees conflate with the hybrid's legs. The scissor motif functions on two levels, evoking a sense of the magical that relates to two belief systems that differ greatly. In the first of these belief systems, Surrealism, ordinary things seen outside their utilitarian context become mysterious and thereby hint at the ultimate mystery of life. In the second, the Afro-Cuban religion *lucumí*, a Yoruba-derived religion in Cuba that is now most often referred to as Santería, the Osain priest is empowered to collect plants and herbs that are used for cures and ceremonies.[33] Before uprooting nature's vegetation, the Osain priest asks permission of the *orisha* Osain, who is the deity of traditional herbal medicines. In its relationship to Santería, the scissor motif of the painting suggests a ritualistic function.

Femme (cat. no. 11), in which the figure is surrounded by and partially merged with leaves, also anticipates the hybrids who are completely merged with landscape in the four pictures mentioned in the last paragraph. Those hybrids have legs that conflate with the sugar-cane stalks and breasts that echo the form of the papaya fruit from the paw-paw trees. Through his use of a wide range of motifs whose significance can be explained by Santería, the artist conjures a world of rites and ceremonies that springs from the traditions, legends, and beliefs of the Afro-Cuban

6
Lidded box
Mali, Dogon, Lower Ogol Village,
Tabda Quarter
Wood
12¼" high
Musée de L'Homme, Paris

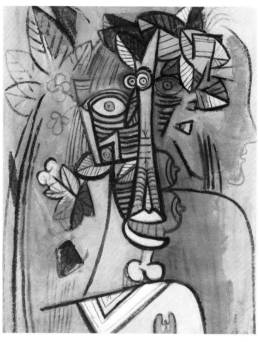

people. In *Lumière dans la forêt*, for example, the hybrid has a quarter-moon face. Cuban lore abounds with stories about the moon. According to the *lucumí*, the moon is the wife of the sun.[34] In daily life it is customary to greet the moon and ask for its blessing. Afro-Cubans learn that the crescent-shaped new moon and the full moon are propitious for ritual activities. For that reason, the best time for uprooting herbs is under the light of the late moon, just before the sun rises.[35]

The union of the human, animal, and plant kingdoms is made tangible in these four Jungle pictures. The hybrids-cum-landscape in these works recur in Lam's multifigural painting also titled *The Jungle* (cat. no. 21), which is now in the collection of The Museum of Modern Art in New York.[36] This painting sums up his thematic directions and iconographic innovations through 1942. Had he painted no other work, Lam would have achieved his objective of expressing the black Cuban spirit (*la presencia negra*) through this work alone. The picture stands as a monument in its content and form, a view already professed in the contemporary literature of the 1940s. Lam himself realized the importance of this painting at the time he executed it. In a letter of September 16, 1943, to Pierre Matisse, the artist wrote that he hoped *The Jungle* would be exhibited in his next show, since it synthesized his directions over the last few years. The

hybrids in *The Jungle* (cat. no. 21) display the anatomical features and mask faces that recur in Lam's works of these years—once again invested with new life. The moon face, the animal mask surmounted by pointed animal ears, the enlarged buttocks—sometimes with animal tail—the phallus as facial element, the muzzle, and the mane are all present here. The biomorphs are fused with the vegetation that surrounds them, thus becoming one with Mother Nature. In the Afro-Cuban context, the *monte*, a dense untilled botanical area in which magic-religious practices take place,[37] is a sacred terrain; it is the place where the *orishas* were born and religion came into existence. Everything the black Cubans need for their magic and for the conservation of their health and general welfare is provided there.[38] When a devotee enters this frondy universe, he or she must respectfully acknowledge the spirits and present them with an appropriate offering, as is suggested by the figures offering plants in their outstretched palms. The hybrid figures-cum-sugarcane-stalks appear monumental, occupying as they do the height and breadth of the pictorial space. The dense, flora-filled background pushes the hybrid forms forward, crowding the foreground and creating spatial tension. This tension is heightened by the upward pull of the vertical forms. Further oppositions are achieved by the enlarged feet, hands, and boldly

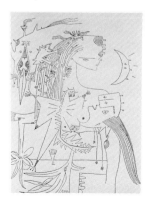

configured masks that contrast with the delicate, thin forms of the sugar-cane-stalks-cum-limbs. A sense of dynamism results from the push forward and the pull upward, which, together with the thumping of the large feet, create the sensation of the forms moving in different directions over the ground. Slowly and rhythmically the group—amalgams of human, plant, and animal forms—dances in honor and celebration of the spiritual, life-giving forces found in all aspects of nature.

Lam understood those forces largely because he came from a bicultural background that believed in them. His view of the Antillean world of which Cuba is a part is charged with his retention of African cultures that were transplanted to and crossfertilized in the New World. Aided in part by his mastery of Surrealist form, the Cuban painter had begun to shape an art in which Afro-Cuban subjects were given a new aesthetic and symbolic form.

A complex nexus of artistic interests, personal considerations, and historical circumstances prompted him to rethink his artistic direction, and he began a period of exploration. Lam began to express an Afro-Cuban spirit shortly after his return to his native country. As he began to explore American subjects, especially Afro-Cubanism, Lam began to utilize the Cubist and Surrealist experiments that radicalized twentieth-century art during the interwar years. He was on a course that paralleled that of the Surrealists in Europe and the Americans in the United States who were particularly attracted to the myths of peoples indigenous to the New World. When Lam began to investigate his Afro-Cuban roots in search of a visual vocabulary and a theoretical framework, he was well aware of the Surrealists' longtime interest in the art and culture of non-western peoples, his culture included.[39] The artist's first response to "Primitivism" is demonstrated in his work in Paris and Marseilles that incorporated Africanizing motifs, which continued to appear in his early Havana work. African art provided him with the formal means to restructure traditional Western figuration; and it also made it possible for him to participate in the contemporaneous modernist dialogue with "Primitivism," a dialogue all the more relevant to Lam because of his mother's antecedents in Africa. The challenge for Lam was to find a visual language that could communicate the religious beliefs of a syncretistic people of African origins who had survived uproot-

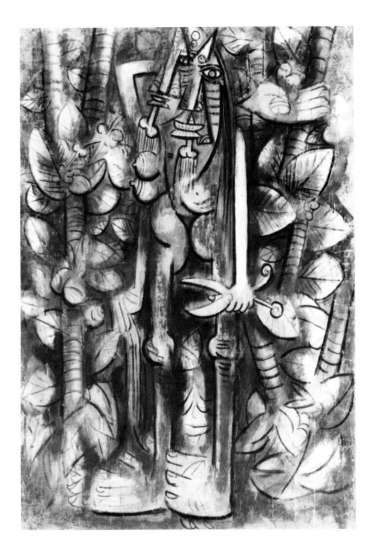

ing, slavery, and colonialism, and Afro-Cubanism, his own personal legacy, provided him with that imagery. Thus, the artist's investigation of his own Afro-Cuban roots was triggered by the European avant-garde's fascination with non-European cultures. The same can be said of writers such as Lèopold Senghor of Senegal and Aimé Césaire of Martinique, and artists such as Joaquín Torres García of Uruguay and Tarsila Do Amaral of Brazil, all of whom lived and studied in Europe and later returned to their countries of birth, where they synthesized autochthonous expressions with European modernism.

A complex set of interests and circumstances contributed to Lam's decision to express a black spirit. Lam acknowledged that his own reaction to Afro-Cuban culture in Cuba at the time of his return

10
Wifredo Lam
The Jungle (Personage with Scissors). 1942
Tempera on paper on canvas
75⅜ x 51¼″ (192.1 x 130.2 cm)
Mrs. Lindy Bergman

instigated a rethinking of his aesthetic imperatives. In a conversation with Antoñio Nuñez Jiménez many years later, Lam said that his return to Havana was like going back to his early beginnings and that the only way he could deal with them was to find a way to integrate in his art the transculturation that had occurred in Cuba among the aboriginals, Spaniards, Africans, Chinese, French, pirates, and others that formed the Caribbean peoples.[40] Although the artist acknowledged the impact of the encounter with Afro-Cuban culture, he never spoke about the importance of the larger intellectual current of Afro-Cubanism and its influence on his evolution.

On his return, Lam interacted with a small group of Cuban avant-garde intellectuals who were exploring Afro-Cuban subjects in music, dance, literature, anthropology, and folklore. Fernando Ortíz, the father of Cuban anthropology, was a key figure in this Afro-Cuban movement. Beginning in the late teens, Ortíz investigated the diverse manifestations of African culture, introducing the term *Afro-Cuban*. In 1923, Ortíz established the Sociedad de Folklore Cubano and also published an important book, *Glosario de Afro-negrismos*, a valuable source of African references and Cuban folk language and customs. Toward the end of the 1930s, Ortíz became a founding member of the Sociedad de Estudios Afrocubanos (Society of Afro-Cuban Studies). In 1940, Ortíz was president, while Nicolás Guillén, a poet of Afro-Cuban background, was one of two vice presidents. Both the executive board and its membership comprised men and women of biracial backgrounds, a remarkable advance for any country in the Americas at that time. Those Cuban intellectuals had expertise in many subjects, including musicology, anthropology, history, journalism, poetry, prose, and sculpture. The Sociedad de Estudios Afrocubanos published an ambitious and scholarly journal titled *Estudios Afrocubanos* (*Afro-Cuban Studies*).[41] The titles of studies that appeared in this publication demonstrate the range of subjects on black culture in Cuba, the Caribbean (Haiti and Puerto Rico), and South America (Uruguay). They include, in 1937, "Cubanness and Mixed Races" (*Cubanidad y Mestizaje*) and "African Slaves from the 18th to the 19th Centuries"; in 1938, "Sacred Music of the Yorubas in Cuba" and "Racial Prejudice in Puerto Rico"; in 1939, "The Religious System of the *lucumís* and other African Influences in Cuba" and

"Black Presences in Popular Cuban Poetry in the 19th Century"; in 1940, "From the Samba in Africa to the Marinera in Peru" and "Black Literature in Cuba Today (1902–1934)." *Afro-Cuban Studies* was one source among several in which avant-garde writers had the opportunity to publish their findings. (See Giulio V. Blanc.)

Lam had the good fortune to connect with this circle of Cuban intellectuals through his friendship with two prominent figures, folklorist and ethnographer Lydia Cabrera and journalist and critic Alejo Carpentier. These three Cubans are of the same generation and had all spent many years in Europe. When Cabrera first lived in Paris, she studied art. Then she turned to writing. Affected by the European interest in African art, she began to record the stories of Afro-Cubans, beginning with her own nanny. Carpentier sent articles from Paris to *Social* and *Carteles* in Cuba, thereby keeping the Cuban public up-to-date on the rapidly changing European artistic trends and fashions in the thirties.[42] When Cabrera returned to Cuba from Paris in 1938, she had already published *Contes Negres de Cuba* (in 1936), the first of many books that would make her a leading authority on Afro-Cuban culture as well as an important literary figure in her own right. Carpentier was a well-known journalist and critic of the arts in Cuba when he returned there in 1939 from Paris.[43] Toward the end of 1941, when Cabrera and Lam met, she was investigating the myths, religious beliefs and practices, and folkways of Afro-Cubans of diverse ancestry, including *lucumí*, Abakuá, and Congo.[44] Much of the first-hand material she collected was published first in *Porqué... Cuentos Negros de Cuba* of 1948 and later in *El Monte* of 1954, a monumental work still considered a definitive study of Afro-Cuban folklore. Carpentier and Lam met sometime in early 1942, while the French-Cuban was gathering material for *La Música en Cuba*, a scholarly historical account of Cuban music from the colonial period to the modern that was published in 1946. Cabrera and Carpentier's researches came at a time when the general public was uninterested in and even dismissive of *cosas negras*. During the 1940s, Lam formed very close friendships with both that lasted a lifetime despite the fact that they eventually lived in different countries.[45] In my judgment, those friendships encouraged Lam's new explorations in the 1940s and helped him adjust to the

11
Wifredo Lam
Le Bruit. 1943
Oil in maroufle paper
33⅛ x 41⅜" (84 x 105.1 cm)
Musée National d'Art Moderne,
Centre Georges Pompidou

difficult period of transition he was undergoing at that time.[46]

Cabrera and Lam shared many experiences over the years, beginning in early 1942, when they went together to *bembes* in the Pogolotti and Regla sections of Havana.[47] According to Cabrera, she discussed ritual ceremonies with Lam on those occasions. However, he never spoke about his own personal history or experiences with her.[48] Cabrera said that during the 1940s it was common for blacks not to speak to whites about their Afro-Cuban rituals or beliefs. Reluctance to do so evidently stemmed from having grown up in post-colonial Cuba, when being African or Asian was considered less than desirable. Whatever the reason for Lam's not wanting to discuss his past, Cabrera felt that he knew very little about Afro-Cuban religions when they first met. This puzzling state of affairs can perhaps be accounted for by the fact that Lam had been estranged from Afro-Cuban traditions for eighteen years.[49] In addition, Lam may well have been reluctant at that stage of their friendship to reveal aspects of his past that he considered very private. Lam certainly did not have the erudition in cultural anthropology that Cabrera was acquiring. After all, the folklorist was documenting oral histories through a network of informants who were often priests and priestesses (fig. 12). In contrast to her scholarly ethnographical work, Cabrera's literary style—as exemplified by her short stories—was creative and inventive, based upon but not bound to the oral accounts she was collecting. Her literary approach was similar to Lam's aesthetic approach; both symbolized popular religious beliefs using an imagery of Surrealist comminglings.

In 1943, Lam and Cabrera collaborated on several other projects, among them the translation and illustration of Aimé Césaire's *Cahier d'un Retour au Pays Natal*. Cabrera translated the poem from French to Spanish (*Retorno al País Natal*), Lam illustrated it with three drawings, and Benjamin Péret wrote the introduction.[50] The four collaborators, who were living in three different countries—Cuba, Mexico, and Martinique—were interconnected by their shared interests in *negritude* and Surrealism. Lam first met Césaire through André Breton in Martinique in April of 1941, when the group from Marseilles was staying there. Césaire had just published the first issue of the cultural review *Tropiques*, which presented a variety

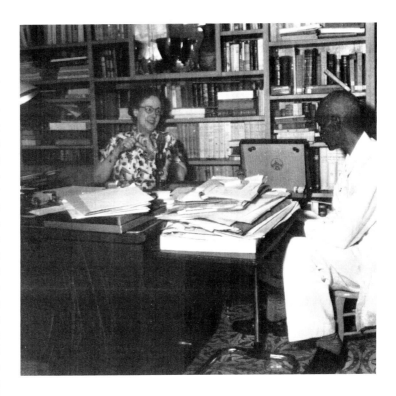

of articles intended to fill a literary gap and at the same time to instill pride in the Martinicans of African heritage.[51] To help achieve these objectives, Césaire published articles by Latin American writers and by American writers from the United States, most of whom were of African background.[52] The editors also had a strong commitment to Surrealism that was reflected in articles written by the Surrealists in exile as well as in general commentaries on their activities. For example, *Tropiques* reported the stopover made by Breton, Masson, and Lam in Martinique.[53] Further mention of Lam appeared over the next four years, for example, in Pierre Mabille's essay "La Jungle."[54] Césaire also wrote an essay on Lam's work that appeared in *Cahiers d'Art*.[55] The work of the Martinican writer and the Cuban painter reached wider audiences beyond the borders of the Antilles. In New York, for example, the French-American poetry magazine *Hémispheres* published an issue titled *New American Poetry*, in which a drawing by Lam appeared.[56] The preceding issue, dedicated to the West Indies, included a section called "Rediscovery of the Tropiques," in which Césaire's essay "Colombes et Menfenil" appeared together with poems by two of the founders of the Afro-Cuban literary movement, Nicolás Guillén and Emilio Ballagas, an essay by the expatriate Surrealist writer and editor of the magazine,

12
Lydia Cabrera with her Abakuá informant Saibeke. Cuba, c. 1955
Isabel Castellanos

Yvan Goll, titled "Cuba, Corbeille de Fruits," and an article by André Breton on Aimé Césaire titled "Un Grand Poete Noir."[57] Both Lam and Césaire were important voices for advancing the cause of *negritude* in the Antilles. Through correspondence, the two kept informed of each other's activities.

In 1943, Cabrera began to give titles to many of Lam's works, a practice that continued for several years. According to Helena Holzer Benitez, Cabrera suggested titles because the images in the paintings reminded her of specific experiences she was documenting.[58] Among the works she named is *Malembo* of 1943, a major painting in which anthropomorphic images personify the forces of nature (fig. 13). When Cabrera saw this particular painting, she apparently thought about *malembo*, which means evil at the crossroads in the belief of the Congo. In my conversations with Cabrera some years ago, she told me that if evil is lurking on the roads, *Sarabanda*—the Congo deity equivalent to the *lucumí* deity Ogún, god of war and metal—will kill it.[59] It should be pointed out that contrary to the title recently given it, *Malembo, Deity of the Crossroads*,[60] *malembo* is not a deity.

Beginning in 1943, Lam did a series of fanciful drawings that he gave to Cabrera and her companion María Teresa de Rojas as testimonies to their close friendship. Some of the drawings were done on the spot when Lam and Holzer visited Cabrera.[61] They are part of a larger group of drawings by Lam that Cabrera cherished; she took them with her when she went into exile to Miami in about 1960 and eventually bequeathed them to the Lowe Museum of Art. The drawings, many of which were executed in 1943, are reminiscent of Lam's spontaneous drawings made in Marseilles during 1940–41. The later works in the series are, however, more whimsical, and in many of them the subjects relate to the animal stories Cabrera was writing at the time. One humorous example, *Homenage a jicotea* (cat. no. 25)—the title is inscribed in Cabrera's handwriting—celebrates the kind of tale that delighted Cabrera, who often wrote about turtles.[62] Lam's image is apparently an Afro-Cuban *jicotea* (turtle) who is a trickster and manages to get the best part of everything through cunning and deception. This turtle is wearing a panama hat and is lazily resting on top of two more powerful animals—this in spite of the fact that the turtle is considered to be the lowliest of all animals.

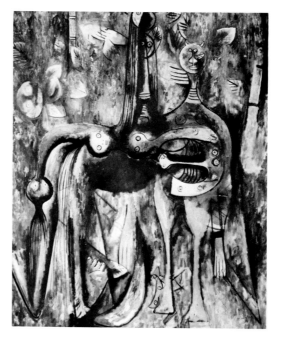

13
Malembo, Deity of the Crossroads. 1943
Oil on canvas
60¼ x 49¾" (158 x 125 cm)
Pierre Matisse Gallery Archives

14
V I E W magazine
Series V, No. 2 (May 1945)
Private Collection

Alejo Carpentier, one of the first to write about Lam, noted in 1944 that Lam's work seemed to reveal everything that is magical, imponderable, and mysterious in the Cuban world.[63] Carpentier, his wife, Lilian, Lam, and Holzer saw a good deal of each other until the writer moved to Caracas in 1945.[64] Carpentier, an impassioned musicologist, was doing research on that subject during those years, and he was also collecting African instruments, which hung on the walls of his living room. During their visits to each others' homes, Carpentier and Lam often discussed African traditions in Cuban music. Carpentier took the artist to Abakuá, or Ñañigo, ceremonies (*juegos ñañigos*). The Abakuá are a religious confraternity founded in the first half of the nineteenth century by people of southern Nigerian origins.[65] Lam also went to Abakuá ceremonies with his Parisian dealer Pierre Loeb. Years later, in 1979, the artist did a drawing for an exhibition in homage to his Parisian dealer on which Lam wrote: "Pierre in Cuba under the signs of the deities of Africa among the palm-trees I went with you to secret ñañigo initiation rites. During those rituals Naña-Yreme, or the masked devil, with his baton and sacrificial roosters attached to his belt, accepted new adherents to the [Ñañigo] sect. During the ceremony the Naña-Yreme drew signs of all different colors on

the backs of the new adherents. The masked devil then threw food to the cardinal points and afterward the tom-toms began their mysterious language."[66] There was great interest in the Abakuá throughout the 1940s, as is evidenced by depictions of them in contemporary art and by articles on them in various publications. (See Giulio V. Blanc's essay.) For example, Carpentier's renderings of the Abakuá symbols that appear on the doors of the ceremony rooms were reproduced in an important 1944 book on contemporary Cuban art titled *Cuban Painting Today*.[67] Lam's work of the period shows his interest in Abakuá. In an untitled painting of 1943 (cat. no. 22), he depicted a Yreme, a figure who represents the incarnation of the spirit of the dead and is popularly known in Cuba as a *diablito*. Painted with pointillist-like brushstrokes in an uncharacteristically representational mode, the *diablito* is dressed in a costume with a conical hat that is typical of a Yreme and is playing a cylindrical drum. The full-figure *diablito* never appeared again in Lam's oeuvre, but he did use the conical headdress of the *diablito* for his illustration that appeared in May of 1945 on the cover of the magazine *V I E W* (fig. 14), in which he distorted the form by adding two leaves for the ears, to create the "I" in the magazine title. Lam referred to the Abakuá in many subsequent works. In *La Petite Forêt* of 1944 and *The Triangle* of 1947 (cat. no. 41), for example, he used a specific Ñañigo symbol—a diamond divided by an arrow into four sections, each section containing a small circle.[68] More commonly, however, Lam adopted variations of the diamond motif in reconfiguring leaves in an extensive series of landscape paintings dating from 1943 to 1945. Examples in this exhibition include *Sur les traces* (cat. no. 38) and an untitled work (cat. no. 39), both of 1945. The diamond-shaped Ñañigo symbol is employed in reconfiguring the hybrid in *Deux figures* of 1945 (cat. no. 34) and in *Femme cheval* of 1950 (cat. no. 51). In the 1947 painting *Cuarto fambá* (cat. no. 44), Lam adopted an Abakuá title, which means sacred room in which many ceremonies take place. Although the painting does not replicate the Ñañigo symbols found in an actual initiation room, the title and the diamond-shaped motifs found in some of the images allude to the Abakuá sect.[69]

The Abakuá symbol was one of many motifs Lam utilized to give a new visual language to the traditional genres of portraiture, still life, figure(s) in a landscape,

and landscape. As has already been noted, Lam was committed to the reconfiguration of the human form from the early 1940s. The standing and seated figure continued to be principal subjects reinvented in his work throughout the decade. In *Anamú* (cat. no. 17), one of the most beautiful gouaches from the early Havana period, a hybrid horse-woman combines an elliptical Africanizing face—comparable to the figure on the left in The Museum of Modern Art's *The Jungle*—with a round humanoid head. This work was shown in Lam's second one-person exhibition at New York's Pierre Matisse Gallery in June of 1944. It was among a remarkable group of fourteen works that included The Museum of Modern Art's *The Jungle*, *La Sombre Malembo*, *Eggue Orissa*, *L'Herbe des dieux*, *Mofumbe ce qui importe*, and *La Lettre*. Although the Museum of Contemporary Art in Chicago assigns *Anamú* a date of 1942, the work is dated 1943 on Pierre Matisse's archival photograph, and the fluid draftsmanship, the little splashes of color, and the technical application of the pigment seem more characteristic of Lam's style of 1943. *Anamú*, a Spanish word that is perhaps of Indian origin, refers to a very common wild plant that grows about three feet high and has white flowers. In Santería it has extensive ritual and medicinal uses. According to Afro-Cuban folkways, many people put two leaves of *anamú* in the form of a cross on the cushion of their shoes to deflect evil, or *malembo*.[70] In 1944, the artist's style continued to be characterized by the delicate splashes of color present in *Anamú* that were applied in a kind of pointillist brushstroke; significant areas of the canvas were left unpainted. This delicate technique distinguishes the seated figure in *Femme* (cat. no. 29).

The single figure took another interesting formal turn in 1947, when Lam began to depict his hybrids more naturalistically. Those compositions, built up from planes of solid color in which figure and ground are separated from each other, suggest a three-dimensional presence for the figures. The single figure continued to be formed by diverse symbols that originate from an Afro-Cuban syncretistic context. An extraordinary group of works were exhibited in Lam's fourth one-person exhibition at the Pierre Matisse Gallery in April of 1948. These included *Personnage* (cat. no. 42), *Figure* (cat. no. 43), and *Le Guerrier* (fig. 15), all from 1947. *Le Guerrier* can be identified as Ochosí, a deity who is a warrior and hunter in Santería, by his

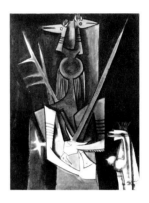

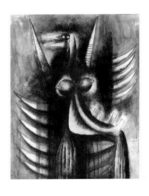

15
Wifredo Lam
Le Guerrier. 1947
Oil on canvas
41¾ x 33⅛" (106 x 84 cm)
Courtesy Galerie Lelong,
New York

16
Wifredo Lam
Figure surréaliste. 1947
Tempera on paper on canvas
35⅓ x 30" (90 x 76 cm)
Courtesy Sotheby's, New York

attributes—a sword, a lance, and birds. Although the birds are depicted in a generalized manner, it is probable that they are vultures, which are the divine messengers of Olofi, the supreme deity who is present in every *orisha*. A Santería devotee believes that Olofi (or Oludumare) lives in every human's head. The Yoruba word *eleda* expresses the concept that an *orisha*/deity lives in a devotee's head.[71] In the painting, this concept appears to be symbolized by the two birds above the warrior's head. The bird-head motif in *Personnage* and in *Figure surréaliste* (fig. 16) can also be seen as a reference to that belief.

Another interesting formal innovation that makes its appearance in the single figure subject at this time is the pointed element, notable especially in the abstract hair or braid of *Figure* (cat. no. 43) as well as in the *Figure surréaliste*. This motif could very well be a transformation of the plantain flower, a plant that grew in Lam's garden (fig. 17). The vegetation in Lam's garden consisted of banana trees, papaya, bitter oranges, anon, avocados, and various flowers and odorific shrubs.[72] The papaya fruit and the plantain flower found their way into his paintings, where they commingle with forms such as birds' beaks and wings, Africanizing masks, horseshoes, horns, candles, and round heads. Carpentier wrote that Lam never went out into nature to paint the actual landscape,[73] but he did use the forms of Cuba's native flora that grew in his own backyard in his reconfigurations of human form.

As had been his practice all along, Lam continued working simultaneously in several formal directions. He was depicting woman-horse figures such as those in *Personnage* (cat. no. 42) and *Figure* (cat. no. 43), in which the torso is rendered in a manner typical of the Surrealist subversion of common expectations. At the same time, he was also working in an abstracting vein, as exemplified by *L'Esprit aveugle* (cat. no. 48), a work in this exhibition that was shown alongside *Figure* in the Matisse Gallery show in 1948 (fig. 18). In this work, there are three animated figures; none, however, has a human form. A synthetic Cubist style of broad, flat, overlapping planes is introduced in the three interacting forms. The figure in the foreground has a horse-head with phallus attached to an arm and hand; the figure in the middle ground has anatomical features too abstract to identify except for the round head with horns and the Abakuá-derived diamond

shape substituting for the body; and the figure in the background has an anatomy that, aside from the papaya fruit-breasts surmounted with horns, is a mystery. The papaya fruit from the paw-paw tree is the visual source for the configuration of breasts in Lam's hybrids. In Havana, papaya fruit is often referred to as *fruta bomba*, a slang reference to female genitalia. This papaya/breast/genitalia punning ties in with Surrealist erotic imagery and also with Cuban lore in which mulatto sensuality is so often described.

Lam's abstract directions respond to the larger international currents of abstraction afoot in New York. Lam kept himself informed of events and directions in the New York art world through reviews, books, and magazines that Pierre Matisse sent him.[74] Lam also visited New York in the summer of 1946 on his way to Europe and again when he returned from France in December of that year, at which time he visited galleries and met with many New York artists. (See Lowery S. Sims.)

From 1943 to 1945, Lam did a series of figures in landscapes in which the anthropomorphic nature of Afro-Cuban *orishas* comes alive. *Orishas* are spiritual beings, thought of as gods, aspects of God, and forces of nature. While each is capable of manifesting itself in a variety of ways, the *orisha* is most often thought of as having human characteristics.[75] The forces of nature live in the *monte*, a sacred place of prayer and entreaty. In *The Green Morning* of 1943, the large voluptuous figure has many heads, huge bird wings, horseshoe-shaped feet, and round heads for kneecaps (fig. 19). The two *orishas* in this painting are Elegguá and Ogún, both of whom retained their primacy from the African to the Cuban context. Elegguá is signified by the little round head surmounting the central head of the winged figure. Among the many manifestations of Elegguá, one of the most important is as guardian of one's paths. In this role, he is thought of as keeper of the roads, predicting, preventing, and allowing for the vicissitudes of life.[76] Ogún's presence in *The Green Morning* is signified by the horseshoe motif. He is venerated for different roles. As the protector of the *monte*, he is closely associated with hunters and farmworkers. As the god of iron, he protects those whose occupations are related to the use of iron and metal—smiths, soldiers, chauffeurs, mechanics, doctors, and cyclists, for example. It is customary to symbolize his presence with various metal objects,

17
Lam's garden in Havana
Detail of plantain tree
Lowery Stokes Sims

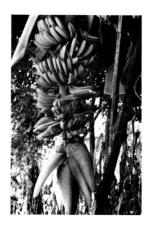

18
Installation of Lam's exhibition at
Pierre Matisse Gallery.
Spring 1948
Pierre Matisse Gallery Archives

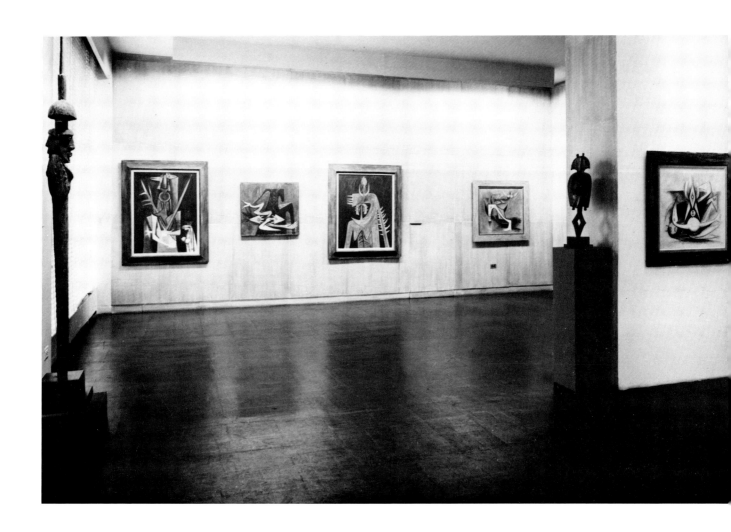

such as a pointed knife, ax, or machete. Lam referred to his role specifically as patron of the blacksmiths in *Ogún, God of Iron* (1945). In ritual ceremony when the *orisha* takes possession, the devotee (the horse) dances in warlike steps, miming the movements of a swordsman. In popular practice, Ogún is propitiated with offerings of food and drink, which are placed at the foot of the silk cotton tree (*ceiba*).[77] Although there are no trees in *The Green Morning*, there are sugar-cane stalks next to which a food offering is found. Further manifestations of the spirit world find their way into *The Green Morning* in the form of little heads with ring-toothed mouths. Their ominous appearance evokes evil, which looms large in the *monte*. Oral tradition is full of stories of evil spirits.[78]

The messenger god Elegguá is the equivalent of the Greek messenger god Hermes. In the Santería pantheon, Elegguá facilitates communication among the gods and devotees. Although the central figure in Lam's 1944 painting *Hermès* (fig. 20) is not specifically identifiable, the various iconographic motifs—together with the title—suggest that the figure is Elegguá.[79] The round head at the top of the figure as well as the many little round heads that fill the pictorial space are attributes identified with Elegguá. Most of the Elegguá images in this painting have horns, a syncretistic element that originates from the Christian identification of Elegguá with evil or the devil. Directly below the central head, Lam inserted gourds, which are also associated with Elegguá. The depiction of the goat in the lower right suggests an offering. Before a sacrifice is given to any other *orisha*, Elegguá must receive his portion.[80] The feathers allude to an important sacrificial rite known as *acobijarse* or *acobija-miento*, which literally translated means "to cover oneself." When a feathered animal has been sacrificed to a deity, feathers are then plucked and used to cover the *orisha*, who is represented by *otan* (holy stones). The devotee feels that through the act of covering the *orisha*, he or she is also covered, that is, protected from harm.

The Green Morning, *Hermès*, and *La Présent éternel* are a few examples of Lam's multifigural compositions in which the anthropomorphic nature of the *orishas* is manifested. In 1945, when Lam painted *La Présent éternel* (fig. 21), he had evolved a figural style quite different from that of the previous two years. The hybrids in *La Présent éternel* have a sculptural qual-

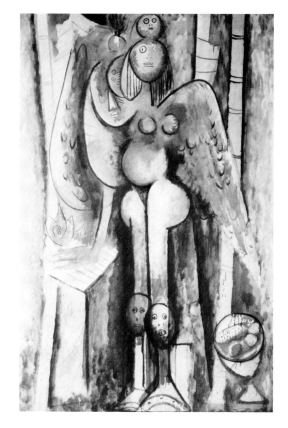

ity, and their forms no longer conflate with the surrounding vegetation. The iconography suggests the presence of four warrior deities. Starting at the left, the first figure is Oshún; the second, Elegguá; the third, Ogún; and the fourth, Ochosí. Oshún, *orisha* of the river and fresh water, is also a warrior who uses her sensuality to win conflicts.[81] According to legend, Oshún enticed Ogún out of the woods by luring him with honey, an element with which she is associated, and the bird in Oshún's hand could be interpreted as a reference to this tale.[82] Elegguá's eternal presence is manifested in *La Présent éternel* by the now-familiar little round head with horns—here, barely visible—and also by the votive image at the lower right. Small votive images made of clay, cement, or stone, with eyes and mouths painted or of cowry shells, are commonly placed in a small receptacle near the entrance to Cuban homes of Santería practicants as a measure of protection. Representations of these small statue heads, circular or conical in shape, also appear in Lam's later works, such as *Belial, empereur des*

19
Wifredo Lam
The Green Morning. 1943
Oil on paper on canvas
73½ x 48½" (186.7 x 123.8 cm)
Private Collection

20
Wifredo Lam
Hermès. 1943
Oil on canvas
61 x 49½" (155 x 126 cm)
Private Collection

21
Wifredo Lam
Le Présent éternel. 1945
Mixed media on jute
85 x 77½" (215.9 x 196.9 cm)
Museum of Art, Rhode Island
School of Design

mouches of 1948 and *Rites secrets* of 1950. Ogún, the warrior-blacksmith deity, is symbolized by the knife in the hand of the figure at the right, which, when used in ritual sacrifice, is guided by the *orisha*'s power. Ochosí, the god of the hunt and of the mysteries of the forest, keeps close company with Ogún and Elegguá; they are, in fact, virtually inseparable. In this painting, the lance, one of Ochosí's symbols, serves to identify the *orisha*.

The subject of landscape provided Lam with new possibilities for symbolizing Afro-Cuban sacred and profane beliefs. This genre engaged Lam's attention particularly during the first half of the 1940s. Paintings such as *The Triangle* (cat. no. 41) attest to his ongoing interest in this theme, but there are relatively few landscapes from the late 1940s. From the time of his return to Cuba, Lam was fascinated by the dense, lush, natural wildlife of his country. He painted in his light-filled garden, seeing in it a microcosm of the island's natural tropical splendor. In 1944, Lam executed a series of landscape paintings with natural forms in which he captured the tropical light. These works are personal testimonies to a nation's pride in the beauty of the land and its natural elements, and they are also celebrations of a people who live in harmony with Mother Earth. Landscape becomes a metaphor for cultural identity in works such as *Oiseau lumière* (cat. no. 32) and an untitled work of 1944 (cat. no. 27); they are anthropomorphized landscapes, brought to life by natural forces. Presented close up, the animated flora is almost impenetrable; its thickness is relieved only by the feathery strokes of high-keyed color and by the white ground. Palm fronds are reshaped into triangles with staring eyes, little horns, papaya fruit-breasts, and a variety of other metamorphosed forms originating in human, animal, and plant species.

Lam did a small series of black-and-white landscape paintings, of which *Sur les traces* of 1945 (cat. no. 38) is a prototypical example. The image cannot be fully identified, but fragments of Changó's thunder ax, eggs, scepter, and candle are among the numerous motifs that are visible. Just to the left of the middle of the composition is a candle motif with a base in the shape of a staff. Its significance is enigmatic, but the fragment of the staff could be a reference to the *osun*, the medicine staff belonging to the *orisha* Osain, who is the god of medicine and protector of the

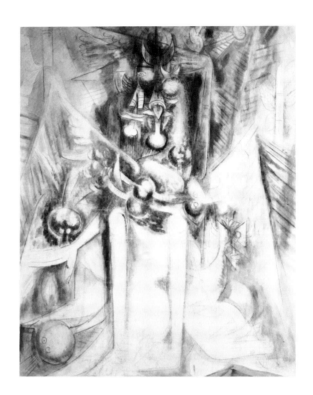

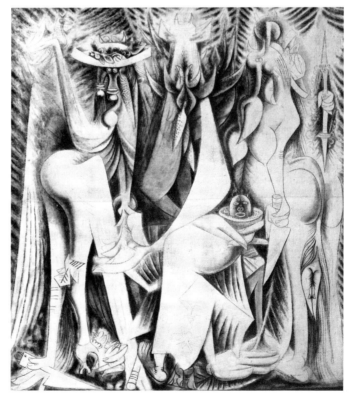

monte. The candle traditionally symbolizes the guiding light. The commingling of the candle and staff may be intended as a reminder of the guiding force that the *osun* provides.

If one considers that Lam made few still lifes, they do not seem to be as significant in his oeuvre as was portraiture, landscape, and figures in landscapes. Notwithstanding, *The Night Lamp* of 1945 (fig. 22), is an exceptional example of his treatment of that traditional theme. Once again, the iconography contains camouflaged references to the *orishas* and the ceremonies held in their honor. The night-light—from which the title originates—that appears at the center of the composition is given principally as an offering to Oshún, Elegguá, and Changó. Night-lights (*lámparas*) are made from hollowed-out pumpkins or coconuts to which oil is added; wicks are then floated in the oil. These offerings are made for the purpose of asking the deities to open a path, to provide guidance, or to bring about a change. In the painting *The Night Lamp*, the anthropomorphic figure at the upper left is identifiable as Changó by the thunder ax, which forms his head. Another attribute of the deity, the banana leaf, is found below the head. Also in this painting is a small altar, which is held by two hands. On the top of the altar are the horseshoe, symbol of Ogún, and two bull horns that symbolize Oyá, the *orisha* that accompanies Changó.

Lam's presentation of the altar as still life is another example of his inclination to utilize a traditional genre in untraditional ways. Common in Cuba during Lam's time, home altars were made indoors or outdoors (in one's yard) to honor one's *orisha*/saint.[83] Their importance is attested to by their continued presence throughout the United States in those Latin American communities whose members are influenced by both African and Catholic beliefs and traditions. Domestic altars connect and mediate between the terrestrial and celestial, the material and the spiritual, and the personal and communual aspects of life. The altar-cum-still-life takes an interesting turn in a number of works, including *Autel pour Elegguá* (cat. no. 28), *Autel pour Yemayá*, *Grenadine Curtain*, and *Table in the Garden*, all of 1944. The artist returned to this theme in *Rites secrèts*, an extradordinary painting of 1950 (fig. 23). The table in *Autel pour Elegguá* is outdoors; on it is an array of barely discernible objects. All the images converge, making it impos-

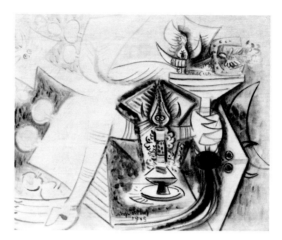

22
Wifredo Lam
La Lámpara. 1945
Oil on canvas
23⅜ x 28½" (59.5 x 72.5 cm)
Courtesy Sotheby's, New York

sible to describe each component literally. The small votive image of the omnipresent Elegguá, however, is clearly visible. Lam's stylistic language was based on contemporary modernist idioms that were experimental at the time, but his ideology was different. Through his use of Cuban subject matter, he asserted a personal and collective identity that is inherent in a Santería world view.

The art scene in Havana was very different than it had been in Paris when Lam left. In contradistinction to the widespread and fervent activity of the avant-garde European modernists, the circle of contemporary artists who were opposing the entrenched interests of academic art that Lam met in Havana was much smaller and quieter. When Alfred H. Barr, Jr. went to Cuba in 1944 to co-organize the first exhibition of modern Cuban painting for The Museum of Modern Art in New York, he encountered an elitist art-going public that supported academic art and was generally indifferent toward its living artists.[84] Some of the forward-thinking contemporary Cuban writers criticized those conservative attitudes. For example, Lydia Cabrera confronted the parochial mentality of the Cuban art-going public in an article on Lam that appeared in the *Diario de la Marina* in January of 1944. While recalling the public's negative reactions at a recent exhibition of Picasso's works, she chided the readers for being uninterested in art beyond Impressionism, dismissive of the talents of the great modern artists, and unsupportive of Cuba's living artists.[85] Lam soon realized the difficulties he would face as an artist in a country that had little appreciation for its own sense of identity.[86]

In that climate, Lam's exhibition activities got off

to a slow start. Although the artist participated in numerous group shows during the Havana years, he had only three solo exhibitions: the first took place at the Lyceum in the spring of 1946;[87] the second, sponsored by the Ministry of Education, was held in late 1950; and the third, in a small gallery that belonged to a private organization, was in the spring of 1951. At the time of the Lyceum exhibition, Lam was better known outside his country. In New York he had already had three solo shows at the Pierre Matisse Gallery, and, in addition, he had participated in several group shows there. On those occasions, his work was shown in the company of Miró's, Chagall's, and Léger's, among others.

During the 1940s, it was common practice for artists' drawings to appear in artistic publications and/or for artists to illustrate the covers of specialized journals. Lam's drawings appeared in the Cuban journal *Gaceta del Caribe* in the summer of 1944, and his illustrations were on the covers of *Orígenes: Revista de Arte y Literatura* in 1945, 1947, and 1952.[88] *Orígenes*, a leading magazine on the arts, included articles on individual artists as well as reviews of exhibitions. Lam, however, was not written about in either category.

The writings of André Breton, Pierre Loeb, Lydia Cabrera, Alejo Carpentier, and Pierre Mabille form the first body of literature on the artist. With the exception of Breton, the writers either lived in, visited, or published in Cuba. Their writings were readily available. Furthermore, Breton's first comments on Lam were incorporated or reflected in the articles and essays of the four other writers. What follows is a glimpse of that early historiography (1942–46) by these five, who were most familiar with the artist's work.

Breton was at the center of a host of Surrealist activities in the New World. Largely as a result of his efforts, the dispersed group in exile formed a tight network, which included Lam. An unflagging supporter of Lam, Breton wrote and lectured on the artist and included him in two exhibitions during the 1940s. In his foreword for the catalogue brochure for Lam's first exhibition in New York in November of 1942, Breton referred to Lam as a Surrealist artist who understood the marvelous and who began his artistic path from the primitive myth that was a natural part of him. Breton did not, however, elaborate on the themes or images in Lam's work. Specific reference to Afro-

Cuban subjects is subsequently found in a brief text written for Lam's exhibition in Haiti in January of 1946, in which Breton states that the Loa Carrefour—Eleggúa in Cuba—is everywhere in evidence.[89]

In a letter that Lam wrote to Breton, the artist mentioned that Pierre Loeb often visited him and that his Parisian dealer was interested in organizing an exhibition of the artist's work in Havana.[90] Although no exhibition materialized, Loeb wrote a short essay in August of 1942 that was published in *Tropiques* the following year.[91] In Loeb's brief presentation, the Parisian dealer located Lam within the broader currents of art history, comparing his interests in nonwestern art to those of earlier artists such as Degas, van Gogh, Matisse and the Fauves, and Picasso. Loeb subtly alluded to Lam's themes with poetic references to Aimé Césaire and to a world in which the muffled sounds of drums originate in the depths of man and the forest. In an article for the English publication *Horizon* in 1946, Loeb wrote that Lam's images are based on the magical beliefs of the peoples of the West Indies, a place where tom-toms can still be heard and atavisms are still alive. Loeb explicated a current ethnographic Surrealist belief when he wrote that nonwesterners, be they African or Papuan, are in closer contact with their unconscious. The Parisian dealer thus claimed that the black man knows and lives magic, whereas the white man must find it in dreams. After describing Lam as a cultivated man who was also instinctive, he added: "It is the privilege of the Negro, with Chinese blood, to have rediscovered the mystery without which there is no art, and thanks to Wifredo Lam, it is in the West Indies that the instinct of the primitive and the knowledge of civilized man are going to counterbalance one another."[92]

Cabrera wrote two articles that appeared in the art section of Havana's leading newspaper. In the first, the Cuban writer and ethnographer introduced Lam—who was then an unknown artist—to a new readership by focusing on his biographical background. Although Cabrera did not discuss the themes or imagery in his work, she did say that Lam's Asian and African lineage was expressed in his art, adding that "his work was not 'exotic' or 'vulgar' in the commonly understood meaning of the words—for Lam was a trained artist whose work was not to be confused with commercial art."[93] Evidently, Cabrera wanted to distinguish between the fine art of a talented painter and

23
Wifredo Lam
Rites Secrets. 1950
Oil on canvas
41⅛ x 32¼" (102 x 82 cm)
Private Collection

the commercial street-trade kitsch that co-opted Africanizing subjects. In Cabrera's second article, she elaborated on the Afro-Cuban content in Lam's work: "The ancient, ancestral black deities who are withdrawn in the soft and engulfing light of Europe, obsessed him there. Here [in Cuba] they appeared tangible under the resplendent light of perennial summer. Here they are expressed with beauty and lucidity in each corner of the landscape, in each tree-divinity, in each fabulous leaf of his garden in Buen Retiro. With all the resources of a painter who thoroughly knows his craft, he paints the fantastic and prodigious qualities of Cuban nature in his canvases. Nobody is better equipped than Lam...to enter the mysterious threshold of primitive art without getting lost."[94]

In the spring of 1946 Cabrera produced a catalogue for Lam's first exhibition at the Lyceum. Cabrera's essay includes excerpts from the article she had written for the *Diario de la Marina* in May of 1943. In another section of the catalogue, there is a series of brief statements and quotations by poets—Breton, Césaire, Mabille, Péret—French critics—Christian Zervos, Georges Besson, and Charles Théophile—and an American critic—Robert Coates.

A few months after Cabrera's article appeared, Carpentier wrote an essay that is still highly regarded by Lam scholars. The writer defined the artist's iconography as one that blends the human, the animal, and the vegetal.[95] To establish the historical significance of this imagery, Carpentier suggested that Lam was "animating a world of primitive myths with something that was ecumenically Antillean—myths that belonged not only to the soil of Cuba, but to the larger chain of islands."[96] Carpentier saw Lam as an especially [Pan-] American—not a European—artist. The writer, who was also in the process of defining a [Pan-] American literary voice distinct from that of Europe, posited that a European artist could not have conceived of and expressed the Antillean world as Lam did. Carpentier's view of Lam as a [Pan-] American painter has resounding echoes in the art and discussions of contemporary Latin American and Latino artists in the United States, as well as artists of other heritages. Moreover, Carpentier's thoughts are central in recent revisionist scholarship.

Pierre Mabille's most important contribution to the 1940s literature on Lam is an essay titled "La Jungle" that was written in Havana in May of 1944.

It was translated from French to Spanish and titled "La Manigua" when it was first published in the Mexican journal *Cuadernos Americanos*.[97] The original French text was published in Césaire's *Tropiques* in January of 1945. The Spanish version was reprinted in the Havana biweekly magazine *Crónica* in April of 1949.

Having spent time in Cuba and having lived in Haiti, Mabille was well informed of Afro-Cuban beliefs. In writing about *The Jungle*, the Surrealist writer said that the painting evokes a universe in which the elements of life—the trees, flowers, fruit, and spirits—cohabit thanks to the dance. Another important contribution was his thoughtful and respectful account of vodun (voodoo) ceremonies that he, Lam, and Breton observed together in Haiti from December 1945 to January 1946. Mabille's essay provided the most complete biographical background—together with analytical comments—written on Lam for the next twenty-five years. In fact, Michel Leiris's monograph of 1970 owes much to Mabille's early work. Mabille was the first writer to specify the nature of Lam's interest in African art in general and his special interest in Picasso's Africanizing period of circa 1908. Only in recent studies have writers begun to examine more specifically the nature of those connections.

In critical writings, Lam has long been seen by Latin Americans as a master of modernist Latin American art. More recently, however, critical thinking privileges Lam as a progenitor of an aesthetic that occupies a singular place globally in the art of his time. Lam, who trained in the western academic tradition and mastered the modernist idioms of Surrealism and Cubism, created a personal symbology to express the Afro-Cuban heritage. He is therefore viewed by many as having opened the path for artists of many cultural backgrounds to express their cultural identities in their work. He both participated in the international contemporary modernist art dialogue of his day and worked outside it to affirm a cultural identity that articulated a world view central to millions of people living on the American continent. Lam is considered a paradigm for having given a voice to Afro-Cubans, and by extension Pan-Americans of African descent, who had been peripheral in the discourse of art history.

Footnotes

Note: I thank my two colleagues Giulio V. Blanc and Lowery S. Sims for their collaboration and camaraderie over the years on this project. In addition, I acknowledge with deep appreciation the following persons: Helena H. Benitez, whose recollections of people, events, and dates have been invaluable to my study of this period; Miguel W. Ramos, expert in Santería practices, whose lengthy discussions regarding diverse ritual practices and beliefs has enabled me to write about them with greater understanding; Isabel Castellaños, professor, Department of Modern Languages, Florida International University, for discussions on Lydia Cabrera and for providing written documentation otherwise unavailable to me; and Emilio Cueto for answering my many random questions. I am also grateful to Mrs. Maria Gaetana Matisse for permission to consult the correspondence in the archives of the Pierre Matisse Foundation. Special thanks to Andrea Farrington and Margaret Lowden who so patiently assisted me with that archival material.

1. Further chronological work can be undertaken once the planned catalogue raisonée is published.

2. In Pierre Matisse's first letter to Lam of July 10, 1942, the dealer wrote that he would open the season with an exhibition of Lam's gouaches. Matisse asked the artist to choose the fifty gouaches that were the most representative of his work.

3. Fouchet, *Wifredo Lam* (1976), p. 231.

4. Pierre Mabille, "La manigua," *Cuadernos americanos* 16:4 (July–August 1944), p. 246.

5. According to custom, when a Chinese immigrant married an Afro-Cuban, the wife would go to live with the husband's family, in this case, in the Chinese section of town.

6. The black communities throughout the island also preserved their rich oral tradition in part with the aide of storytellers who moved from town to town or from plantation to plantation. See Cabrera, *Porqué... Cuentos negros de Cuba* (Havana, 1948; reprint, Madrid: Ramos, 1972), p. 234.

7. In this essay, the transcription of the Afro-Cuban names is written in Spanish, not in Yoruba. By 1900, the majority of Cubans of African descent were Yoruba. Their religion, music, dance, language, and folklore survived uprooting and transplantation and became especially prominent in all aspects of Spanish-Cuban life. Despite the Catholic Church's mission to Christianize them, Afro-Cubans kept alive their religion by coidentifying African deities with Christian saints. For example, Changó was worshipped in the guise of Saint Barbara, Ogún in the guise of Saint Peter, Elegguá in the guise of Saint Anthony, and Yemayá in the guise of the Virgin of Regla. They also preserved the specific ethnic characteristics of their music and dance, which became institutionalized in societies known as *cabildos*, which were organized by the Church. Each *cabildo* was made up of Afro-Cubans from the same ethnic group or region in Africa. The Church hoped that by encouraging African ethnic organizations, it might find it easier to Christianize their members. By the end of the nineteenth century, some fourteen African nations had preserved their ethnic identity in Havana *cabildos*. The dances celebrated in the *cabildos* were of African origin, each nation dancing in its own style. During the liturgical cycle of the Catholic year, Afro-Cubans had the opportunity to inject their style of celebration into public festivities. The *cabildos* marched into the streets were the masks and rhythms of Africa under the images of Catholic saints. For an overview of the history of *cabildos* in the nineteenth and twentieth centuries, see Murphy, *Santería: An African Religion in America* (Boston, 1988), pp. 23–29.

8. William R. Bascom, "The Focus of Cuban Santería," *Southwestern Journal* 6 (Albuquerque, 1950), p. 66.

9. For the first time, I am identifying Mantonica Wilson's official religious role within the Santería religion. In order for Wilson to have brought Lam under the spiritual guidance of Changó, she had to have been a priestess in the *lucumí* religion. It should be pointed out that Michel Leiris was among the first to provide information on Wilson when he identified her as a healer, adviser, and diviner. However, Leiris did not identify her as a priestess. See Michel Leiris, *Wifredo Lam* (Milan, 1970), p. 6. Following Leiris, Fouchet, in *Wifredo Lam*, 1976, p. 40, states that Mantonica Wilson was a sorceress. Fouchet uses the word sorceress in a European context, in which the word sorcery has connotations of evil or malificence. It does not have the same connotations in the Afro-Cuban context. Therefore, the description of a priestess as a sorcerer misrepresents the positive religious functions of a *lucumí* priestess.

10. Leiris, *ibid.*, p. 6. A practicant is not to be confused with an initiate. A practicant is a lay person in both *lucumí* and Catholicism. An initiate in *lucumí*, however, is a priest or priestess whose official role in the religious hierarchy can be equated to a priest or nun in the Catholic religion. For a very informative explanation of the ceremony that begins with initiation and leads to Ifa priesthood, see Beatriz Morales, "Afro-Cuban Religious Transformation: A Comparative Study of Lucumí Religion and the Tradition of Spirit Belief" (Ph.D. diss., City University of New York, 1990), pp. 60ff.

11. In Santería, the Christian words godmother and godfather are used to designate the ceremonial kinship of the family who is related, not by blood, but by initiation. The godmother and godfather formally initiate the devotee into the religion. Accordingly, the godchildren come under their protection. See Murphy, *Santería: An African Religion in America*, pp. 52, 53.

12. Numbers and numerical patterns reflect the paths (*caminos*) of each *orisha*. Spiritual work done with Changó, for example, should be done in fours or sixes. See Murphy, *Santería: An African Religion in America*, pp. 41, 43. I wish to thank Mme Lou Laurin-Lam for granting permission to Maria Balderrama to exhibit this highly personal item.

13. Miguel W. Ramos, who has observed similar changes, suggests that the chlorophyll from the *omiero*, an infusion of leaves used in the preparation of amulets and other rituals or practices, in all likelihood caused the white to change to its present pale green.

14. Leiris, *Wifredo Lam*, p. 6. According to Miguel W. Ramos, cleansing ceremonies are private and conducted on a one-to-one basis. It is possible that Lam could have been present at cleansing ceremonies for family members, but the young Lam could not have been present at ceremonies that were conducted for other followers.

15. In a conversation with the author on February 7, 1990, Helena H. Benitez maintained that he was an atheist.

16. In 1968, Fouchet and Lam were invited to attend the Third World Cultural Congress in Havana. On that occasion, they visited Sagua la Grande, where Lam recounted his childhood memories. For a discussion of these remembrances, see *Wifredo Lam* (1976), pp. 37, passim.

17. Leiris, *Wifredo Lam*, p. 6.

18. Late in life Lam recounted these memories to Gerardo Mosquera, *Exploraciones en la plástica Cubana* (Havana, 1983), p. 186.

19. In addition, Lam executed a number of important multifigural

works which include: *Le mariage, Jeu de fête, Composition*, and the *Groupe*. Although the artist also painted some still lifes, that particular genre developed in a more interesting fashion after 1942.

20. The exhibition took place from November 17 to December 5, 1942. A catalogue brochure listing the titles of the fourteen gouaches included an essay by André Breton.

21. The untitled drawing is illustrated in Julia P. Herzberg, "Wifredo Lam," *Review* (January–June, 1987), p. 25. Signed and dated, it was executed in pencil, pen, and ink on paper, 8⅝ x 6⅝ inches. It is in the Collection of Vassar College Art Gallery, Poughkeepsie, N.Y.; Museum Purchase, the Duncan Fund for Contemporary Latin American Drawings.

22. The term Afro-Cuban, or Afro-Cubanism, commonly refers to an African presence in religion, language, literature, or the arts. For discussion of the complex phenomenon of transculturation of Europeans, Euro-Cubans, Africans, and Afro-Cubans, see Jorge Castellaños and Isabel Castellaños, *Cultural afrocubana* 1 (Miami, 1988), pp. 19–59.

23. For a discussion of the figure and its origins in Picasso's *Guernica*, see Julia P. Herzberg, "Wifredo Lam: The Return to Havana and the Afro-Cuban Heritage," Qualifying Paper, Institute of Fine Arts, New York University, 1986.

24. *Les Yeux de la grille* was exhibited in November at the Pierre Matisse Gallery, but *Déese avec feuillage* was not. In the Invoice of Merchandise *Déese avec feuillage* was descriptively listed as "Composition with two faces and leafage." Its present title is noted in the original archival material of the Pierre Matisse Foundation.

25. Helena H. Benitez said that Lam and she often spoke about this world view, which holds that plants and animals and the deity have a soul, a vital force. Benitez also added that she did not think that this notion needed explaining or intellectual analyzing, because one feels it everywhere in Cuba. This view of oneness with nature was part of Lam's makeup; for Benitez it had been inspired by Carl Jung's ideas. Conversation with the author, February 7, 1990.

26. For a discussion of spiritual possession, see Lydia Cabrera, *Porqué... Cuentos negros de Cuba*, pp. 238–39. See also Janhein Jahn, *Muntu* (New York, 1961), p. 63.

27. In a letter of September 2, 1942, Lam wrote to Pierre Matisse that he was sending his shipment of gouaches to New York with temporary titles to facilitate *les formalites consulares et douanières*. Lam noted that he would ask André Breton to title them.

28. Joseph M. Murphy, *Santería: An African Religion in America*, p. 15. The Yoruba word *ebó* refers to an animal sacrifice or a cleansing ritual; *adimu* refers to a plant or food offering.

29. Sacrifices are also made to deities during such special ceremonies as initiation; they are also made as a gesture of propitiation to ward off evil or to prevent illness or negative elements of a castigating nature. Animal sacrifices are eaten in a communal meal as a celebration between the divinity and the devotee. I appreciate Miguel W. Ramos's discussion of these rites with me. See also Lydia Cabrera, who discusses the food preferences of the *orishas* in *El monte* (Miami, 1975). For example, roosters for Ogún and Changó; guinea hens for Yemayá and Babalú Ayé; chickens for Oyá; and so forth.

30. The untitled gouache 1942 (cat. no. 15) is almost identical to *Venus*, a picture that is in Cuba and is illustrated on the cover of *Homenaje a Wifredo Lam, 1901–1982*, exh. cat. (Madrid, 1982).

31. In a letter dated September 2, 1942, Lam wrote to Pierre Matisse that he would send fifty gouaches to New York in three different groups. According to the Invoice of Merchandise attached to the consular invoice dated October 7, 1942, *Femme* and an untitled work are not included.

32. *The Jungle* is alternately known by its descriptive title, *Personage with Scissors*. It was owned for many years by Mr. and Mrs. E. A. Bergman, who donated it to the Art Institute of Chicago, where it forms part of the Lindy and Edwin Bergman Collection.

33. The three common terms used for the Yoruba-derived religion practiced in Cuba are *la regla lucumí*, or simply *lucumí*, and *la regla de ocha*, or *ocha*, and *Santería*.

34. Cabrera, *El monte*, pp. 119–20.

35. Ibid., pp. 115, 118, 119.

36. *The Jungle* was painted in oil on kraft wrapping paper attached to canvas. It was painted over a twenty-day period beginning in December of 1942 and completed in January of 1943, according to Antoñio Nuñez Jiménez, "Genesis de la jungle," *Plástica latinoaméricana: Revista de la Liga de Arte de San Juan* (March 1983), p. 18. This painting was purchased by The Museum of Modern Art in 1945 from the Pierre Matisse Gallery, after it was exhibited in Lam's second solo show there.

37. In the traditional rural life of the Afro-Cuban, the *monte* describes an untilled area that, by definition, is sacred. However, in industrialized society, the *monte* can be a river bank in a city or even the backyard of a *lucumí* devotee. It should also be noted that although the Spanish word *jungla* (jungle) is also used to describe the physical aspects of a natural forest area, it does not connote a sacred terrain. Nor is the Spanish word *selva* (forest) used to describe a sacred terrain. Cabrera states (*El monte*, pp. 66, 67) that only *monte* or its synonym *la manigua* are appropriate in this context.

38. Cabrera, *El monte*, pp. 3, 150.

39. The Surrealist poets Antonin Artaud and Robert Desnos wrote about the African cultures in Cuba during the 1930s. See Michel Leiris, "1970—Inédit en français: Extrait," in *Wifredo Lam 1902–1982* (Paris, 1983), pp. 2–3.

40. See Antóñio Nuñez Jiménez, *Wifredo Lam* (Havana, 1983), pp. 117–18, where he notes: "Aquel despojo me impelió a recuperar todos mis recuerdos de la infancia, llenos de brujas, supersticiones, mitos heredados, y otros creados por mi propia imaginación. Ciertamente, lo único que me quedaba en aquel momento era mi viejo anhelo de integrar en la pintura toda la transculturación que había tenido lugar en Cuba entre aborígenes, españoles, africanos, chinos, immigrantes franceses, piratas, y todos los elementos que formaron el Caribe. Yo reivindico para mí todo ese pasado" Translation is by the author.

41. The journal was published from 1937 to 1940. Ortíz was both an editor and a contributor.

42. See Roberto Gonzalez Echevarría, *Alejo Carpentier: Pilgrim at Home* (Ithaca, 1977), pp. 36, 37.

43. According to Gonzalez Echevarría, Carpentier was also considered a minor literary figure whose involvement in the Afro-Cuban movement was well known, but he probably did not yet consider himself a writer. He began to be recognized as an important writer toward the end of the 1940s. See Gonzalez Echevarría, *Alejo Carpentier: Pilgrim at Home*, pp. 36, 37, 98.

44. Professor Robert Farris Thompson pointed out that Cabrera's fieldwork lasted three times longer than typical anthropological fieldwork usually does. Lecture on May 22, 1984, on the occasion of the exhibition "Lydia Cabrera: An Intimate Portrait" at the INTAR Latin American Gallery, New York.

45. Carpentier moved from Havana to Caracas in 1945. Cabrera moved to the United States in 1960 during the Revolution. She lived in Miami until her death in 1991.

46. Cabrera has taken credit for encouraging Lam to paint aspects of his black heritage. Conversation with the author, May 24, 1984.

47. Conversation May 5, 1984. Lam was introduced to Cabrera by a dentist named Dr. Morin, who had been a friend of the artist during their school days in Havana. Conversation with Helena H. Benitez, February 7, 1990.

48. Cabrera found Lam self-conscious about being of mixed racial background. Helena H. Benitez corroborated that view. Furthermore, Benitez said that Lam never mentioned Mantonica Wilson to her. Conversation with the author, February 7, 1990.

49. Regarding the strength of Afro-Cuban retentions in and around Havana at that time, Pierre Loeb wrote that the tom-toms can still be heard and the atavisms are still alive. See Pierre Loeb, "Wifredo Lam," *Horizon* 13:76 (1946), p. 265.

50. According to Helena H. Benitez, Césaire sent them a copy of the book in French and asked her to translate it into Spanish.

Although Benitez spoke Spanish very well, she could not translate a poetic text, and therefore she asked Cabrera to do this. Conversation with the author, February 7, 1990.

51. *Tropiques* was published in Fort-de-France from 1941 to 1945. Its editorial board consisted of Aimé Césaire, Suzanne Césaire, and René Ménil. For discussion of their objectives and their connections to the Surrealist movement, see Jacqueline Leiner, "Entretien avec Aimé Césaire," *Tropiques* 1:1–5 (April 1941–April 1942) (Paris, 1978), p. 8.

52. Cabrera's poem "Bregantino, Bregantin (Conte negre-cubain)" appeared in *Tropique* issue 10 (February 1944). In the spirit of interchange Césaire's poem "Batua" was translated by Helena H. Lam and appeared in the Havana publication *Origenes* 2:6 (1945), pp. 22–26.

53. *Tropiques*, no. 2 (July 1941). Reprinted in *Tropiques*, vol. 2 (Paris, 1978), pp. 75–77.

54. Pierre Mabille, "La jungle," *Tropiques*, no. 12 (January 1945) Reprinted in *Tropiques*, vol. 2, nos. 6–7 to 13–14 (February 1943–September 1945) (Paris, 1978), pp. 175–87.

55. Aimé Césaire, "Wifredo Lam," *Cahiers d'art* (Paris, 1945–46), pp. 357–66.

56. *Hémispheres*, no. 4 (1944).

57. *Hémispheres*, nos. 2–3 (1943/44). In Surrealist circles in New York, there was an interest in the Antilles. Yvan Goll, the editor of *Hémispheres*, wrote an article titled "Découverte des Tropiques," nos. 2–3 (1943/44), and in the same issue, André Breton wrote an article on Aimé Césaire titled "Un grand poete noir." Part of Goll's essay was reproduced in *Tropiques*, no. 11 (May 1944).

58. Conversation with Helena H. Benitez, February 7, 1990.

59. Conversation May 5, 1984. For references to *malembo*, see Cabrera, *El monte*, pp. 17, 325, 499.

60. *La Sombre Malembo* is the original title written on the archival photograph in the Pierre Matisse Foundation. The more recent title, *Malembo, Deity of the Crossroads*, is found in Fouchet, *Wifredo Lam* (1989), p. 200.

61. Giulio V. Blanc first documented the drawings when they were in the collection of Lydia Cabrera and María Teresa de Rojas. I thank Giulio V. Blanc for sharing with me the background on these drawings over the course of our collaboration. I am also grateful to Isabel Castellanos for the very useful information she provided regarding the literary references to these drawings.

62. A book of Cabrera's turtle stories, *Ayapá: Cuentos de Jicotea*, was published in 1971.

63. Alejo Carpentier, "Reflexiones acerca de la pintura de Wifredo Lam," *Gaceta del Caribe* (July 1944). Reprinted in *Alcance a la Revista de la Biblioteca Nacional José Martí*, no. 3 (1989), p. 99.

64. Helena H. Benitez said that the Carpentiers and they got together at least once every week beginning in early 1942. Letter June 1, 1992.

65. See Lydia Cabrera, *La sociedad secreta Abakuá* (Editorial C.R. 1969), p. 9.

66. *L'aventure du Pierre Loeb: La Galerie Pierre, Paris, 1924–1964* (Paris: Galerie Albert Loeb, 1979), p. 35.

67. José Gómez Sicre reproduced copies of Carpentier's drawings in *Cuban Painting Today* (1944), the first book on contemporary Cuban art from that period. Acknowledging the origin of these drawings, the Cuban curator and critic added that the original ones drawn in yellow chalk were about twenty inches in height.

68. This particular Abakuá symbol is referred to as the emblem of Moruá Erikundi in Lydia Cabrera's *Anaforuana: ritual y símbolos de la iniciación en la sociedad secreta Abakuá* (Madrid, 1975), p. 251. *Piccola foresta* is illustrated in Leiris, *Wifredo Lam*, p. 62.

69. Martínez Pedro, a Cuban painter discussed in Giulio V. Blanc's essay, did a series of *Cuarto fambá* that was exhibited in New York. It is possible that the younger painter, who began to deal with Afro-Cuban subjects in the late 1940s, was responding to Lam.

70. Cabrera, *El monte*, p. 323.

71. Murphy, *Santería: An African Religion in America*, p. 147.

72. Correspondence with Helena H. Benitez, June 11, 1992.

73. Alejo Carpentier, "Reflexiones acerca de la pintura de Wifredo Lam," reprinted in *Alcance a la Revista de la Biblioteca Nacional de José Martí*, p. 99.

74. In several letters to Matisse, Lam asked his dealer for recent publications from The Museum of Modern Art and from the book store Wehye.

75. Cynthia Turner, "Orisha/Santos: Yoruba Religion in the New World," in *Orisha/Santos: An Artistic Interpretation of the Seven African Powers* (New York, 1985), n.p.

76. Cros Sandoval, *La Religión afrocubana*, p. 166. Also see Jahn, *Muntu*, p. 64.

77. To honor Ogún, his devotees leave a necklace or a chain of objects including an arrow, a yoke, a pike, an ax, a machete, a hammer, and a key at the foot of the silk cotton tree. See Cros Sandoval, *La Religión afrocubana*, p. 241.

78. Cabrera, *Porqué…Cuentos negros de Cuba*, pp. 36–37.

79. *Hermès* and *La Présent éternel* were in the exhibition "Wifredo Lam" at the Lyceum in Havana in April 1946. Perhaps the mythic title *Hermès* was chosen out of a feeling of camaraderie for similar titles given to contemporaneous works by artists such as Mark Rothko and Adolph Gottlieb, for example.

80. See Jahn, *Muntu*, p. 63.

81. For a discussion of the sensual prowess of Oshún and Changó, see Morales, "Afrocuban Religious Transformation," pp. 54–55.

82. I thank Miguel W. Ramos for bringing this tale to my attention.

83. Cros Sandoval, *La Religión afrocubana*, p. 55.

84. Alfred H. Barr, Jr., "Modern Cuban Painters," *Museum of Modern Art Bulletin* 11:5 (April 1, 1944), p. 7. Many years later, José Gómez Sicre, who co-organized the exhibition "Modern Cuban Painters" with Alfred H. Barr and later became the founder and first director of the Museum of Modern Art of Latin America, Washington, D.C., spoke about the general cultural and social milieu for the arts as being intolerable in Cuba in the 1940s. See Alejandro Anreus, "Ultima conversación con José Gómez Sicre," *Linden Magazine* 11:1 (March 1992), p. 10.

85. Cabrera, "Wifredo Lam," *Diario de la Marina*, January 30, 1944.

86. Antoñio Nuñez Jiménez, "Genesis de la Jungla," *Plástica latinoaméricana: Revista de la Liga de Arte de San Juan* (March 1983), p. 20.

87. Lydia Cabrera organized the exhibition at the Lyceum, a women's club that held contemporary art exhibitions and other cultural events. It was an important venue in Havana at that time.

88. *Origenes: Revista de arte y litertura*, a leading magazine on the arts, was published from 1944 to 1956. Lam's contemporaries, including René Portocarrerro, Mariano Rodriguez, Cundo Bermúdez, Roberto Diago, and Amelia Peláez, also did cover illustrations. José Clemente Orozco and Rufino Tamayo were among the foreign artists who did cover illustrations.

89. André Breton, *Wifredo Lam*, exh. cat. (Port-au-Prince, 1946).

90. Lam's correspondence to André Breton, July 1, 1942.

91. Pierre Loeb, "Wifredo Lam," *Tropiques*, no. 4 (1943). Reprinted in *Tropiques*, vol. 2 (1978), pp. 61–62.

92. Pierre Loeb, "Wifredo Lam," *Horizon* 13:76 (April 1946), p. 268.

93. Lydia Cabrera, "Wifredo Lam," *Diario de la Marina*, May 17, 1943.

94. Ibid., January 30, 1944. Translation is by the author.

95. Carpentier, "Reflexiones acerca de la pintura de Wifredo Lam," *Gaceta del Caribe*, p. 99.

96. Ibid. Translation is by the author.

97. Pierre Mabille, "La manigua," *Cuadernos Americanos*, pp. 241–56.

Cuban Modernism:
The Search for a National Ethos

GIULIO V. BLANC
Art Historian and Independent Curator

Antecedents

The history of Cuban art begins with a mulatto painter of religious subjects, José Nicolás de la Escalera (1734–1804).[1] His most important work is a series of paintings in the church of Santa María del Rosario near Havana. Completed in the 1760s, they depict Saint Dominic Guzmán and other Catholic saints. Given the themes that would preoccupy Cuban artists two centuries later, one canvas is of special relevance. The painting (fig. 1) depicts the first Count of Casa Bayona, founder of the town of Santa María del Rosario, surrounded by his family, members of the clergy, officials, and servants, who are all in prayerful devotion to Saint Dominic. One of the servants is a black man wearing a crucifix, a cloak, white stockings, and shoes with buckles, and holding a broad-brimmed hat. He is shown in an attitude of thoughtful meditation, sitting with his legs crossed and his chin in his right hand. With his left hand, he appears to be pointing at the ground. According to local legend, this African slave discovered a spring with curative properties, which he used to affect the Count's miraculous recovery from various ills. We know almost as little about José Nicolás de la Escalera as we do about the Count's benefactor. What is most important about this painting is the fact that the artist, himself a person of color, was the first to depict an Afro-Cuban in a major Cuban painting. Furthermore, he gave him a position of prominence in this group of Spanish aristocrats, dressing him in clothing that connotes at least a minimal level of status rather than in exotic or demeaning garb.

José Nicolás de la Escalera's painting, in which an Afro-Cuban contributes his knowledge of a spring with magical powers to his white overlord and is treated respectfully as an integral participant in the devotional scene, symbolically sums up the concerns of the island's twentieth-century artists—myth, the role of the African legacy in the context of national identity, and the presentation of socio-cultural realities without resorting to caricature and stereotype.

The nineteenth century's enormous economic development in Cuba[2] was sustained mainly through the importation of vast numbers of African slaves to work in the sugar-cane fields as well as through the cultivation and manufacture of tobacco. One by-product of the tobacco industry was the establishment of lithography workshops for the creation of cigar bands, colorful decorative wrappers, and related art-work, all meant to promote the sale of the Cuban cigar abroad. These workshops stimulated the development of printmaking on the island. They were utilized by foreign artists, some of whom also dedicated themselves to the needs of the tobacco industry.[3]

Like other "traveler reporter" artists who worked in the Americas during the nineteenth century and produced images collected by Europeans curious about the New World as well as by local elites, foreign artists in Cuba left accurate records of daily life.[4] As might be expected, the picturesque and the exotic were emphasized, but this did not exclude realistic subject matter. Artists such as James Sawkins, Eduard Laplante, Hippolyte Garneray, and Frédéric Mialhe created images that included views of Havana and other cities, life and work at sugar plantations, and the rural landscape.[5] Afro-Cubans are ubiquitous, but now the *guajiro*—the small farmer of white, black, or mixed stock—makes his appearance. The term *guajiro* is Indian and probably comes from Venezuela.[6] The life of the rural population of Cuba—who live in *bohíos* (huts) made from the fronds and trunks of the royal palm and who cultivate the *yuca* root, tobacco, and other native Caribbean crops—speaks of a Taino Indian heritage. Indian genetic and cultural survivals cannot be ignored; they have been noted by scholars, but they remain to be investigated thoroughly, having been overshadowed by more obvious Spanish and African contributions.[7]

Frédéric Mialhe (1810–1881), a French painter and lithographer, left what is certainly the most complete set of views of the Cuban way of life in the mid-nineteenth century. His *Día de Reyes* of 1848 (fig. 2) depicts the January sixth Catholic feast of the Epiphany, which celebrates the arrival of the three Wise Men in Bethlehem.[8] Eliminated at the end of the nineteenth century, this festival was the principal opportunity for the various tribal groups of Afro-Cubans to gather, parade, and celebrate together. The most notable event of the *Día de Reyes* was dancing to the beat of drums. Mialhe depicts a group of these dancers in African and European fancy dress in front of the church of San Francisco. Those in African dress wear wide straw skirts, anklets, masks, and feather and horn headdresses. Especially prominent is an individual in the African-derived *diablito* costume usually associated with the Abakuá or Ñañigo secret society.[9] The dancers are accompanied by two musicians, one

Mario Carreño
Sugar Cane Cutters. 1943
The Museum of Modern Art
cat. no. 82

holding a beaded gourd *maraca* and the other a cylindrical wood-and-hide drum. Surrounding the group are Afro-Cubans in various types of European dress, ranging from elegant attire to work clothes. A number of white Cubans are also present. In *El zapateado* of 1848 (fig. 3), Mialhe turns his attention to *guajiros*. A couple is performing a traditional Spanish-Cuban dance to music provided by another *guajiro* with a small guitar. Surrounding them are various other *guajiros*, including a black man. A number of the participants in this scene wear the broad-brimmed straw hats, kerchiefs, and *machetes*—swordlike blades for agricultural use and personal protection—that are typical of the inhabitants of the countryside. A *bohío* is visible in the background.

Like the lithographs of Mialhe—which reached a wide audience in Cuba, Europe, and the United States and were even pirated and plagiarized—the paintings and prints of Víctor Patricio Landaluze (1828–1889) provide vivid documentation of daily life in Cuba during the colonial period. Although he sometimes caricatured his subjects, this Spanish artist produced accurate depictions of Afro-Cubans and *guajiros* engaged in domestic tasks, toiling in the sugar-cane fields, and participating in festivities. He made a number of canvases showing versions of the *Día de Reyes*, which are similar to Mialhe's prints in their attention to details of African dress (fig. 4). Landaluze also painted and drew individual *diablitos* such as *El ñáñigo* of 1881 (fig. 5). His *guajiro zapateado* scene titled *El zapateo* (fig. 6) that related to Mialhe's demonstrates Landaluze's awareness of the earlier artist's compositions. However, like Mialhe, he was a careful observer and had ample opportunities to witness first-hand the scenes he depicted.

On the whole, native Cuban artists of the nineteenth century were less concerned than the European visitors with the documentation of their land and people. Founded in 1818, the Academia de San Alejandro provided solid training based on European antecedents and produced artists interested in conventional treatment of mythological, religious, and historical subjects and in portraiture.[10] Although Armando Menocal (1863–1942) and Leopoldo Romañach (1862–1951) sometimes depicted Afro-Cubans and *guajiros*, these prominent professors at San Alejandro were intent on painting images that reflected European academic standards. Their sub-

1
José Nicolás de la Escalera
Familia de Casa Bayona. 1760s
Oil on canvas
Santa Maria del Rosario, Cuba

jects are little more than props, pretexts for good compositions, and, as a result, their works convey impressions of exoticism and maudlin theatricality. In landscape painting of this period, an effort was made to record tropical vegetation and local topography, and occasionally, Afro-Cubans, *guajiros*, and *bohíos* do appear. The emphasis, however, is on the picturesque. Among the more successful nineteenth-century landscapes are those of Esteban Chartrand (1840–1883), a Cuban of French descent who may have had ties to the School of Fontainbleau.

The Generation of 1927

During the nineteenth century, images of blacks and *guajiros* were part of the repertory of both "traveler reporters" and Cuban artists, but they were usually anecdotal or exoticized. Occasionally, the conservative academicians utilized themes from national history and folklore, but they were little concerned with serious issues of identity and nationalism. These attitudes persisted after independence was finally achieved in 1902, as they were favored by the government in its program of decoration of the new capitol and the presidential palace. The tastes of the small elite group that was commissioning or purchasing art were also confined to outdated European academic styles and their Cuban versions. All of this would be challenged in the 1920s by a new, rebellious generation of artists. The island won independence from Spain in 1898 after a long struggle, and this was ultimately

2
Frédéric Mialhe
Día de Reyes. 1848
Lithograph
Private Collection

3
Frédéric Mialhe
El zapateado. 1848
Lithograph
Private Collection

4
Víctor Patricio Landaluze
Día de Reyes en la Habana. n.d.
Oil on canvas
Museo Nacional, Havana

5
Víctor Patricio Landaluze
El ñañigo. 1881
Ink drawing
Private Collection

6
Víctor Patricio Landaluze
El zapateo. n.d.
Oil on canvas
Museo Nacional, Havana

accomplished by means of United States intervention. The United States, formally on the basis of the Platt Amendment to the Cuban Constitution and more surreptitiously through its ambassadors, attempted to exercise a strong influence on the island's affairs. In reality, and much to the distress of many citizens who had expected a different future, Cuba became a protectorate of the United States, whose foreign policy and commercial priorities helped determine its fate.[11]

Organized in 1923 and made up of young writers, artists, and intellectuals, the Grupo Minorista was the catalyst for a profound change in Cuban culture, one that emphasized Afro-Cuban and folkloric contributions and led to their serious treatment in works of art, literature, and music. European, especially Parisian, modernism was a motivating factor in this cultural renaissance, as was the example of Mexico and its government-supported muralists who documented the pre-Columbian and folk heritage of their country.

Cuban intellectuals had to contend with the prejudice of traditional Cuban society. Slavery had been abolished only in 1886, and for most white Cubans, Afro-Cuban culture was perceived as unworthy of serious consideration and even as a source of embarrassment. The *guajiro* and colonial heritage, while viewed nostalgically as picturesque, represented a backward past. The intellectuals of the Grupo Minorista thus faced a daunting educational task.

A number of key events served to underline the growth of what became known as *afrocubanismo* as well as related approaches to cultural nationalism.[12] In 1923, the Sociedad de Folklore Cubano was founded by Fernando Ortíz, an anthropologist with a keen interest in Afro-Cuban and folk culture. In 1925, the composer Alejandro García Caturla wrote his *Danza lucumí*, and Amadeo Roldán created *Obertura sobre temas cubanos*. These and other composers paralleled literary and artistic trends in their incorporation of the Afro-Cuban and popular into mainstream culture. It was an innovation that would have a far-reaching impact on twentieth-century music on an international level. The year 1927 was a watershed in this process of creating a national ethos. The *Revista de Avance* (1927–1930), organ of the Minoristas, began publication.[13] It included fiction and essays by avant-garde writers from Cuba and elsewhere and debated issues such as "What constitutes Latin American Art?" It was illustrated with works by the young

generation of modernists and reflected the new concern for Afro-Cuban, *guajiro*, and other popular themes. For the Minoristas, socio-economic progress and nationalism were tied to artistic innovation. Their commitment in this respect was demonstrated through their sponsorship of an exhibition of "new art" that included members of the Cuban avant-garde as well as some foreign artists living on the island. The purpose of the exhibition was stated in a declaration by the group in the April 15, 1927 issue of *Revista de Avance*. They did not intend "to define or single out a particular trend or style of painting. This, we think, would be very premature. We wish only to bring together the work of young artists stimulated by a sense of anxiety, inquiry, a search for new horizons. It is not simply a question of enlisting forces, but of a much needed revision of values that will enable us to move forward."[14]

Reaching a wider audience than the *Revista de Avance*, the literary supplement of the *Diario de la Marina*, Cuba's most influential newspaper, emphasized *afrocubanismo*, including the poetry of Nicolás Guillén. The supplement was edited by the Minorista leader José Antonio Fernández de Castro. Another leader of the avant-garde, Alejo Carpentier, pursued his interest in Afro-Cuban culture and, in 1933, published his novel *Ecue-Yamba-O*. Meanwhile, Fernando Ortíz was actively researching and publishing. His disciple, Lydia Cabrera, would publish her *Contes Nègres de Cuba*, in Paris, in 1936. In 1940, Cabrera's landmark collection of stories based on Afro-Cuban myths and legends appeared in a Spanish version with an introduction by Ortíz that stresses the biracial nature of Cuban culture.[15]

Afro-Cuban and other folkloric investigations were co-opted by the mass media and the entertainment industry, only to degenerate into touristy Art Deco illustrations, posters, and floor shows. Nevertheless, the efforts of these avant-garde writers and artists were sincere. Aware of similar movements in the Americas and in contact with their intellectual counterparts in the United States and Europe—from Langston Hughes and the Harlem Renaissance African-American cultural movement to the Parisian Surrealists—they were in a position to mold a Cuban identity, at least in theory. This identity would be built on a heritage that combined the Afro-Cuban, *guajiro* culture and urban life with its Cubanized Spanish baroque aesthetic.

For several years during the 1920s and 1930s, the leaders of the modern art movement in Cuba lived and studied in Paris, where they assimilated the latest aesthetic developments. The modern Cuban art that developed, which blends European modernism with Cuban national elements, exemplified by Víctor Manuel García's 1929 *Tropical Gypsy* (fig. 7). Painted in Paris, this icon of Cuban art history reflects Víctor Manuel's (as he is usually referred to) exposure to Gauguin and the Fauves, as well as to Medieval and Renaissance art. The gypsy face combines white, African, and Indian features. Like its landscape setting, this figure possesses a faux-naive spontaneity. This *guajira* is neither servile nor exotic; she regards the viewer with a direct, even serious, gaze.

This exhibition revolves around Wifredo Lam and the years 1938–52, when he rediscovered his African and Afro-Cuban heritage. Those years coincided with the full flowering of the first and second generations of his Cuban modernist contemporaries. Like them, Lam was in search of a national identity, of a way to apply the lessons he had assimilated firsthand in Europe for his own purposes. It is clear that Lam saw his art as a statement of liberation and of Afro-Cuban identity.[16] Both in the United States and in Europe, it has been customary to see Lam in isolation. This view, however, is misleading. His contemporaries were equally concerned with the issues of cultural nationalism dealt with by Lam. Despite stylistic differences and emphasis on different aspects of Cuban myth and reality, their ultimate goals were not all that dissimilar.

In an exhibition of this scope, it is impossible to include every Cuban modernist who, from the 1920s to the 1940s, demonstrates the concerns discussed above. Therefore, a group of the most significant artists has been chosen.[17] Included from the first generation of modernists are Víctor Manuel García, Carlos Enríquez, Amelia Peláez del Casal, Fidelio Ponce de Leon, and Teodoro Ramos Blanco, and from the second generation are Cundo Bermúdez, Mario Carreño, Roberto Diago, Luis Martínez-Pedro, and Mariano Rodríguez. All the works in the exhibition are from the period between about 1938 and 1952.

Víctor Manuel García (1897–1969) is considered the founding figure of Cuban modernism.[18] He was the son of a caretaker who worked in the building where the Academia de San Alejandro was located.

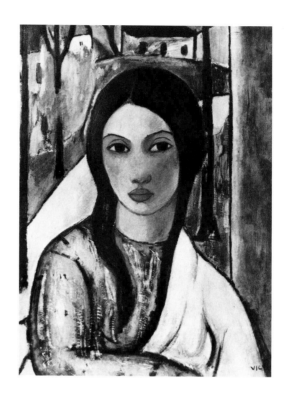

García showed his talent at a young age; when he was only fourteen, he was made a teaching assistant in drawing at San Alejandro. He subsequently studied with Leopoldo Romañach. He rejected a teaching career at the academy and left for Paris in 1925. In Paris, García became a member of the informal Grupo de Montparnasse, whose members were expatriate Cuban and Latin American intellectuals. At one festive gathering, his colleagues insisted on changing the artist's given name of Manuel García Valdés to the more melodic Víctor Manuel. He returned to Havana in 1927, a militant modernist. That same year, he participated in the *Revista de Avance* new art exhibition, and he also had a revealing solo exhibition. A talented teacher, Víctor Manuel discussed his European experiences with other Cuban artists. The attraction of Paris proved strong, and he went back once again in 1929. He returned to Havana that same year, carrying his *Tropical Gypsy* with him.

Tropical Gypsy became the prototype for hundreds of similar images that Víctor Manuel created during his long career (fig.7). These racially mixed, Madonna-like peasant women, characterized by their simple line and color, evoke a mood of wistful nostal-

7
Víctor Manuel García
Tropical Gypsy. 1929
Oil on canvas
Museo Nacional, Havana

gia. Related themes painted by Víctor Manuel include the male counterpart to the *guajira*, young peasant couples, rural and urban landscapes (cat. 92), and Afro-Cubans. *Carnival* (cat. 91), which features a *diablito* of the type encountered in nineteenth-century paintings and prints, is one example of the artist's treatment of Afro-Cuban themes.

Many of Víctor Manuel's works evoke an edenic Cuba in which *guajiros* alone or in pairs appear in landscapes with clean blue streams, flaming royal poinciana trees, and *bohíos*. The artist also made scenes of sly humor, such as those in which men urinate behind trees and on street corners, much to the shocked amusement of the matrons who see them. *Carnival*, in which two of the participants appear be engaged in either a provocative dance or a romantic tryst, is filled with joyful exuberance and earthy humor. It is the pictorial equivalent of countless popular Afro-Cuban and Afro-Cuban-inspired songs and dances.

The idealized Cuba of Víctor Manuel stands in contrast to the Cuba of Carlos Enríquez (1901–1957).[19] Like Víctor Manuel, Enríquez was of Spanish descent; unlike him, he came from a wealthy family and had the opportunity to study at the Pennsylvania Academy of the Fine Arts in 1924. There he met the North American artist Alice Neel, whom he married in 1925. (They were divorced around 1930.) Enríquez participated in the polemics of the Grupo Minorista, but it was only after he spent the years 1930 to 1934 in Spain and Paris that he arrived at a style that, although it owed much to Surrealism, depicts the artist's vision of Cuban myth and history. Although Enríquez denied that he was a Surrealist, his obsession with eroticism, X-ray imagery, metamorphosed beings, and dreamlike scenes points to the influence of that European movement.

Enríquez invented the concept of the *romancero guajiro*, his fantasy of romance of the Cuban countryside, especially as it existed in the turbulent years of the 1890s, when the War of Independence was being fought. Bandits, abducted mulatta women, and the life and labors of the *guajiro* are favored themes in his paintings, and they appear in three novels by the artist as well. Violence and eroticism are recurrent in Enríquez's work. In *Landscape with Wild Horses* of 1941 (cat. 88) and in *Cuban Outlaw* of 1943 (cat. 89), two key mature works, Enríquez presents his vision of the island of Cuba. In the first painting, the landscape with

royal palms and stream doubles as a weeping eye, but it can also be interpreted as the female sexual organ, with the tiny horses representing the male element. Enríquez wrote about this painting to Alfred H. Barr, Jr., then the Director of New York's Museum of Modern Art, which had acquired the work: "It is the end result of a series of watercolors I did with the aim of proving that the Cuban palm tree is not simply a postcard motif or that of a turn-of-the-century painting, but also has infinite aesthetic possibilities."[20] In *Cuban Outlaw*, as in related paintings, Enríquez seems to have given the bandit his own face. The desperado's horse doubles as the body of a woman. Indeed, even the leaves of the surrounding tropical plants suggest parts of the female anatomy.

Enríquez's use of the metamorphosed horse-woman parallels an image in a work by Lam of the same period. There is no evidence of direct influence by either artist on the other. As Julia P. Herzberg discusses in her essay in this catalogue, Lam's *Femme cheval* series probably relates to the beliefs of the syncretistic Afro-Cuban Santería religion. This may not be the case for Enríquez, although he was no doubt familiar with the idea of spiritual possession of a devotee, who thus becomes the deity's "horse." Enríquez often dealt in harsh realities; starving peasants, rural violence, and machismo, for example, recur in his works.

A friend of the Afro-Cuban poet Nicolás Guillén (whose books *El son entero* and *Elegía a Jesús Menéndez* he illustrated), he had a special fascination with Afro-Cuban life and legends. In 1945, he took an extended trip to Haiti, where he had a solo exhibition at the Centre d'Art. That stay further stimulated interest in African contributions to Caribbean culture. *The Mahogany Tree in the Garden* of 1946 (cat. 90) depicts the dark trunk of a mahogany tree in a garden. The tree is transforming into a black woman, complete with breasts and other female anatomical attributes. As in *Cuban Outlaw*, the vegetation itself takes on an erotic character. The whole atmosphere, created with transparent veils of green, appears suffused with drenching tropical humidity. Diego Rivera, who befriended Enríquez in 1943, wrote in his introduction to a major solo exhibition of Enríquez's work in Mexico City: "The essential quality is the rootedness in the Cuban soil. Humid heat and perspiration that makes the colors run like a woman's mascara during lovemak-

ing...the whole sad tragedy of a semi-colonial Indo-Afro-Ibero America."[21]

In her search for a Cuban ethos, Amelia Peláez del Casal (1896–1968) was inspired by the life of the mainly white Cuban bourgeoisie, the milieu in which she was raised.[22] A distinguished graduate of San Alejandro, Peláez made the almost-obligatory pilgrimage to Paris, where she stayed from 1927 to 1934. She became interested in the Cubism of Picasso, Braque, and Léger, and studied with the Russian Constructivist Alexandra Exter. While in Europe, she began to appreciate the artistic potential of her Caribbean heritage. Very soon after her return to Cuba, the artist began painting voluptuous Cubistic still-life paintings featuring Caribbean fruit and flowers such as the papaya, mamey, guanabana, and hibiscus. *Still Life in Red* of 1938 (cat. 97) is an example from this series. Peláez also created a series of drawings of popular themes such as women sewing, *guajiros* playing cards, and *guajiras* napping under ceiba trees.

By the late 1930s, Peláez had assimilated Cubism and was creating Cubist-based renditions of the forms of traditional Cuban colonial architectural and decorative motifs such as stained-glass fanlights, iron grillwork balconies and window guards, and baroque columns and capitals. Interiors with wicker furniture, elaborate knickknacks, and crafts products such as lace doilies and embroidered tablecloths were also similarly used by the artist. *Fishes* of 1943 (cat. 98) and *Fruit Dish* of 1947 (cat. 99) exemplify the artist's Cubist-inspired breakup of Cuban forms and colors into faceted planes and their kaleidoscopic reconstruction.

In addition to innumerable still lifes, Peláez also painted women alone or in pairs, usually in settings reminiscent of the surroundings she shared with her widowed mother and her sisters. In her still lifes of flowers and fruits and in her studies of women napping, reading, or engaged in household tasks, there is a subtext of feminine sexuality. Rounded, womblike forms abound. *Still Life in Red*, *Fishes*, and *Fruit Dish* are metaphors for feminine sensuality and wholeness as well as celebrations of the Cuban essence.

Peláez's single known excursion into Afro-Cuban culture is *Diablito* of 1937 (cat. 96). Like the case of Víctor Manuel, this masked figure with its peaked hat, *maraca*, and bagpipes recalls (and may be based on) nineteenth-century prototypes. Constructed with Cubistic planes and curves, this elegant blue, black, brown, and white figure was created for a 1937 exhibition on the dance at Rockefeller Center in New York.

Peláez's art can be seen as a response to the ever-increasing Americanization of Cuban life in the twentieth century. Secluded in her quiet family home with its enclosed garden in the Havana suburb of La Vibora, the artist turned inward and to the past for an affirmation of the Cuban spirit. Many visitors to the Peláez home noted that it seemed frozen in time, out of another age.

The curious figure of Fidelio Ponce de Leon (1895–1949), the pseudonym of Alfredo Fuentes Pons, might appear at first glance to have little to do with the other artists included here.[23] Born into the bourgeoisie of the provincial town of Camaguey, he attended the Academia de San Alejandro in the teens, but he did not participate in the avant-garde activities of the 1920s and did not have his first one-person exhibition until 1934. In 1938, he had a well-received solo exhibition in New York, at Alma Reed's Delphic Studios.

Ponce de Leon's expressionistic work is almost devoid of color. Off-white, gray, and brown predominate, and pale blue and pink appear occasionally. In his canvases, rapidly and loosely applied brush and palette-knife strokes predominate, with occasional refined, if sketchy details such as facial features. Ponce's subjects are usually sickly women and children, and religious figures that have a remote, mystical aura. *First Communion* of 1935 (cat. 100) and *Saint Ignatius of Loyola* of 1940 (cat. 101) demonstrate the otherworldly, hallucinatory bent of his work, which recalls Edvard Munch or James Ensor. *Saint Ignatius of Loyola* is based on a poem by Federico García Lorca in which the founder of the Jesuits stabs a rabbit and the animal's cry continues to reverberate from the bells of Spanish churches.

Ponce de Leon had allegiances to both tradition and innovation. He was a virulent opponent of the academy and some of its professors, but he revered Spanish masters of the past, especially El Greco and Murillo. He also respected the academic master Leopoldo Romañach. Many of Ponce de Leon's paintings, although they are executed in a modernist style, have qualities of academic art. These qualities are evident in the handling of the richly painted surfaces and in the compositions, and especially in the subject

matter. The melodramatic sick-bed scenes, ladies going to church, and religious images favored by Romañach, for example, are also prominent in Ponce de León's work. Many of his paintings reflect both traditional Cuban rituals and devotions and the contemporary problems of underdevelopment, poverty, and disease. He led a bohemian life of economic want, alienation, and illness. He died of tuberculosis. A resident of flop houses and a witness to the political and economic troubles of Cuba in the 1930s, Ponce de Leon did not live in an ivory tower. Walker Evans's poignant photographs of Depression-era Havana reiterate the truthfulness of Ponce de León's bleak vision.[24] Ponce de Leon never left Cuba. Although he made little effort at self-promotion, he received the praise of Alfred H. Barr and of Wifredo Lam's French dealer, Pierre Loeb, who spent World War II in exile in Cuba.

The Afro-Cuban sculptor Teodoro Ramos Blanco (1902–1972) studied at San Alejandro and graduated in 1928.[25] The winner of a national competition to make a sculpture to honor Mariana Grajales, the mother of Antonio Maceo, an Afro-Cuban hero of the War of Independence, he left for Rome to carve the monumental statue and remained in Europe until 1936. For many years during the 1920s a policeman, soon after his return to Havana he received a professorship at San Alejandro. During the 1930s and 1940s, Ramos Blanco was the best-known Cuban sculptor in both Europe and the United States. He won a gold medal at the 1929 Seville Exposition and participated in the 1940 American Negro Exposition in Chicago. Although Ramos Blanco never really rebelled against the academy, his psychologically insightful Rodinesque sculpture and his dedication to black themes allied him with the first-generation modernists. Far from treating his subjects in a picturesque or anecdotal manner, Ramos Blanco sought to emphasize the physical attributes of Afro-Cubans, thus proudly affirming their identity. He often utilized rare native wood, as in *Old Negro Woman* of 1939 (cat. 106).

Ramos Blanco had strong ties to the "Harlem Renaissance." He was friendly with poet Langston Hughes, whose bust he sculpted (cat. 107), and he corresponded with the scholar and collector Arturo Schomburg. In addition to his movingly honest portrayals of anonymous Afro-Cubans, Ramos Blanco also created busts and statues of Antonio Maceo. He traveled to Haiti, where he was commissioned to make memorial statues of King Christophe and Alexandre Petion.

The Second Generation

The so-called "generation of 1927" supported the reformist, modernist goals of the *Revista de Avance* intellectuals. These young artists, who achieved prominence in the late 1930s and early 1940s, had ties to another group, which was led by the poet and novelist José Lezama Lima, the sculptor Alfredo Lozano, and other writers such as José Rodríguez Feo, Father Angel Gaztelu, Cintio Vitier, Eliseo Diego, and Gaston Baquero.[26] These intellectuals were responsible for the "little" literary magazines of the period—*Verbum* (1937), *Espuela de Plata* (1939–41), *Nadie Parecia* (1942–44), and *Origenes* (1944–56). The long-lasting *Origenes* devoted most of its covers to artwork by virtually all the principal first- and second-generation modernists and included line illustrations and reproductions of their paintings in its pages. These literary magazines published reviews and articles on the Cuban artists. Along with the *Gaceta del Caribe*, which included among its editors Nicolás Guillén, they served a crucial function. As *Revista de Avance* had done, they brought together the Cuban avant-garde and placed it in the context of international currents. What became known as the Grupo Origenes was characterized by the hermetic, baroque style of its most eminent member, José Lezama Lima. But cultural nationalism, including the Afro-Cuban contribution, also received its due. For example, *Origenes* published Robert Altmann's seminal essay on Amelia Peláez and her transformation of colonial architectural elements and lengthy pieces by and on Lydia Cabrera and her folkloric research,[27] and *Gaceta del Caribe* published an important essay by Alejo Carpentier on Wifredo Lam.[28]

During the period from 1938 through 1952, the artists discussed above reached their full flowering. It witnessed the emergence of the critic—curators Guy Pérez Cisneros and José Gómez Sicre—and the beginning of a serious historical analysis of the evolution of Cuban art history, especially modernism. Cuban art began to receive international attention through the spring 1944 exhibition "Modern Cuban Painters" at The Museum of Modern Art in New York, the publi-

cation of a lavishly illustrated accompanying catalogue, and favorable essays and reviews by Alfred H. Barr and *New York Times* critic Edward Alden Jewell. From 1945 to 1952, major group exhibitions were held in Moscow (1945), Port-au-Prince (1945), Guatemala City (1945), Mexico City (1946), Buenos Aires (1946), Stockholm (1949), São Paulo (1951), Paris (1951), Venice (1952), and Washington, D.C. (1945, 1949, and 1952). The Museum of Modern Art's purchase of representative works by most of the first- and second-generation modernists—accomplished through the Inter-American Fund and donations by Edgar J. Kauffman, Jr. and a Cuban private collector—was a further vindication of those artists and their supporters. United States collectors visiting Cuba acquired paintings, and at the same time, solo exhibitions by Peláez, Mario Carreño, Martínez-Pedro, Mariano Rodríguez, and René Portocarrero in New York galleries were further increasing awareness.

During this period, Cuba was politically and economically a stable, prosperous, and hopeful country. The Platt Amendment had been abrogated in 1934, a new, enlightened constitution was adopted in 1940, and World War II led to a small economic boom. The second-generation modernists flourished in a positive environment that differed considerably from the civil turmoil and economic depression that characterized the late 1920s and most of the 1930s. Although local support for the arts continued to leave a great deal to be desired, the energetic exhibition program of the Lyceum, a women's cultural organization founded in 1929, together with the art patron María Luisa Gómez Mena and her Galería del Prado in Havana (1942–44), helped keep the artists in the limelight. In addition, the example set by the preceding artistic generations and the nurturing provided by the "little" magazines and their writers led to the rapid emergence of Cundo Bermúdez, Mario Carreño, Roberto Diago, Luis Martínez-Pedro, René Portocarrero, and Mariano Rodríguez as major contemporary figures.

Cundo Bermúdez, who was born in 1914 and now lives in San Juan, Puerto Rico, studied diplomacy and social sciences at the University of Havana in the 1930s, but he soon discovered his true vocation was painting.[29] He briefly attended San Alejandro and in 1938 went to Mexico, where he attended drawing classes at the Academia de San Carlos. This sojourn in Mexico, where revolutionary artistic developments

were occurring, was to have a great impact on Bermúdez. Upon his return to Havana, the artist worked on color separations for a magazine, enhancing his knowledge of color variations.

Cundo, as he is commonly referred to, acknowledges the stimulus of Amelia Peláez on both his style and imagery. *The Balcony* of 1941 (cat. 78), *Barber Shop* of 1942 (cat. 79), and *Musicians* of 1943 (cat. 80) contain fanlights, grillwork, and columns that are suffused with loud primary colors. But Cundo is less interested in formal reconstruction then Peláez, often to the point of abstraction, and prefers a more down-to-earth, faux-naive interpretation of popular life. His vignettes have elements of humor and fantasy, such as bizarre and outlandish musical instruments and household utensils. His figures are appealing, long-

8
Romeo y Julieta
Cigar box cover, 20th century
Private Collection

9
Cundo Bermúdez
Romeo y Julieta. 1943
Oil on canvas
Private Collection

nosed men and women, who are often subtle self-portraits.

In *Romeo y Julieta* of 1943 (figs. 8 and 9), the artist has adapted a garishly colorful cigar-box label, representing the legendary lovers at their Verona balcony differently from his source. Here Romeo and Juliet are in a Cuban setting of lush vines, iron grillwork, and elaborate *mamparas*, the colonial half-doors that provide both privacy and ventilation. With a touch of bawdy humor, the artist has portrayed the couple in all their nakedness. The scene retains some of the compositional motifs and the vivid color scheme of the original.

Cundo is of Spanish stock, but his ocher-skinned Cubans, like those of Víctor Manuel, seem to be intentionally nonspecific racially and recall the mulatto and mestizo backgrounds of so many of the island's inhabitants. During the 1950s, the artist incorporated Abakuá pictographs into his images of drum-playing musicians.

Mario Carreño, who was born in 1913 and now lives in Santiago, Chile, was a precocious child; he attended San Alejandro at the age of twelve in 1925 for barely a year and then taught himself, working as a retoucher and illustrator for various Havana newspapers and magazines.[30] In 1930, he had his first exhibition, which consisted principally of drawings of workers processing sugar cane. Sugar cane, the mainstay of the Cuban economy, was heavily dependent on the United States and was thus a source of controversy.

Carreño lived in Spain from 1932 to 1935. During these years of the Spanish Republic, he illustrated the poet Rafael Alberti's journal *Octubre* and created posters and other works with socio-political content. He returned to Cuba in 1935 and the next year left for Mexico, where he studied with the Dominican artist Jaime Colson and familiarized himself with the accomplishments of the muralists. From 1937 through 1939, Carreño was in Paris and in Italy, where he developed a style inspired by the early Italian Renaissance, Picasso's classical period, Surrealism, and Pompeian frescoes. World War II forced the artist to leave Europe for New York. There he had the first of several well-received solo exhibitions at the Perls Galleries in 1941. Carreño and Wifredo Lam were the best-known Cuban artists in New York during the 1940s.

The artist returned to Cuba in 1942 and soon became a leader of the younger generation. He mar-ried the patron of the arts María Luisa Gómez Mena and was host to Alfred H. Barr and Edgar J. Kauffman, Jr. during their collecting trip for The Museum of Modern Art in the summer of 1942.

Carreño had been deeply interested in African themes and *diablito* images since at least 1937, when he was commissioned to do a carnival poster for the city of Havana,[31] and during the 1940s he developed this involvement further. Two paintings, both titled *Afro-Cuban Dance*, of 1944 (cat. 83) and 1943 (fig. 10), feature *diablitos*. In 1943, the artist also painted a detailed Abakuá initiation room, complete with drums and pictographs (fig. 11).[32] Following the lead of Peláez, Carreño used colonial architecture and decorative motifs in his pictures. In Cuba, Carreño's palette brightened, and his lyrical expressionist buxom figures and voluptuous still lifes reached a maximum of intensity. *The Tornado* of 1941 (cat. 81) and *The Palm Grove* of 1947 (cat. 84) demonstrate Carreño's assimilation of Cubist fragmentation and his vision of a Cuban reality that ranges from the chaotic to the harmonious.

In 1943, the Mexican muralist David Alfaro Siqueiros spent several months in Cuba. Carreño and his wife befriended him and commissioned him to make a duco mural for their apartment. Carreño had worked with duco during his stay in Mexico in 1936, and this renewed exposure to the medium led to a series of large wooden panels. The drawing for one of these panels, *Sugar-Cane Cutters* of 1943 (cat. 82), reflects the artist's continued interest in Cuba's main resource. Muscular and oversized to the point of appearing deformed, the figures in *Sugar-Cane Cutters* recall Siqueiros both in their style and in their aggressive, nationalistic forcefulness.

Roberto Diago (1920–1957) graduated from San Alejandro in 1941.[33] Of African descent, he shared with Wifredo Lam a fascination with African and Afro-Cuban forms and the spirituality inherent in them. Although he did not have the advantage of European apprenticeship, Diago's style is the result of his knowledge of Cubism and Surrealism. Because of this European influence, their shared heritage, and a common thematic interest, Diago has sometimes been viewed merely as a follower of Lam. But although Lam's impact on Diago cannot be discounted, Diago's work possesses an individuality that was recognized in Cuba and abroad. *Still Life* of about 1946 (cat. 85) and

10
Mario Carreño
Afro-Cuban Dance. 1943
Duco on wood
Collection unknown

Birds of 1946 (cat. 86) differ considerably from Lam's works of the same period. Perhaps the major difference between the fantastic interpretations of Afro-Cuban myth and magic that appear in these two artists' works is Diago's far more abstract pictorial language. Lam himself denied any resemblance between his work and that of Diago, noting, "Before anything else, he was Diago."[34]

Luis Martínez-Pedro (1910–1989) studied briefly with Víctor Manuel García and, in 1932, at the Arts and Crafts Club in New Orleans.[35] In 1941, he worked in Mario Carreño's studio. Like Diago, Martínez-Pedro emerged during the early 1940s as an outstanding draftsman. Influenced by the meticulous detail of Dürer and other German masters, his early drawings are Surreal compositions depicting figures from Greek myth. By the mid-1940s, he had begun to create pen-and-ink and pencil drawings relating to a largely fanciful pre-Columbian Caribbean mythology. *Giadrunama and the Bird* of 1945 (cat. 94) exemplifies the *cemis* (idols), creation legends, and heroic chieftains derived from the Taino heritage of Cuba and nearby islands that Martínez-Pedro depicted. The artist took the liberty of elaborating on the few accounts of the Conquest in Cuba and Hispaniola that were preserved at the time. While other modernists were content to portray pre-Columbian survivals as they existed below the surface of *guajiro* culture, Martínez-Pedro was the only artist to overtly acknowledge and seek inspiration in Cuba's forgotten past.

During the late 1940s, Martínez-Pedro turned to Afro-Cuban themes, creating a series of *cuarto fambá* (or Abakuá sacred-room) drawings and paintings that show groups of *diablitos*, often with drums and other instruments (fig. 12). As they did for Carreño, Martínez Pedro's several solo exhibitions at the Perls Galleries brought him favorable recognition on the part of New York critics and collectors throughout the decade of the 1940s.

Born in the decayed aristocratic Havana suburb of El Cerro, René Portocarrero (1912–1985) studied at San Alejandro for one year (1926–27) but was dissatisfied with its archaic methods.[36] In 1937, he participated as an instructor in the year-long experiment of the Estudio Libre de Pintura y Escultura which was conceived as a radical alternative to the academy and directed by Eduardo Abela, one of the leaders of the "generation of 1927." He contributed numerous illustrations to the "little" magazines of the period and was especially close to the *Orígenes* writers, especially José Lezama Lima and Father Angel Gaztelu. In 1941, he illustrated Lezama Lima's *Enemigo Rumor* and he later illustrated that author's magnum opus, *Paradiso* (1968). Portocarrero's baroque sensibility was a natural counterpart to the dense convoluted prose and poetry of Lezama Lima.

Portocarrero explored urban and rural themes. Of Spanish descent, he was equally at home with the rich nineteenth-century colonial heritage—including its element of pious mysticism, which also inspired Ponce—as he was with Afro-Cuban and *guajiro* life. The critic Guy Pérez Cisneros noted that Portocarrero represented a convergence of Spain, Africa, and Indo-America in the centrally located "Atlantic" island of Cuba.[37] The artist's *Cerro Interior* series of 1943 (cat. 102) is a nostalgic rumination on his memories of childhood. He was another young artist who followed in the steps of Amelia Peláez in his use of the somewhat-forgotten baroque forms and colors of colonial Cuba. Portocarrero was a master of excess; his curlicues, finials, stained glass, tiled floors, and gin-

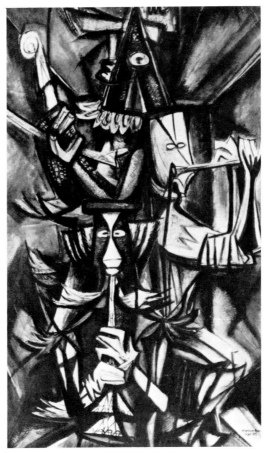

gerbread screens are the antithesis of architectural and decorative styles imported from the United States and Europe during this period of streamlined reductivism. Even the inhabitants of these Cerro interiors differ from the 1940s Hollywood ideals popular in Cuba. They are the solid, frumpishly attired women of the bourgeoisie. Like Carreño and Cundo Bermúdez, Portocarrero's *horror vacui* is closer to folksy exuberance than it is to the more cerebral compositions of Peláez.

A 1944 visit to the countryside led to a series of landscapes described by the artist as follows: "My *guajiro* landscapes were the result of a few days' visit to the Valley of Viñales (Province of Pinar del Rio). I went into a kind of ecstasy in front of the natural beauty, which translated into paintings in which the import of the countryside forcefully manifests itself."[38] Like Carlos Enríquez's scenes of rural violence, Carreño's *Tornado*, and Wifredo Lam's *The Jungle*—all paintings of the early 1940s—Portocarrero's landscapes are not bucolic or idealized; instead, they are often filled with danger and inhuman forces. The *paisaje* included here is not a peaceful scene. A small red devil on a donkey approaches their *bohío*, as a

man and woman, watched by their neighbors, flee down a path. Looming in the foreground is a ceiba tree, sacred in Afro-Cuban folklore. This painting is based on a *guajiro* legend that is part of oral tradition; it tells of a happy family whose existence is disrupted by the sudden appearance of the devil.

In 1945, Portocarrero created a series of *brujos* or *babalaos* (Afro-Cuban priests). The *Brujo* (cat. 104) in this exhibition shows a figure with a peaked headdress and two attributes of Santería, a sacrificial rooster and an arrow. Related examples depict figures bedecked with feathers and other regalia and engaged in ritual dances. Later in his career, in 1962–63, Portocarrero painted individual *diablitos* as well as deities from the Santería religion.

After a very short time at San Alejandro, Mariano Rodríguez (1912–1990) traveled in 1936 to Mexico, where he studied at the Academia de San Carlos with Manuel Rodríguez Lozano.[39] He also studied fresco with Pablo O'Higgins. In 1937, he joined the faculty of the Estudio Libre. Mariano, as he signed his works and is usually referred to, was an editor of *Espuela de Plata* and *Orígenes* and illustrated José Lezama Lima's

11
Mario Carreño
Cuarto fambá. 1943
Gouache on paper
Collection unknown

12
Luis Martínez-Pedro
Músicos. 1948
Private Collection

book of poems *Enemigo Rumor* of 1941. His work revolves around three major themes: roosters, *guajiros*, and lovers. The rooster is a Cuban symbol par excellence. It is the most common sacrificial animal in Santería rituals, and it is also part of *guajiro* culture, serving in the cockfights that are among the few communal entertainments in the countryside. Such a cockfight was also the subject of a lithograph by Mialhe in the nineteenth century.[40] In Cuba, the rooster is traditionally associated with virility and pride. The artist wrote about his obsession with roosters: ". . . the rooster is an element that is a national symbol. It wakes everyone up with its song and gets things moving. He is the master of the yard. The rooster helped me break with rigidity in drawing and allowed me to reach a coloristic liberation, a search for the sensual, the voluptuous, that took me to the Cuban, national context."[41] For Mariano, his loudly colored roosters were an affirmation of Cuban nationhood and pride.

The Cuban artists of the first two modernist generations successfully challenged the academy and its notion of an art remote from Cuban myth and reality. This challenge was also aimed at upper- and middle-class patrons of native academic artists and their European counterparts. The turn-of-the-century Spaniards Sorolla and Zuloaga were as far as these patrons dared to go. Modern art, particularly in its role as a vehicle for the authentic, non-kitsch expression of Afro-Cuban and *guajiro* values, verged on the subversive. At the academy, the modernists were anathema, even though many of them had studied there; indeed, Ramos Blanco was a professor. Paradoxically, the modernists were subverting accepted attitudes and mores by rescuing vital, repressed elements of the traditional Cuban ethos.

The modernist artists responded to European innovations and created styles that represent an intelligent assimilation of them and are also expressions of Cubanness. They were faced with the United States' political, economic, and cultural influences, with a largely apathetic bourgeoisie, and with an unsettled socio-political climate, and this synthesis was the most appropriate response available to them. They lacked government support, and it was primarily the nurturing presence of writers, poets, and politically *engagé* intellectuals that enabled the artists to flourish from the 1920s through the 1940s.

Although they de-emphasized its socio-political content and fervor, United States critics were generally accurate in their assessments of the issues in Cuban modernism. Alfred H. Barr developed a particular fondness for this art. He wrote about it in his essay for the April 1944 *Museum of Modern Art Bulletin*: "There is almost no painting of the Cuban scene comparable to our often literal or sentimental painting of the American scene and there is little obvious regional and nationalistic feeling. Cuban color, Cuban light, Cuban forms, and Cuban motifs are plastically and imaginatively assimilated rather than realistically represented."[42] In his review of the 1944 Museum of Modern Art exhibition "Modern Cuban Painters," the *New York Times* critic Edward Alden Jewell noted: "Though each artist is seen to have developed an individual style, there are certain traits in common, most conspicuous among these being a joyous use of brilliant color. Often no attempt is made to build up a complex palette, artists being quite content with just the primaries. Pretty consistently, besides, the work looks Cuban—this despite the fact that alien influences cannot be missed. Modern Cuban artists have not, it is evident, been unaware of the Ecole de Paris. Some of them have borrowed freely from that source and from others. Yet it is very gratifying to find such borrowings assimilated, absorbed, adapted, not just self-consciously superimposed upon the native product."[43] Like Barr, Jewell preferred to see Cuban modernism as the result of transformation, not derivation, with the indigenous elements accounting for the decisive originality of this art's style and content.

Most Latin American writers fully understood the implications of Cuban modernism. In his introduction to a Cuban exhibition held in Guatemala City in 1946, Luis Cardoza y Aragón contrasts it to the "academicism and superficial, picturesque Indianism" of Guatemala painting, a symptom of greater socio-political malaise: "The young painting of Cuba is clearly distinguishable from all other painting in the Americas. If it were Mexicanized, Europeanized, or childishly Cubanized, it would lack importance and its possibilities be minor ones. It has learned to use the color and the warmth of the sweet land, and also the sensuality and rhythm. And it is achieving this with audacity and truth, reaching for the hidden recesses of its body and soul."[44]

To those who are unfamiliar with Cuban art, Wifredo Lam's international fame—fueled by his

friendships with Pablo Picasso, André Breton, the Surrealists, and other avant-garde artists—has long made him appear the only Cuban artist of any consequence. As we have seen, quite the reverse is true.

In many aspects, Wifredo Lam's life and work parallel those of his fellow modernists. After a short period at San Alejandro in the early 1920s, he left for Spain and later went to France. His direct contact with Cubism and Surrealism encouraged him to investigate his African heritage while still in Europe. After his return to Havana in 1941, he quickly rediscovered Afro-Cuban culture. Like his contemporaries, his artistic journey speaks of assimilation of European styles and transformation of them in the context of deep-rooted Cuban values. It is fitting that the artist painted a *diablito* in 1943.[45] That work can be placed in the context of different evolving representations of this quintessential Afro-Cuban symbol from the nineteenth century to the 1940s.

Lam's relationship with his Cuban contemporaries was a complex one, filled with the professional rivalries that are not uncommon among artists. That he was treated with respect and admiration soon after his return, especially after the creation of *The Jungle* and other paintings of the mid-1940s, is beyond question. The long list of prominent Cuban intellectuals who recognized the importance of this artist who had suddenly made his reappearance on the island is evident from Lam's bibliography. They include Fernando Ortíz, Lydia Cabrera, Guy Pérez Cisneros, Virgilio Piñera, Gastón Baquero, Alejo Carpentier, Marcelo Pogolotti, and Jorge Mañach. Also, Lam's admirable credentials, his ties to the dealers Pierre Loeb and Pierre Matisse, and his friendships with Picasso, Breton, and other luminaries could not help but impress the Cuban intelligentsia. It should be noted that while racist attitudes did exist in Cuba, they were, as we have seen, not as prevalent among intellectuals. The respect accorded Ramos Blanco and Diago and the poets Regino Pedroso and Nicolás Guillén, among others, testifies to this. Although Lam may have encountered racism after his return from Europe, he was welcomed by intellectuals and benefited especially from the moral and practical support of Lydia Cabrera.[46]

The first documented indication of tensions between Lam and his contemporaries occurred at the time of The Museum of Modern Art's exhibition "Modern Cuban Painters." Organized by Alfred H. Barr and José Gómez Sicre, it was largely financed by the independently wealthy patron María Luisa Gómez Mena, who had recently married Mario Carreño. Although Lam was accorded a chapter in the catalogue written by José Gómez Sicre and also financed by Mrs. Carreño, he refused to participate in the exhibition. Later accounts in biographies of Lam note that this abstention was due to the fact that this was an "official" government-sponsored effort.[47] In actuality, it was a private venture. Export duties were levied on the paintings by the Cuban government and the principal patron, Mrs. Carreño, was refused a United States visa to attend the opening.[48]

Writing to his dealer Pierre Matisse on April 18, 1944, Lam explained that his conduct had nothing to do with The Museum of Modern Art or Alfred H. Barr.[49] He did not criticize his fellow artists and indicated his agreement with Barr's laudatory essay in the *Museum of Modern Art Bulletin*. He alleged that the negative personal and professional attitude of Gómez Sicre toward him was the sole reason for his actions. Lam regretted that his refusal to participate in The Museum of Modern Art exhibition prevented the showing of *The Jungle* in this important venue. In retrospect, it is clear that inclusion of Lam and *The Jungle* in "Modern Cuban Painters" would have contributed to a more balanced, all-inclusive view of Cuban modernism.

It is evident that Lam did not wish to offend his contemporaries and was willing to cooperate when appropriate. At the end of 1944, he joined Ramos Blanco, Enríquez, Portocarrero, and several other artists on an anti-Franco committee.[50] In 1945, 1947, and 1952, he contributed covers to *Origenes*, and he participated in a number of group exhibitions during that period, including one at the Centre d'Art in Haiti in 1945 and another major exhibit at the Musée d'Art Moderne in Paris in 1951. In 1948, Lam, along with most of his colleagues, was also a founder of the Agrupación de Pintores y Escultores Cubanos, and he exhibited with the group in 1949.[51]

We know that Lam was interested in the contributions of Ponce de Leon and Enríquez and visited these artists. As has been noted, Ponce de Leon had attracted the attention of Lam's Parisian dealer, Pierre Loeb. Of Enríquez, Lam later said in an interview: "He is the artist who, for me, best reflects Cuba, a *guajiro* Cuba."[52] In the same interview, Lam acknowledged

Footnotes

Amelia Peláez's evocation of the colonial past and called it "Cuban, but of the culture of the elite."

A telling footnote to the issue of Lam's relationship to his contemporaries appeared in 1953 in *Noticias de Arte*, a cultural magazine edited by Mario Carreño. Responding to an article by the Argentine critic Jorge Romero Brest in which Romero Brest expressed puzzlement at Lam's absence from the Cuban modernist representation at the Venice Biennial, an editorial note listed all of the exhibits the artist had refused to participate in from 1944 to 1952.[53] The note added that Lam had abstained "for very personal reasons," without going into further detail.

In all fairness to Lam, his long absence in Europe and his independent achievements made him an "odd man out" among his Cuban contemporaries and the cliques that dominated the island's intellectual life beginning in the 1920s. The only group loyalty he might have been expected to have, and did have, was to his Surrealist friends and colleagues. Despite related career experiences and similar goals, Lam saw himself, and was seen by others, as a figure who stood apart. Although he was proud of his interpretation of Afro-Cuban myth, he eschewed superficial regional and ethnic classifications and the trivialization of Cuban culture.

Ultimately, although a contextual approach in which common aesthetic ends are evaluated as part of a greater historical and cultural whole is useful, it is essential for the Cuban modernists—as it is for all artists—to be understood for their originality and individual contributions. Whatever the status of their feelings of solidarity might have been, it is certain that Lam and his Cuban contemporaries would have agreed on this point.

1. Guy Pérez Cisneros, *Características de la evolución de la pintura en Cuba* (Miami: Editorial Cubana, 1988), pp. 34–39.

2. Hugh Thomas, *Cuba, or the Pursuit of Freedom* (London: Eyre and Spottswode, 1971), pp. 109–55.

3. Guy Pérez Cisneros, *Características de la evolución de la pintura en Cuba*, pp. 52–63.

4. Ibid.

5. Ministerio de Cultura, *Pintura española y cubana y grabados cubanos del siglo XIX*, exh. cat., Museo del Prado (Madrid, 1983), pp. 77–122.

6. Fernando Ortíz, *Nuevo catauro de cubanismos* (Havana: Editorial de Ciencias Sociales, 1974), pp. 273–74.

7. Levi Marrero, *Cuba: economía y sociedad* (Madrid: Editorial Playor, 1978), Vol. 1, p. 160.

8. See Fernando Ortíz, *La fiesta afrocubana del "Día de Reyes"* (Havana: El Siglo XX, 1925).

9. *Diablito* was the name commonly given to individuals in African-derived costume who participated in the *Día de Reyes* and other festivals. Not all *diablitos* belonged to the Abakuá or Ñañigo secret society, but those with the peaked headdresses usually did. The sect originated on the Calabar Coast of West Africa. See Lydia Cabrera, *La sociedad secreta Abakuá* (Miami: Ediciones C.R., 1970).

10. For a history of the academy and its artists, see Esteban Valderrama et al., *La Pintura y la Escultura en Cuba* (Havana: Editorial Les, 1953).

11. Hugh Thomas, *Cuba: The Pursuit of Freedom*, pp. 417–503.

12. For a useful chronology of the Cuban avant-garde from 1923 to 1938, see José A. Navarrete and Ramón Vásquez Díaz, *La Vanguardia*, exh. cat., Museo Nacional (Havana, 1988–89).

13. See Carlos Ripoll, *Indice de la Revista de Avance* (New York: Las Americas, 1969).

14. Dawn Ades et al., *Latin American Art* (New Haven: Yale University Press, 1989), pp. 319–20.

15. Lydia Cabrera, *Cuentos negros de Cuba* (Miami: Ediciones C.R., 1972), pp. 7–10.

16. Max-Pol Fouchet, *Wifredo Lam* (Barcelona: Ediciones Poligrafa, 1976), p. 188.

17. Other first- and second-generation artists who were members of the avant-garde and dealt with folklore and/or cultural nationalism include Eduardo Abela, Jorge Arche, Aristides Fernández, Antonio Gattorno, Alfredo Lozano, Felipe Orlando, Alberto Peña, Marcelo Pogolotti, Domingo Ravenet, Enrique Riverón, Lorenzo Romero Arciaga, Juan José Sicre, and Jaime Valls. For an excellent comprehensive study of the Cuban modernists and their goals, see Juan A. Martínez, *Cuban Art and National Identity: The Vanguardia Painters: 1920s–1940s*, Ph.D. dissertation (Florida State University, 1992).

18. Graciella Pogolotti et al., *Víctor Manuel*, exh. cat., Consejo Nacional de Cultura, Museo Nacional (Havana, 1969).

19. Graciella Pogolotti et al., *Carlos Enríquez, 1900–1957*, exh. cat., Consejo Nacional de Cultura, Museo Nacional (Havana, 1979).

20. Ibid., n.p. Translated by G. Blanc.

21. Ibid.

22. Giulio V. Blanc et al., *Amelia Peláez: A Retrospective*, exh. cat., Cuban Museum of Art and Culture (Miami, 1988).

23. Juan Sánchez, *Fidelio Ponce* (Havana: Editorial Letras Cubanas, 1985).

24. Gilles Mora, *Walker Evans: Havana 1933* (New York: Pantheon Books, 1989).

25. Esteban Valderrama et al., *La Pintura y la Escultura en Cuba*, pp. 243–45.

26. Conversation with Mons. Angel Gaztelu, Miami, February 1992.

27. Robert Altmann, "Ornamento y naturaleza muerta en la pintura de Amelia Peláez," *Origenes* (Winter 1945), pp. 7–14; Lydia Cabrera, "La ceiba y la sociedad secreta Abakuá," *Origenes* (spring 1950), pp. 16–47; this issue included a number of articles on or by Cabrera.

28. Alejo Carpentier, "Reflexiones sobre la pintura de Wifredo Lam," *Gaceta del Caribe* (July 1944), pp. 26–27.

29. Carlos M. Luis, *Cundo Bermúdez*, exh. cat., Cuban Museum of Art and Culture (Miami, 1987).

30. José Gómez Sicre, *Carreño* (Havana: Ediciones Galería del Prado, 1943); Mario Carreño, *Mario Carreño: cronología del recuerdo* (Santiago: Editorial Antartica, 1991).

31. Mario Carreño, *Mario Carreño: cronología del recuerdo*, p. 30.

32. José Gómez Sicre, *Carreño*, n.p.

33. Oscar Hurtado et al., *Pintores cubanos* (Havana: Editorial R, 1962), pp. 31–32, 150.

34. Gerardo Mosquera, *Exploraciones en la plastica cubana* (Havana: Editorial Letras Cubanas, 1983), p. 188. Translated by G. Blanc.

35. José Gómez Sicre, "Un dibujante de las Antillas," *La Revista Belga* (Feb. 1946), pp. 42–50; Vicente Báez et al., *La Enciclopedia de Cuba*, Vol. 5 (Madrid: Playor, 1975), pp. 202–03.

36. Ministerio de Cultura, *René Portocarrero*, exh. cat., Museo Español de Arte Contemporaneo de Madrid (Madrid, 1984).

37. Guy Pérez Cisneros, "Lo atlántico en Portocarrero," *Origenes* (spring 1944), pp. 45–46.

38. Ministerio de Cultura, *René Portocarrero*, p. 54. Translated by G. Blanc.

39. Museo Nacional, *Mariano: uno y multiple*, exh. cat. (Santa Cruz de Tenerife: Sala de Exposiciones Centro Cultural Cajacanarias, 1988).

40. Corporación Nacional del Turismo, *La pintura colonial en Cuba*, exh. cat. (Havana: Capitolio Nacional, 1950), n.p.

41. Marisol Trujillo, "Mariano a corta distancia," *Revolución y Cultura* (Jan. 1986), p. 45. Translated by G. Blanc.

42. Alfred H. Barr, Jr., "Modern Cuban Painters," *Museum of Modern Art Bulletin* (April 1944), p. 4. The artists in "Modern Cuban Painters" were Cundo Bermúdez, Mario Carreño, Roberto Diago, Carlos Enríquez, Víctor Manuel García, Felipe Orlando, Amelia Peláez, Fidelio Ponce de Leon, René Portocarrero, and Mariano Rodríguez. Also included were the naive artists F. I. Acevedo and Rafael Moreno.

43. Edward Alden Jewell, "Cuban Paintings on Display Today," *The New York Times* (March 17, 1944).

44. Ministerio de Educación Publica, *Exposición de Pintura Cubana Moderna*, exh. cat., Academia Nacional de Bellas Artes (Guatemala City, 1945), n.p.

45. See the catalogue essay by Julia P. Herzberg for a discussion of this painting.

46. In conversation with Wifredo Lam, Albisola Mare, Italy, June 1978; in conversation with Lydia Cabrera, Miami, May 1987.

47. Max-Pol Fouchet, *Wifredo Lam*, p. 252.

48. H. Felix Kraus, "Imports from Cuba: Verve at the Modern Museum," *Art News* (April 15, 1944), p. 21; Mario Carreño, *Mario Carreño: cronología del recuerdo*, pp. 52–56.

49. Letter to Pierre Matisse, April 18, 1944. Archives of the Pierre Matisse Foundation. I appreciate Julia Herzberg bringing this letter to my attention.

50. A.P.E.C. Manifesto, "Constituida la Agrupación de Pintores," *Diario de la Marina* (Nov. 27, 1948). In June of 1946, Lam also joined his fellow modernists in signing a withering manifesto aimed at "the gentlemen who bureaucratically paint academic pictures in our country." The academic artists had protested their exclusion from the important exhibit of that year in Mexico City. Courtesy of the Archives of the Art Museum of the Americas, O.A.S., Washington, D.C.

51. "Comité de artistas plásticos cubanos de ayuda al pueblo español," *Gaceta del Caribe* (Nov.–Dec. 1944), n.p.

52. Gerardo Mosquera, *Exploraciones en la plástica cubana*, p. 188 (Havana: Editorial Letras Cubanos, 1983). Translation by G. Blanc.

53. "Romero Brest habla de la pintura cubana en la Exposición Bienal de Venecia," *Noticias de Arte* (Jan. 1953), p. 6.

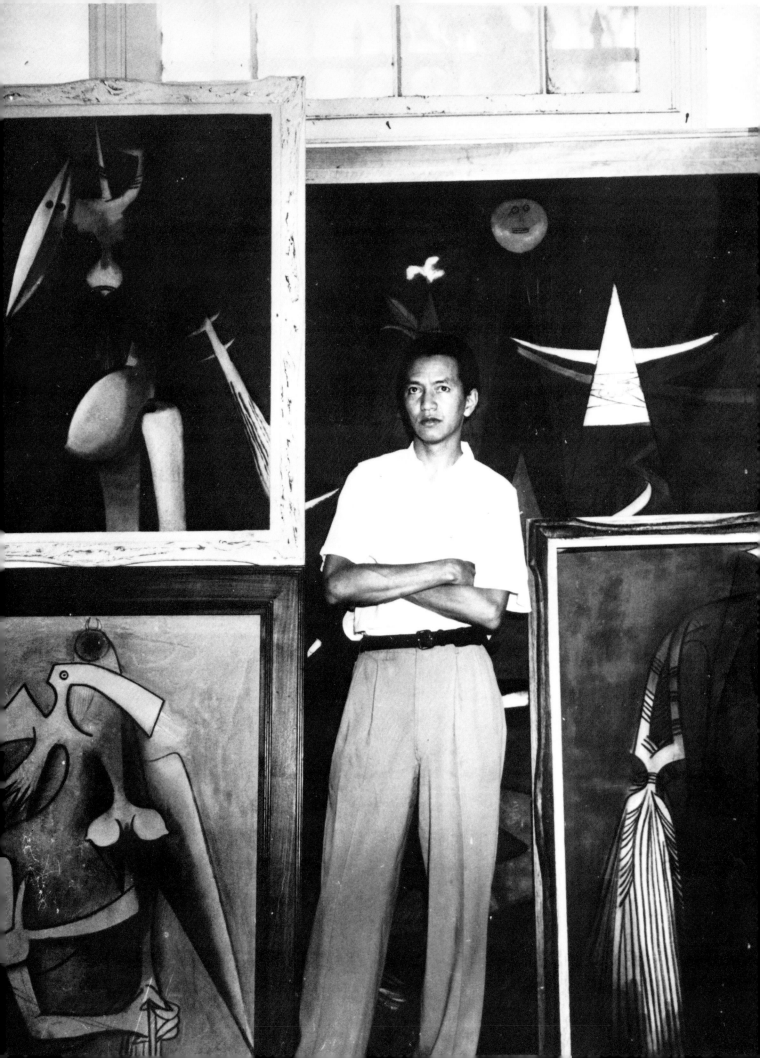

Myths and Primitivism: The Work of Wifredo Lam In the Context of the New York School and the School of Paris, 1942–1952

LOWERY STOKES SIMS
Associate Curator, 20th Century Art
at The Metropolitan Museum of Art

December 31, 1942

Very Dear Friend André:

You will find herein the envelope of a letter that I sent you several weeks ago which was returned to me a few days ago. Happily I'd received meanwhile your letter of October 22 which is most important for me, as it is proof of a deep friendship, and of the interest that you show for what I am in the midst of trying to do.

These paintings—as I said to you in my last letter—are the beginning of a long road I will pursue, and in which I hope to realize something that will justify my pretensions.

Matisse sent me...a very nice letter as well as the catalogue of the exhibition which is very beautiful. Your preface, dear André, is marvelous being at the same time so concrete and so subtle and poetic, that it surprises me that scarcely any journalists understood it.... Your titles are superb. They are very significant for me and I was greatly moved by them....At this moment I am so involved in the preparation of the large painting about which I spoke in my last letter, that I don't want to interrupt my work.

Many thanks for having put the gouaches in the exhibition of French relief for the benefit of children and French prisoners.[1] I would like very much to have the catalogue. You will find inside also the gouache for Peggy Guggenheim's museum. The colors are those of the Marseilles period, it is very possible they are in bad condition either from the voyage or other accidents. In this case, in my own interest, please propose an exchange to Peggy Guggenheim....

We regret that you are so occupied by work which is not your own. Perhaps later on you will be able to take to writing poetry. We wish you, dear friend, a happy new year. Be assured of our esteem and sincere affection.

Helena and Wifredo Lam[2]

This letter from Wifredo Lam and Helena Holzer to André Breton unequivocally demonstrates Lam's intention to maintain the aura of his burgeoning presence in the international art world while he was ensconced in his native Cuba during the Second World War. Initially, Breton acted on his behalf in New York, not only by writing about his work but also as Lam's intermediary with Pierre Matisse and also with others in the New York art world. Breton had met Lam in Paris in 1939, and he became the artist's friend and supporter. The Surrealist group, of which Breton was the leader, readily welcomed Lam as a kindred spirit. Breton and Lam escaped from France in 1941 to Martinique via Marseilles, and they parted company in May, 1941, when Lam returned to Cuba with Helena Holzer via St. Thomas and the Dominican Republic. Breton, with his wife, Jacqueline, and daughter, Aube, continued their trip, stopping over in Guadeloupe and the Dominican Republic and then arriving in New York in early July.[3] Breton was immediately in contact with the American Surrealist contingent, and Kay Sage, who was the cousin of the sculptor David Hare and later became Mrs. Yves Tanguy, lent him an apartment. In the fall of 1941, an interview between Breton and Charles Henry Ford appeared in *VIEW* magazine in which Breton described his first impressions of the United States and reaffirmed his Surrealist mission.[4]

In the meantime, Lam remained in the Dominican Republic for about a month and returned to Cuba at the end of July. He lived for a time in Havana and then settled into a house in Marianao, a suburb of that city. The paintings executed during the second half of 1941 and early 1942, such as *L'Attendu* and *La Langue maternelle* (see Herzberg, fig. 3), show a further evolution of the approach to form and space seen in the works done in Paris and Marseilles between 1938 and 1941. In *L'Attendu*, a seated figure leans on her chin, recalling the figures in *Personnage assis* (cat. no. 3), but in contrast to the three-dimensionality of the figures of 1938 to 1940, this figure dissolves into the background, melding with her environment. This stylistic change indicates developments to come in the works of late 1942, when Lam painted *The Jungle* (cat. no. 21). She is also curiously twisted in space so that while she faces us, her derrière is also visible. *La Langue maternelle* is closely based on a 1941 drawing Lam made in Marseilles; both have an awkward "trumpet" head, and in both, the mother's

Wifredo Lam in his studio. Havana. 1950
Schomburg Center for Research in Black Culture, The New York Public Library

hands interlock with the chin of the infant. *L'Homme à la vague* (cat. no. 16), *Déesse avec feuillage* (cat. no. 13), and *Les Yeux de la grille* (cat. no. 14) also exemplify works from 1942 in which there are elements that relate to the Marseilles drawings. These include a more virtuoso linearity, the exaggeration of form, and permutations of the first version of the "*femme cheval*" with differently articulated features—bulbous chin, sometimes with beards, multiple countenances with several pairs of eyes, and distinct snouts, fruit-shaped breasts, and expressive gesturing of hands and fingers.

Les Yeux de la grille, *La Langue maternelle* and *L'Homme à la vague* were among the fourteen paintings shown at the Pierre Matisse Gallery in November 1942. In the letter cited at the beginning of this essay, Lam alludes to the preface that Breton wrote for the brochure of this exhibition, in which Breton positioned Lam and Picasso at opposite ends of a continuum between primitive and civilized, meeting at the midpoint, at "the point of contact with . . . Picasso . . . who . . . had come to posit the necessity of a continual return to first principles in order to renew contact with the myth."[5] The titles of Lam's works in this exhibition evidence the mark of Breton's hand: *Oubli*, *La Chanteuse des poissons*, *L'Enfant et la miroir* are typi-

cal of the poetic ambiguity of Surrealist titles and writings. They evoke both the paintings of René Magritte and the early psychological studies of perception and self-image by Jacques Lacan and Pierre Mabille that appeared in the Surrealist journal *Documents* during the 1930s.[6] Only *Conte Colibri* makes any reference to the Antillean ambience in which Lam was now creating, and perhaps Lam's hesitation about the comprehensibility of such references to a New York audience is the reason he insisted that Breton replace his own "tentative" titles.[7]

The critical reaction to Lam's work, which he found "superficial," is typified by a review in *Art Digest*:

> Much under the influence of Picasso this young artist in whose veins runs both Chinese and Negro blood gives the spectator something to figure out as well as view. His ingenious creations, which belong to the "eye and angle" school, might be idols of ancient gods of modern mechanical devices, for in all of them may be perceived an assortment of all-seeing eyes peering out from unsuspected places and

1
Jackson Pollock
Pasiphaë. 1943
Oil on canvas
56⅛ x 96″ (142.6 x 243.8 cm)
The Metropolitan Museum of Art

sharp angles usually associated with tin and wrought iron. African masks have been a help, too.... Edward Alden Jewell, referring to the "picassolamming reverence" in Lam's work, suggests that...the symbols themselves might have been snitched from *Guernica* and set to the transforming music of Ravel."[8]

The reference to "Picassolamming," the title of this review, was not the first time that the identities of Lam and Picasso had been conflated in the American art press. A review of Lam's first New York exhibition at the Klaus Perls gallery in 1939, which appeared in the November 19, 1939, issue of *Art News*, described him as a "protege of Picasso...who now lives with him." His "flatly indicated figures ...seem to harken back faintly to Picasso's cubist phase." The reviewer concludes that "one feels in the young artist definite freedom in experimenting with forms. He has achieved considerate emotional quality...but it is in his potentialities of growth that he seems most remarkable."[9]

The titles of Lam's works in the next exhibition at the Pierre Matisse Gallery in 1944 became more specifically Afro-Cuban, including *La Sombre Malembo, Mofumbe, Ce qui importe, Anamú, Eggue Orissa, L'Herbe des dieux, L'Enchanteur*, and, of course, *The Jungle*. In her essay in this catalogue, Julia P. Herzberg notes that Lydia Cabrera eventually became involved in providing titles for Lam's work, which were often predicated on any associations Cabrera found in Lam's work that corresponded to her own research on Afro-Cuban religion and culture. Although *The Jungle* later became Lam's most famous work, reviews of the exhibition made no specific reference to it. Instead, a critic writing in the *Art Digest* singled out *Abeille Arcture*, triumphantly announcing her discovery of a thunderbird in the composition in spite of "the impossibility of making heads or tails of the symbolisms involved."[10] Critics also took note of the progression of Lam's imagery. The same *Art Digest* reviewer observed: "Lam's paintings heretofore have been filled with Picasso-like motifs (the horse-face, double profile, etc.). A return to Cuba, and an actual and renewed interest in that land, has produced a new kind of expression, one concerned with exotic plant growth, gods, and ties of African origin, practiced

today in Cuba."[11] The same writer also noted that Lam "has reached the point where his native West Indian inheritance takes precedence over the Africa via Paris strain which hitherto dominated his work.... There is a thoughtful quality to his work, a deep interlocking of forms, an experimental interest in textures which gives promise of what Lam has nevertheless not realized: an authentic integrated expression all his own."[12] Despite this assessment, many of the works shown in Lam's 1944 exhibition—which have since become among Lam's best-known mature works—show an adroit synthesis, unique to Lam's work, of African mask motifs in discontinuous Cubist space with inventive imagery based on the Surrealist *cadavre exquis*.

It becomes clear in retrospect that the pivotal time in Lam's career during 1942–43 coincides with artistic developments that were taking place in New York City, where a group of artists were also working with a new mythic imagery that was couched in a morphology that married Surrealist improvisation with Cubist structure.[13] The struggle to achieve this synthesis was impelled by the presence of artists such as André Masson and Matta (Roberto Sebastian Matta Echaurren), who imparted to the Americans some of the technical aspects of Surrealist picture-making, notably

2
Pablo Picasso
Les Demoiselles d'Avignon.
Paris (June–July 1907)
Oil on canvas
8' x 7'8" (243.9 x 233.7 cm)
The Museum of Modern Art

automatic drawing and spontaneous paint application through dripping and spattering.[14] The results of experimentations along these lines can be seen in *Collective Painting* by William Baziotes, Gerome Kamrowski, and Jackson Pollock (cat. no. 56), and in the richly appointed compositions of Richard Pousette-Dart, exemplified by *Abstract Eye* (cat. no. 73), and *Figure* (cat. no. 74). Pousette-Dart in particular sustained a commitment to the transcendental through the use of symbols that resonated with the correspondences that exist throughout history among various cultures. In 1943, Jackson Pollock created works such as *Pasiphaë* (fig. 1), and *Burning Landscape* (cat. no. 71), in which the process of painting resulted in an accumulation of glyphs that increasingly supplanted recognizable figuration. Lam's approach to painting in *The Jungle* exhibits repetitive curving movements and an intermeshing of plant, mask, and human forms that convey an energy comparable to that in Pollock's works, which supersedes the visual analogy that is usually cited for this painting, Picasso's *Les Demoiselles d'Avignon* (fig. 2).[15] Along with Pollock and Gottlieb, Lam arrived at a fully-developed mythic and totemic imagery in the early 1940s, and set the stage for similar manifestations in the work of other New York artists.

By 1945, references to Picasso had disappeared from reviews of Lam's work. During that year, *Art News* complained that the latest paintings were "anemic" and "mannered," and the color "thin and sparse, stippled around harsh black and white forms" that "peter out." In the "endless clusters of wings, bird legs, and glowering black-eyed buttons," the reviewer saw "an ornithologists' nightmare."[16] The writer was probably referring to works such as *Sur les traces* (cat. no. 38) and *Butinantes* (cat. no. 40), in which Lam had reduced his palette and application of paint to a minimum. The play on positive-negative space in *Sur les traces* in particular makes the forms appear to hover as if just appearing or about to disappear, suspended between states of being and non-being. This quality, indicative of Lam's tendency at mid-decade to increasingly dematerialize his forms, certainly seems tamer than the outwardly energetic gestural surfaces of Jackson Pollock. Lam's pictures relate to those of Matta, who at this time, in works such as *Et At It* (cat. no. 67) of 1944, was painting in layers of translucent films of color into which he traced linear patterns that suggest

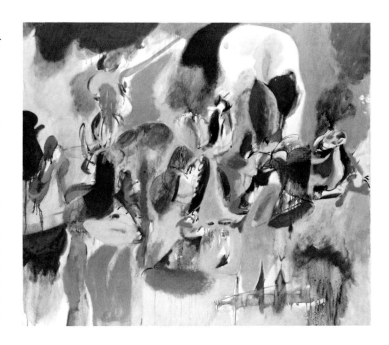

fluid ambiences. Lam's work also finds comparisons with Mark Rothko's delicate biomorphic watercolors of the period and with Arshile Gorky's concurrent works, such as *Water of the Flowery Mill*, also of 1944 (fig. 3).

In contrast to the niggling complaints in *Art News*, Margaret Breuning, reviewing the same 1945 exhibition at the Matisse gallery in *Art Digest*, perceptively defined Lam's distinctive position in the art world, noting, "While this is fantastic art, it is far removed from surrealism which seeks to destroy the visible world of our experience; the world that Lam creates is an end in itself, an occult, mysterious universe governed not by the laws that regulate our cosmos, but by some undercurrent of magic...[which]...makes itself felt in every canvas....There are recognizable forms...but they appear not so much realities as the symbols of an inner mystic existence."[17] Breuning was also attuned to the multiplicity of references in Lam's work. She observed in the work "the character of Chinese painting, of Primitive African art, and even...the symbolic figures of the Alaskan Indians. Yet these diverse influences...[are]...carried out in a highly personal ideology of artistic expression." Breuning also wrote an appreciation of Lam's handling of paint and singled out *La Parade Antillaise* (fig. 4) for its "soundly organized design."[18]

3
Arshile Gorky
Water of the Flowery Mill. 1944
Oil on canvas
42½ x 48¾" (107.3 x 123.8 cm)
The Metropolitan Museum of Art

Breuning's analysis of Lam's work is pertinent for its attention to the issues of the totemic and the occult, which were central in New York School ideology during that period. It is interesting that Lam clearly was not seen as another Surrealist progenitor to the New York School. This fact is affirmed in an article titled "A Way to Kill Space," which appeared in *Newsweek* magazine in August of 1946. The writer proclaimed that the "excitement of the 1946 season was provided by some of America's own young abstractionists who think they have found the long-waited 'new direction' in art.... The modernists insist that the new 'abstract art' is different from what has previously gone by that name." This work was variously called "imaginative abstraction" or "surrealistic formalism." The writer continued: "The young artists who are identified with the new trend paint abstractly but they do not, like School of Paris followers, abstract real objects and people. Instead, using the surrealists' method of free association, they evolve shapes, images and ideas out of the subconscious. Unlike the surrealists, however, they do not paint dreams, nor do they paint in literal representational styles."[19] Robert Motherwell, Lam, and Adolph Gottlieb are discussed as three artists who typify this new abstraction:

> For example, Robert Motherwell, a West Coast bank president's son, who at 31, is one of the youngest artists represented in the show of American art now in London, sometimes uses ominous black dots and precariously balanced shapes to express the premonition of danger. ... Wifredo Lam, 43, ... fills his canvases with strange winged creatures and voodoo gods which suggest rather than represent the mysteries of the jungles in his native Cuba. The paintings of Adolph Gottlieb, 43, who is also represented in the London show, look something like ancient hieroglyphics.... Gottlieb breaks up his canvases into rough rectangles. To those who still look for perspective in painting, the reason for this will come as a shock. "It's a device I use," says Gottlieb, "to kill space."[20]

Within four years, Lam had progressed from

being viewed in association with the exiled Surrealists to being considered part of the new art emerging in New York.[21] The *Newsweek* critic did not indicate which of Lam's work provoked his or her reaction. During the 1945–46 season (November 20–December 8, 1945), Lam exhibited at Pierre Matisse Gallery, and the writer was most likely referring to the same exhibition that the critic in *Art News* found "anemic."

From even the most basic formal analysis, it is already evident that Lam's work shared certain qualities with that of the New York artists.[22] But the business-as-usual attitude assumed by the *Newsweek* critic in including Lam among "America's own abstractionists" is surprising today, given the sharply demarcated national lines that have been enforced in the art world since the 1950s. Lam, for example, has been completely cast as a Latin American artist, to the exclusion of any consideration of his relationship to the School of Paris, much less to the New York School. During the 1940s, however, he was perceived as a member of a group of artists on the American art scene who were grappling with a new subject matter and

4
Wifredo Lam
La Parade Antillaise. 1945
Oil on canvas
49⅜ x 43¼" (125.5 x 110 cm)
Private Collection

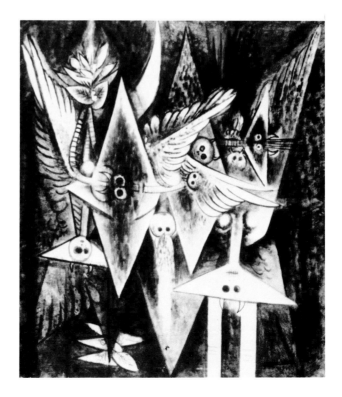

stylistic approach in their art.[23] Lam's position during that period was predicated on several factors. During the 1940s, there was certainly a great familiarity with the work of artists from Latin America in evidence in the American press. The spate of exhibitions of the work of artists from Central and Latin America that were held during the 1930s and 1940s in New York galleries, as well as surveys of pre-Columbian and Amerindian art in such institutions as The Museum of Modern Art in New York, provided a ready reception for artists from the southern hemisphere.[24] In the June 1944 review of Lam's work in *Art News*, it is observed that he "doesn't merely cut loose with the paint pots" as do "many of the Cubans."[25] The Cubans referred to here are probably the artists included in the exhibition "Modern Cuban Painters," which was shown at The Museum of Modern Art earlier that year. Lam did not participate, but Mario Carreño did, and he, like Lam, exhibited his work in New York during that time.[26] Compared to the more subdued surfaces of Lam's painting, the bright color and bold forms in Carreño's work (see cat. nos. 82 and 83) would suggest that he "cut loose with the paint pots."

The most convincing correlation between Lam's work and that of his North American contemporaries is their shared interest in mythic and totemic imagery. This mutually held involvement engendered an early communal sense of "Americanness," which is expressed in writings published by Barnett Newman during the 1940s. Much of the seminal thinking that accompanied the passage of American art into a new era can be glimpsed in Newman's essays and statements.[27] He articulated the basis for what was a widespread interest in non-European traditional art among artists and intellectuals, and—most interestingly for this discussion—many of those writings were done for *La Revista Belga*, which has been described as a "propagandistic wartime publication of the Belgian government aimed at South America."[28] Newman wrote about an exhibition of pre-Columbian stone sculpture that he had organized for Betty Parsons at the Wakefield Gallery,[29] about the exhibition organized at The Museum of Modern Art on the occasion of its fifteenth anniversary,[30] and about a comparative study of the work of the Mexican artist Rufino Tamayo (fig. 5) and New York artist Adolph Gottlieb (cat. nos. 62 and 63).[31]

In The Museum of Modern Art review, Newman applauded the absence of "isolationist, nationalist painters" in the exhibition and singled out the work of Tamayo and Matta as among the "good sampling of Latin American artists" in the show.[32] From this review, Newman developed his article "The Painting of Tamayo and Gottlieb," published in *La Revista Belga* in 1945, in which he observed that the two artists "have so many things in common that a critical study of the two men would help toward an increased understanding of their work."[33] Newman went on to say that "an analysis of their working aesthetics should give us a clue...to the attitude that ought to motivate our American artists and those art laymen who are concerned with the establishment of an 'American' tradition."[34] Newman's claim of a common tradition in North and South America is grounded in Gottlieb's and Tamayo's appreciation of "the great art traditions of our American aborigines....Only by this kind of contribution is there any hope for the possible development of a truly American art, whereas the attempts of our nationalist politics and artists, both in South and North America, have failed and must continue to do so."[35] Newman then noted the common "preoccupation with myth" on the part of both artists and ventured to see a similar palette based on earth tones.[36] Newman parlayed the concepts he explored in these earlier writings into the discussions in his essays "Northwest Coast Indian Painting" of 1946[37] and "The Ideographic Picture" of 1947,[38] in which he crystalized his analysis of the relationship of abstract painting to aboriginal art. In the Gottlieb and Tamayo essay, he discussed the "geometric designs" and abstract shapes in a flat two-dimensional space in their work that was used "to express a symbolic idea."[39] This work engendered a group of abstract artists in New York City called the Indian Space Painters, who adapted the flat, separated shapes of American Indian designs to their abstract compositions.[40]

That Newman, writing in the mid-1940s, could comprehend a commonality between the artistic explorations of North and South American artists is intriguing and indicates the non-alignment attitude that was pervasive in New York even before the end of World War II. In an article titled "Art of the South Seas," published in *Ambos Mundos* (the successor to *La Revista Belga*), Newman discussed another phenomenon that captivated the interest of New York artists, that of

magic.[41] What interested Newman about Oceanic art was its expression of "magic based on terror," a primordial sensibility that Newman—with Rothko, Gottlieb, and others—postulated for a new American art that was seeking to transcend narrative systems. Newman asserted that by grappling with terror, the Oceanic artist "developed a pictorial art that contained an extravagant drama—one might say theater of magic."[42] In reviews of Lam's work, critics perceived it as having been "painted under a kind of spell,"[43] as being full of the "dark mysteries of voodoo,"[44] or, as Margaret Breuning wrote, as depicting a mysterious world in which "the sinister power of the supernatural forces are set down in symbolic language."[45]

There are, however, important distinctions in their respective approaches to myth between Lam and these North Americans. While the Abstract Expressionists were widely engaged by Greek myths, often interpreted first through Freudian and later through Jungian ideas, Lam was primarily engaged by the African-based religion of Cuba, Santería. Like the Abstract Expressionists, Lam relied on Surrealism as well as Cubism to achieve a synthesis of idea and form.[46] The North American artists, however, for the most part cultivated more indeterminate forms, leaving them to suggest rather than delineate. Their use of primal symbology was also more improvisational than that of Lam, who through the mid-1940s worked from a specific and consistent iconography with a clearly recognizable symbology.

The implications of this engagement of totemic and mythic material were also different for Lam from those of the Abstract Expressionists. It is true that the Abstract Expressionists were engaged in a search for spiritual renewal—not merely by compositional effects—and that their appreciation of so-called "Primitive" cultures also posited a critique of western materialism and cultural imperialism.[47] During the 1920s, artist Marsden Hartley brought Native American culture to the attention of his contemporaries and declared the importance of establishing an American art based on the values of Native American culture.[48] The Abstract Expressionists responded to this call some twenty years later, but, in the final analysis, their attention to these cultures was only a temporary stop along their route toward an imagery that soon lost all overt references to its sources. This distinction must also be noted in light of Barnett Newman's previously

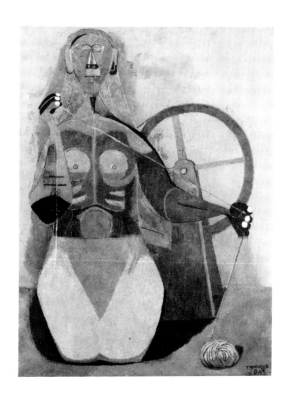

5
Rufino Tamayo
Woman Spinning Wool. 1943
Oil on canvas
42 x 33″ (106.7 x 83.8 cm)
Courtesy Mary-Anne Martin
Fine Art

discussed comparison between the work of Gottlieb and Tamayo. Tamayo, who was of Zapotec Indian heritage, was in a position comparable to that of Lam; both artists had an *a priori* relationship to the culture evoked in their art. The overtly political aspect of *Mexicanidad* or the celebration of indigenous Amerindian culture (of which Tamayo's work was a prime example) was inextricably linked to a renewal and reclamation of Mexican cultural identity.[49] Lam too was clearly devising a pictorial strategy to engage issues about his native culture, about the conditions of African peoples in contemporary Cuban society, as well as the debased economic and social position of blacks worldwide. As Lam himself said: "I . . . wanted to paint the drama of the negro spirit, the beauty of the plastic art of the blacks. In this way I could act as a Trojan horse that would spew forth hallucinating figures with the power to surprise, to disturb the dreams of the exploiters. I knew I was running the risk of not being understood either by the man in the street or by the others [the art world]. But a true picture has the power to set the imagination to work even if it takes time."[50] This statement relates to Mark Rothko's assertion that the work of the new generation of American artists is "of the

Earth, the Damned, and the Recreated," and creates "new hybrids from old myth."[51] But while the Abstract Expressionists could make such dramatic statements without fear of reprisals, Lam actually risked being ostracized both by the Cuban society into which he had just returned and by the larger world, in which the political condition of Africanized peoples was not to be resolved until the 1950s and 1960s. From this perspective, Lam must be considered one of the pioneers of African self-reclamation, the progenitor of an art that is comparable to the concept of *negritude* that impelled the poetry and politics of Aimé Césaire and Leopold Senghor, two of the originators of this philosophical and political stance.[52] By infusing a visual syntax with a mythic subject matter, Lam effected a profound reconciliation of structures of desire (self-affirmation) and actualization in the empirical world (self-liberation).

The change from Surrealist associations to New World mythic imagery can also be observed in how Lam was treated in artist-run magazines. Lam's work frequently appeared in *VVV*; the March 1943 issue illustrated *La Chanteuse des poissons*, which was exhibited at the Matisse gallery,[53] and his playing cards "Alice" and "Lautreamont" illustrated Breton's article on *Jeu de Marseilles* (cat. no. 117, and see Sims, "From Spain Back to Cuba," figs. 16 and 17).[54] In the fourth issue of *VVV*, there is a photograph of Lam in his studio in Havana, crouching in front of *The Jungle*.[55] Lam's work was also featured several times in *VIEW* magazine; he did the cover for the May 1945 issue, edited by Paul Bowles, which was devoted to the topic "Tropical Americana."[56] Lam submitted the letterhead to his inimitable imagizing, with tidbits of a leaf-cum-cane, a winged candle, triplets of breasts, and a type of horned sea monster. The central form is a horseshoe flanking a horned rhomboidal head, which is sitting atop intertwined stems with bulbous fruit forms, terminated by fingers, wings, and branches.

The period's perception of Lam's relationship with the contemporary artistic scene in New York is well characterized by the reproductions of his work that appeared in *Tiger's Eye*. In the December 1948 issue Lam's *L'Arbre aux miroirs* appeared on the same page with Yves Tanguy's *Second Message* of 1929,[57] following Gorky's *Water of the Flowery Mill* of 1945, and Miró's *Le Chant du roissignol à minuit et la pluie matinale*. That issue also featured reproductions of

works by Loren MacIver, Boris Margo, Matta, Robert Motherwell, Barnett Newman, Richard Pousette-Dart, Ad Reinhardt, Clyfford Still, Mark Tobey, and Bradley Walker Tomlin. In the short-lived publication called *Instead* (cat. no. 118), which was started by Lionel Abel and Matta in 1948, line drawings by Lam appeared in a grouping of reproductions by Matta, Petrov, and Toyen in a feature titled *Usoup* by "Manhatta" (Matta).[58] In a subsequent issue of the same year, composed of one article by Maurice Blanchot titled "Face to Face with Sade," a Lam composite drawing of winged creatures demonstrates his evolution to a more fantastically oriented imagery.[59] The presentation of Lam's work in this context is significant because the editorial decisions for *Instead* were fueled by the controversy engendered as Existentialism emerged to challenge Surrealism as the philosophy most appropriate in the face of the realities of the post-World War II era. As Ann Gibson has noted, Matta and Abel also published articles that demonstrated for the first time the affinities between Abstract Expressionism and Existentialist thought.[60]

Immediately after the Second World War in 1946,

7
La Chevelure de Falmer, Lam's altar installation from the International Exposition of Surrealism. Paris, 1947

en route back to Paris from Cuba, Lam made his first visit to New York. In 1980, he reminisced about that event, commenting in particular on his friendship with Arshile Gorky:

> I saw Gorky for the first time at the airport in New York when I arrived from Havana in 1946. He was with his wife and Jeanne Reynal, who was wearing American Indian dress. We were all invited to Nicholas Calas's house, where we talked all night long. The next day we went with Frederick Kiesler to Gorky's studio in Union Square where he showed us his paintings, and we spent a very pleasant evening there. Gorky was someone who was very cordial and amiable. The following day Gorky and I went to the photograph studio of *Vogue* magazine with Rosamond Bernier. Irving Penn took photographs of us all afternoon. He enlarged a very nice photograph of Gorky and me sitting around an old Parisian cafe table [fig. 6]. I saw Gorky again when I visited the United States often in his studio in New Milford.[61]

Over the next four years, during short stays in New York, Lam met and socialized with Alexander Calder, David Hare (in whose studio he often worked), Robert Motherwell, Isamu Noguchi, and Sari Denes, whom he visited regularly. He also had contact with John Cage, Marcel Duchamp, John Bernard Myers, Anais Nin, Yves Tanguy, and Edgar Varese.[62] Lam had exhibitions at the Pierre Matisse Gallery in 1948 and 1950. In his review of the 1948 exhibition, Thomas Hess compared Lam's synthesis of diverse tendencies to that achieved by the Mexican artist Rufino Tamayo.[63] Significantly, Hess situated Lam within the scope of Latin American art. From the very first time that Lam exhibited in New York, all references to his national origin have been made to clarify the formal characteristics of his work rather than to posit a stylistic identification. Lam later insisted that he resisted such parochial associations, and he explained that the reason for his conspicuous absence from the 1944 exhibition "Modern Cuban Artists" organized at The Museum of Modern Art was because he viewed the exhibition as a political event and was against the implied ghettoization of Cuban artists.[64] But in fact, Lam did occasionally show his work in group exhibitions of Cuban artists, and had important exhibitions of his work in Cuba and Venezuela during the 1950s that established his reputation in Latin America.

In an article of 1949, Pierre Mabille heralded Lam as a progenitor of a new force in art:

> For the last three years production in Europe and America has been for the most part unoriginal continuations of cubism, fauvism and surrealism. They have been characterized by incoherence because they have lacked personal certitude on the part of their authors. In contrast Lam's works achieve vehemence, a magical power and a sure artistry. Having exhausted the conscious cycle of European culture and of pedagogic pictorial techniques, Lam succeeds in recovering and surpassing what the sorcerers of the jungle accomplished by virtue of their faith and their most secret dreams.
>
> The example Lam has set assumes a remarkable significance in contemporary art. He has proved that the road from cubism via surrealism to the future holds many an ambush, and many a blind alley. Nevertheless it remains the sole road to that great emotional urge, which since the dawn of history has provided the fundamental source of art and poetry. His break with tradition and his technical procedures of investigation are thoroughly warranted.[65]

Mabille's assessment that Surrealism still held the key to the future of modern art demonstrates why Lam, on his return to Paris, would find a ready reception and association with the CoBrA group—an association of young artists, most from Scandinavia, Belgium, and the Netherlands, and some from South Africa and Japan. As noted in the essay in this catalogue *Wifredo Lam: From Spain Back to Cuba*, Asger Jorn—the catalytic personality behind the CoBrA group and international situationists—had already been to Paris in the

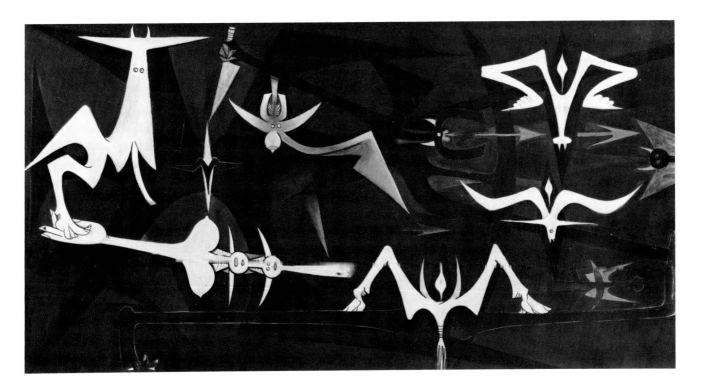

late 1930s. At the outbreak of World War II, Jorn returned to his native Denmark, where he spent the war years refining his concept of an internationalist art movement.[66] He first met Lam in 1948, and they had a long and fruitful association in Paris and Italy until Jorn's death in 1973. Lam participated in the frequent communal studio experiments with members of the CoBrA group in Paris, and his work was included in the last CoBrA show, "Exhibition of Experimental Art," held in Brussels in 1951.[67]

The CoBrA artists were resolutely anti-French and anti-Surrealist. Resistant to the dominance of France in the modernist dialogue, they expounded on the vitality of art from the rest of Europe, especially northern Europe. The founding members of the group—Jorn, Pierre Alechinsky, Corneille, and Karel Appel—composed its name from the first one or two letters of their native cities—Copenhagen, Brussels, and Amsterdam. They were also against the hierarchical organizational structure that Breton had imposed on the Surrealists, and the history of the short-lived but vital CoBrA movement is marked by communal art projects and by the self-determination of its various components.[68] But in spite of these contentions, the activities and interests of CoBrA were not incompatible with those of the Surrealists. It might be said that

CoBrA resumed where the Surrealists left off in the cultivation of folk art and children's art as sources of artistic inspiration. The peculiarly nationalistic nuances in their multiple activities were certainly predicated in Lam's adaptation of his native culture to the Surrealist paradigm. Although there are morphological distinctions between CoBrA and Jean Dubuffet's "art brut" on one hand and Lam's work of the late 1940s and 1950s on the other, these various interests in signification, spontaneity, experimentation, and a non-rationalist point of view constitute a common ground in their artistic goals. There are also parallels in the developments that were taking place in New York-based art and in the CoBrA group during the late 1940s and early 1950s. Certainly the vigorously expressive figuration that characterized the works of Corneille, Jorn, Carl Pederson, and Appel, which had been evolving in their own work since the early 1940s (see cat. nos. 55, 64, 65), manifested interests in mythic and totemic subjects similar to those in the works of the Abstract Expressionists. The work of most of the Americans moved further toward abstraction, but a return to figuration did occur, especially during the early 1950s, which is evident in the work of de Kooning and Pollock.

Lam's relationship with the Surrealists changed

8
Wifredo Lam
Rumblings of the Earth. 1950
Oil on canvas
59¾ x 112″ (151.7 x 284.5 cm)
Solomon R. Guggenheim Museum

during the period after the Second World War. He maintained an amiable relationship with André Breton, but he no longer involved himself in Surrealist group activities. He did participate in the 1947 Surrealist exhibition at the Galerie Maeght in Paris, which was organized by Breton in an attempt to reassert his authority in the Parisian art scene. Breton planned an ambitious installation, enlisting the talents of Marcel Duchamp—the guiding spirit behind the environmental exhibition "First Papers of Surrealism" that took place in New York in 1942. Along with Matta and Frederick Kiesler, Duchamp created another environment that was intended as much to elicit an emotional response from the visitor as it was to accommodate the artworks. Breton described his conceptualization in his invitation to participants, which was later published in the catalogue of the exhibition:

> The general structure of the exhibition will...retrace the successive steps of an initiation, where the transition from one room to another will culminate in the graduation....
>
> The ground floor will be devoted to...works by pre-surrealist artists (Bosch, Arcimboldo, Blake, Rousseau, Carroll, etc.) and the works of contemporaries who had been in contact with the surrealists at one time or another, but for one reason or another have ceased to gravitate in its orbit ([de]Chirico, Picasso, Masson, Dali, Paalen, Magritte, Dominguez)....
>
> At the threshold of the second floor, the "Salle des Superstitions," we will be obliged to overcome these in order to visit the exhibition [the architectural realization of this room is entrusted to Frederick Kiesler, Marcel Duchamp and Matta].... Each of the twelve octagonal alcoves...will be devoted to a being, a category of being or a subject worthy of being given a mythic life, and to which one will raise an altar like those of pagan cults...[69]

Among the subjects worthy of mythic life Breton listed the *Chevelure de Falmer*, a reference from chant IV of Lautreamont's *Les Chants de Maldoror*, the nineteenth-century work that is one of the seminal sources of the Surrealist philosophy.[70] Lam chose to honor this mythic entity with his altar. Extant photographs of the installation (fig. 7), which was actually executed by others, document this assemblage of disparate thematic motifs from Lam's work, which exemplifies its esoteric and increasingly symbolist nature during the later 1940s.

The central element in Lam's alcove was a configuration of two pairs of rotund female breasts protruding from an arrangement of fabric. An arm with its hand brandishing a knife stretched outward from each side of the abbreviated torso. This apparition sat on a shelf that divided the alcove into two sections. Above it on the back wall hung an upside-down crucifix. Below the shelf, on an altar-like structure, were various vessels and forms that approximate the still-life offerings that appeared in such paintings of the 1940s as *Autel pour Elegguá* (cat. no. 28). On each side of the altar was a painted "standard" consisting of circular forms encompassed by crescent shapes.

This type of "dismembered" body can be observed increasingly in Lam's work during the late 1940s and early 1950s, especially in the large painting titled *Rumblings of the Earth* (fig. 8), in the collection of the Solomon R. Guggenheim Museum. The symmetrical and hieratic composition of the *Chevelure de Falmer* recurs in Lam's work of this period. *Reflets d'eau* (cat. no. 54) shows an intricate "vine" of plant tendrils, spikelike elements set in an elongated vertical format, which have pertinent relationships to masonic organizations, for example. *Cuarto fambá* (cat. no. 44), which resembles a room reserved for ceremonial purposes, includes several heraldic forms located on various shifting planes that rupture the spatial continuity of the boxlike space. Dismembered limbs protrude upward from the floor and are stacked along the walls in this distinctive composition. The isolation of various motifs within separately framed compartments is a device that Lam used increasingly in the 1950s to present his figures, with their companions and accoutrements, in a non-narrative space. This type of arrangement was later used with great efficacy by Francis Bacon in his paintings of the early 1950s. Lam gradually stopped delineating the compartmentalized structure, leaving the various elements to float within the space of his compositions.

In the September 1950 issue of *Art News*, Lam was the focus of an artist-painting-a-picture feature written by Geri Trotta. She traveled to Havana to interview and observe the artist as he worked on a "*femme cheval*" identified as *The Horse*.[71] That article is a revealing document of Lam's painting technique. Trotta describes in detail how Lam drew the contours in charcoal and then applied the paint, thinned with turpentine, onto the canvas. The article also reveals certain stylistic changes that had occurred in Lam's work—including the predominance in his palette of darker purples, blues, olives, and browns, colors that he found "deeper and more profound."[72] The frontality and flatness of *The Horse*—which differs from the firm modeling of forms in the early to mid-1940s—demonstrates Lam's future direction in his pursuit of seemingly endless variations on the form of the *femme cheval*. In *Zambezia, Zambezia* (fig. 9), *Lisamona* (cat. no. 50), and *Femme cheval* (cat. no. 51), for example, that figure appears in varying degrees of reductive abstraction, with combinations of a set repertoire of characteristics that include bulbous chin, beard, mane, horns/ears, knife blades, candles, horseshoes, and crescents, all of which individualize heads that are flat ovals, rhomboids, or "trumpet"-shaped forms.

A different treatment of the *femme cheval* in the late 1940s occurs in *Exodo* (cat. no. 46). Here, three entities hurl themselves hither and yon through the composition in an unexplained frenzy. At the top of the painting are a diamond-headed figure sporting horns and an Abakuá symbol similar to that on the May 1945 cover of *VIEW* magazine (see Herzberg, fig. 14). Pointed in the opposite direction is a figure with an elongated snout that ends in the familiar bulbous chin and with breast forms where the eyes should be. At the extreme lower region of the composition, an outstretched female form succumbs to the moment, as a double-headed familiar with finlike wings observes the scene. This supine figure invites comparisons with several female figures who swoon backwards in a state of total abandon in Lam's work of the early 1940s, and it also relates to the humanoid half of a somewhat encumbered *femme cheval* in the painting *For the Spanish Refugees* of 1946.

For the Spanish Refugees is probably a nostalgic reference to the Civil War era. It is interesting that in 1947–48, Robert Motherwell began his own homage to Republican Spain in a series of paintings collectively called *The Spanish Elegies*. Those works include numerous *Elegy to the Spanish Republic* paintings and *Five in the Afternoon* of 1949, which was inspired by the poem by Federico García Lorca, "Lament for Ignacio Sánchez Mejías."[73] Motherwell always demurred from a political reading of his paintings, noting that they were "general metaphors of the contrast between life and death, and their interrelation . . . my private insistence that a terrible death happened that should not be forgotten."[74] These works by Lam and Motherwell bracket the 1947 declaration by Francisco Franco of Spain's status as a monarchy, with himself as its regent for life. This political maneuver—a triumph of form over substance—was calculated to end the ostracization of Spain on the world scene. Whether or not this event, or those leading up to it, directly impinges on the work of Lam and Motherwell, both artists—one an "*ancien*" partisan, the other a Republican sympathizer—were obviously linked by their sense of the tragedy inherent in the collapse of the Republican regime in Spain.

Starting in the late 1940s, in pictures such as *Pasos miméticos* (cat. no. 49), Lam suggested a transition from physical to metaphysical space, or from

9
Wifredo Lam
Zambezia, Zambezia. 1950
Oil on canvas
49⅜ x 43⅝" (125.4 x 110.8 cm)
Solomon R. Guggenheim Museum

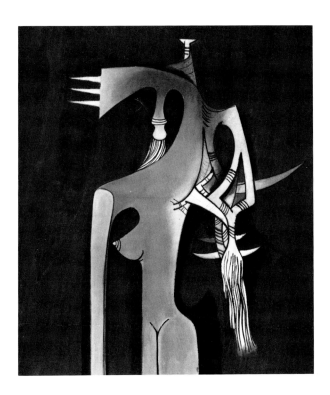

10
Wifredo Lam posing with
shadows. New York, 1950
Private Collection

foreground to background by his use of "bands" or
"lanes" of space that evoke shadows of existence
through their definition of multiple presences and
planes. In the 1950 *Art News* article, Lam referred to
these shapes as "diabolical birds,"[75] inviting an associ-
ation with an incident from his childhood about watch-
ing a bat flickering in the light, which he later related
to Max-Pol Fouchet. According to Lam, that experi-
ence was pivotal and marked the point when he
became fully conscious of the nature of his own exis-
tence.[76] This interpretation is reinforced by a 1950
photograph of Lam (fig. 10) posing in front of cast
shadows that assume the form of a flying being and
approximate the relationship between figures and
background elements in his paintings. This theme in
Lam's work is more fully developed in works such as
When I Don't Sleep, I Dream of 1955, in which a figure
cowers in her bed, while batlike shadows loom above

it. Such imagery occurs again and again in paintings
of the 1950s and 1960s, as if Lam were attempting
to exorcise this seminal experience from his childhood.

Such autobiographical elements increasingly
supersede specific references to Santería in Lam's
work after 1947–48. As exemplified by the series of
sepia *femme cheval*s executed in 1947, his work was
also influenced by objects he was collecting, which
included Oceanic art as well as African art after the
mid-1940s (cat. nos. 111 and 112). By the late 1940s,
like artists such as Antonin Artaud, Jean Dubuffet,
Jean Fautrier, and Henri Michaux, Lam was delving
into a kind of "Primitivism" that is grounded less in
specifics and more in the psychic angst that relates to
the primordial manifestations of the cycles of terror
and rebirth manifest in the human spirit, sentiments
much in evidence after World War II, in Paris and New
York. This condition was described in an article pub-

lished in the tenth, and last, issue of *CoBrA* magazine. In "Pour un Nouveau Totemisme,"[77] Luc Zangrie (*sic* de Heusch), an art historian, critic, and filmmaker who was associated with CoBrA, bemoaned the alienation experienced by humanity, betrayed by its leaders and roused by doomsday prophets, and he makes special note of the horrifying destruction exemplified by Hiroshima. As an antidote to this condition, Zangrie called for "*la poésie de la résistance*," for poets to return to nature (the forest) "to discover the dignity of the tree, the discretion of wood, and the elasticity of the fiber. We ought to be like plants whose hearts devour the sun. This passion, in the realm of plant life, is like love, and inspires the conduct of certain wise people who recognize in plant life their first ancestors and venerate nature as the essence of life."[78] He took his "friends the artists" to task in particular and challenged them to distance themselves from the life of the city and rediscover the countryside, exulting popular art as an agrarian expression and positing nature as the sole painterly realm. He ended by noting that some artists had already heeded this call, and he chose a 1950 work by Lam titled *Peinture* to illustrate the article.

Lam led a peripatetic existence after World War II, spending periods of time in Cuba, New York, and Paris, and finally establishing a permanent residence in Paris in 1951. But this attempt at stability was short-lived. As Lou Laurin-Lam has related, by the mid-1950s the backlash against African peoples that occurred in the wake of the Algerian war made living in Paris difficult. Laurin-Lam, who met Lam in 1955 and married him in 1960, remembers their two years spent in Zurich in exile from Paris and Lam's finally deciding to join Asger Jorn and a growing coterie of Italian and international artists in the small Italian sea-coast town of Albisola Mare in Liguria. Lam estab-lished a studio there in 1960, where he launched several new directions in his art, experimenting with ceramics and initiating an extraordinary production of graphic work. This last phase of his career, which has often been dismissed as degenerative, offers many new insights into Lam and his art, which will be the subject of the author's doctoral dissertation, which is in progress.

Lam's relationship with the New York School and the postwar School of Paris was multifaceted and prob-ably more seminal than has been perceived until now. His cultivation of a totemic and mythic metamorphic imagery during the early 1940s was contemporane-ous with that of the Abstract Expressionists. He dis-tinguished himself from the Surrealists by expressing an intention that was about exploring the unity of nature rather than deconstructing it. He distinguished

11
Poster from the last CoBrA exhibition. 1951
Private Collection

Footnotes

himself from the mythic phase of Abstract Expressionism in that he willingly lay claim to specific subject matter. Finally, Lam was one of few individuals who actually could bridge the Parisian and the New York art worlds, which became increasingly estranged from each other as the 1950s progressed. In this last capacity, he persisted in the internationalist flavor that had characterized the early aspirations of the Abstract Expressionists, as they sought to bring American art out of the narrowly focused regionalism, isolationism, and ethnocentricity that prevailed at the time.[79] As has been noted, he heralded the new autochthonous "Primitivism," by which artists looked to their own culture and the self. During the 1950s, Lam's reputation was also established in Latin America, especially as a result of the exhibitions organized in Havana in 1950 and 1955 and in Caracas in 1955. This internationalist persona was reinforced as he lent his name and his art to permutations of the CoBrA group that manifested themselves as the Group Phase (fig. 11) and the Situationists, which were impelled by Eduard Jaquer[80] and Guy de Bord,[81] respectively.

Until his death, Lam continued to move back and forth between continents and philosophies with an openness that was unparalleled, while the marketing strategies of the art world stressed sharply defined national distinctions. He was truly a master for our time.

NOTE: The material in this essay on Lam's relationship to the School of Paris after 1945 originates from research suggested by Dr. Robert Pincus-Witten in 1985 and was published in *Arts Magazine* in December 1985 (Lowery S. Sims, "Wifredo Lam and the Transposition of the Surrealist Proposition in the post-World War II Era," pp. 21–25). The material in this essay on Lam and the New York School was first presented at a symposium and published in the exhibition catalogue *The Mind's Eye: Dada and Surrealism* (Museum of Contemporary Art, Chicago) in 1984. It was then presented in an embellished form in the symposium at The Metropolitan Museum of Art held in conjunction with the exhibition *Latin American Spirit: Art and Artists in the United States, 1920–70* (1989), organized by the Bronx Museum of the Arts. Similar material was then presented in the panel *Abstract Expressionism's Others* at the College Art Association Annual Meeting in New York City in 1990. Many individuals have guided me to important sources, and I wish to express my appreciation especially to April Paul, Ann Gibson, and Cesar Paternosto.

1. The exhibition referred to is "First Papers of Surrealism," which was sponsored by the coordinating Council of French Relief Services at the Whitlaw Reid Mansion at 451 Madison Avenue, New York City, from October 14 to November 7, 1942. The title was an allusion to the "first papers" of immigrants to the United States. For this exhibition, Marcel Duchamp designed an installation consisting of a maze of string, "an Adriadne's thread beyond which the pictures hung like secrets at the heart of a labyrinth." Quote is from William S. Rubin, *Dada, Surrealism, and Their Heritage* (New York: Museum of Modern Art, 1968), p. 160.

2. Letter from Wifredo Lam to André Breton, December 31, 1928; Collection Bibiothèque Jacques Doucet, Paris. Transcription by the author is from letter exhibited in *André Breton: La beauté convulsive*, Musée National d'Art Moderne (Centre Georges Pompidou, April 25–August 26, 1991).

3. There are different versions of the itinerary of Lam and Breton. One version has Lam leaving Martinique and going directly to St. Thomas and then the Dominican Republic. According to the catalogue of the Breton exhibition cited in note 2, Breton, Lam, and Masson left Martinique on May 16, passing through Pointe-a-Pitre, Guadeloupe, where they were reunited with Pierre Mabille, who in 1945 was appointed French cultural attache in Haiti. At the end of May, they went to Santo Domingo, where Breton met the painter E. F. Granell, and Lam continued on alone to Cuba. Breton arrived in New York at the beginning of July (see ibid., p. 350).

4. *VIEW*, nos. 7–8 (October 1941).

5. This text was later published in André Breton, *Le surréalisme et la peinture. suivi des "Genèse et perspectives artistiques du surréalism" et "Fragments inedits"* (New York: Bretano's, 1945), pp. 181–83.

6. See, for example, Jacques Lacan, "The mirror state as formative of the function of the I as revealed in psychoanalytic experience," in Jacques Lacan, *Ecrits: A Selection*, trans. by Alan Sheridan (New York and London: W.W. Norton, 1977), pp. 1–7; and Pierre Mabille, "Miroirs," *Minotaure*, no. 2 (Paris, 1938), pp. 14–18.

7. *André Breton: La beauté convulsive*, p. 352.

8. "Picassolamming," *Art Digest* 17 (December 1, 1942), p. 7.

9. "Picasso Footnotes: His Drawing, Lam's Painting," *Art News* 38 (November 18, 1939) p. 22.

10. M.B., "The Lore of Cuba," *Art Digest* 43 (June 1, 1944), p. 14.

11. Ibid.

12. "The Passing Shows," *Art News* 43 (June, 1944), p. 22.

13. See Robert Carleton Hobbs and Gail Levin, *Abstract Expressionism: The Formative Years*, exh. cat., Herbert F. Johnson Museum, Cornell University and Whitney Museum of American Art (New York, 1978), pp. 18–19.

14. See Sidney Simon, "Concerning the Beginnings of the New York School: 1939–43. An Interview with Robert Motherwell Conducted by Sidney Simon," *Art International* 11 (Summer, 1967), pp. 20–23.

15. *Les Demoiselles d'Avignon* was not included in the 1936 exhibition of Picasso's work that Lam saw in Spain, but it was mentioned in the catalogue written by Guillermo de Torre (see *Les Demoiselles d'Avignon*, exh. cat., Vol. 2, pp. 603–04, Musée Picasso (Paris, 1988). In fact, after 1916 this painting was not exhibited again until 1937, when it was shown in the exhibition "20 Years in the Evolution of Picasso, 1903–23" at the Jacques Seligmann Gallery in New York City. Between 1939 and 1941, the work toured the United States as part of the exhibition "Picasso: Forty Years of His Art," organized by The Museum of Modern Art in New York. It was seen again in Paris in 1953, as part of the exhibition "Le Cubisme, 1907–1914" at the Musée National d'Art Moderne (*Les Demoiselles d'Avignon*, pp. 692–93).

16. "Wifredo Lam, Gouaches at Pierre Matisse," *Art News* 44 (December 15–31, 1945), p. 21.

17. Margaret Breuning, "Lam's Magical Incantations and Rituals," *Art Digest* 20 (December 1, 1945), p. 16.

18. Ibid. This reference to Chinese painting is important. Until very recently, the influence this aspect of Lam's heritage had on his work has been minimized. Marta García Barrio-Garsd has attributed a Chinese influence to Lam's draftsmanship and calligraphy, as well as his thin and loose treatment of paint in the 1940s works. In an unpublished paper presented in May 1990 at a symposium on Lam's Chinese heritage sponsored by the Asian American Institute at Queens College, this writer, at the New School for Social Research, suggested there may be cultural crossovers encoded in certain motifs in Lam's work—for example, cane and bamboo—and said that a comparison with iconographic interpretations of these elements in Chinese paintings may yield some interesting information. Most recently, Xing Xiao Sheng has compared Lam's hybrid creations to fantastical creatures in Chinese mythology; see *Gravures de Wifredo Lam*, preface by Roland Dumas, foreword by Quan Qi Chen, essay by Xing Xiao Sheng and Jacques Leenhardt, 1991.

19. "A Way to Kill Space," *Newsweek*, August 12, 1946, pp. 106–07).

20. Ibid., p. 107.

21. See note 1.

22. See Lowery S. Sims, "Wifredo Lam and Roberto Matta: Surrealism in the New World," in *In the Mind's Eye: Dada and Surrealism*, Terry Ann R. Neff, ed., exh. cat., Museum of Contemporary Art (Chicago, 1985), pp. 91–103; and Valerie Fletcher, "Wifredo Lam," in *Crossroads of Modernism: Four Latin American Pioneers: Diego Rivera, Joaquin Torres-Garcia, Wifredo Lam, Matta*, Valerie Fletcher with essays by Olivier Debroise, Adolfo M. Maslach, Lowery S. Sims, and Octavio Paz (Washington, D.C., Hirshhorn Museum and Sculpture Garden in association with the Smithsonian Institution Press, 1992), p. 175.

23. Ad Reinhardt included Lam as a leaf on his family tree of modern art in America, which was published in the June 2, 1946, issue of *P.M.* magazine. Lam is situated—albeit apart—on two clusters of leaves on the same branch that contains the names of fantastic imagists such as Tanguy, Tchelitchew, Seligmann, Dali, Dorothea Tanning, Louis O. Guglielmi, Peter Blume, Enroc Donati, and Boris Margo (see David Anfam, *Abstract Expressionism*, London: Thames and Hudson, 1990, p. 23).

24. See Félix Angel, "The Latin American Presence," in *The Latin American Spirit: Art and Artists in the United States, 1920–1970*, essays by Luis R. Cancel, Jacinto Quirarte, Marimar Benítez, Nelly Perazzo, Lowery S. Sims, Eva Cock Croft, Félix Angel, and Carla Stelleweg (New York: The Bronx Museum of the Arts in association with Harry N. Abrams, 1988), pp. 222–39.

25. See note 12.

26. See Lowery S. Sims, "New York Dada and New World Surrealism," in ibid., pp. 170–71.

27. *Barnett Newman: Selected Writings and Interviews*, John O'Neill, ed., text notes and commentary Molke McNickle, intro. Richard Schiff (New York: Alfred A. Knopf, 1990), p. xii. Newman's writings about commonalities between trends in art in North and South America during the 1940s was brought to my attention by César Paternosto. See his unpublished lecture, *The Hemispheric Sources of Abstraction: Re-Visiting the Art of Torres García and Barnett Newman*, delivered at the Hirshhorn Museum and Sculpture Garden, June 27, 1992.

28. Ibid., p. 66.

29. Ibid., pp. 62–65.

30. Ibid., pp. 66–71.

31. Ibid., pp. 71–77.

32. Ibid., p. 70.

33. Ibid., p. 71.

34. Ibid., pp. 71–72.

35. Ibid., p. 72.

36. Ibid., pp. 76–77.

37. Ibid., pp. 105–07.

38. Ibid., pp. 107–08.

39. Ibid., p. 75.

40. See *The Indian Space Painters: Native American Sources for American Abstract Art*, essays by Sandra Kraskin, Allen Wardwell, Barbara Hollister, and Ann Gibson, exh. cat., The Sidney Mishkin Gallery, Baruch College (New York, 1991).

41. *Barnett Newman*, pp. 98–103.

42. Ibid., p. 100.

43. See note 9.

44. See note 12.

45. See note 17. The element of primordial magic that could inspire transformative feelings within artists and their audience did assume a more occult, esoteric aspect in the later 1940s. Lam's own work increasingly demonstrated the crossover between masonic orders and African secret societies such as Ñañigo. See Roberto Cobas Amate, "Wifredo Lam: Los laberintos de la realidad," in *Wifredo Lam, 1902–1982: Obra sobre papel: Colección Museo Nacional, Palacio de Bellas Artes, Havana Cuba*, exh. cat., Centro Cultural/Arte Contemporaneo (Mexico, 1992), p. 23. Marta García Barrio-Garsd even goes so far as to identify specific motifs that indicate alchemical content, and she notes Lam's interest in such divination systems as the I Ching in her essay "Wifredo Lam et l'alchemie," in *Wifredo Lam: dessine, gouaches, peintres, 1938–1950*, exh. cat., Galerie Albert Loeb (Paris, 1987). This fascination among Lam's contem-

poraries in New York is reflected in Kurt Seligmann's 1948 publication, *The History of Magic* (New York: Pantheon Books), which summarizes a myriad of beliefs from different cultures and different epochs, focusing on alchemy, divination arts, and esoteric cults.

46. Hobbs and Levin, *Abstract Expressionism: The Formative Years*, op. cit.

47. David Craven, "Abstract Expressionism and Third World Art: A Post-Colonial Approach to 'American Art,' " *Oxford Art Journal* 14, no. 1 (1990).

48. See Marsden Hartley, "The Red Man," in *Adventures in the Arts* (New York: Boni and Liveright, 1921).

49. Tamayo's natal heritage was often cited in monographic studies of his work. See, for example, Robert Goldwater, *Rufino Tamayo* (New York: The Quadrangle Press, 1947), pp. 7, 23.

50. Max-Pol Fouchet, *Wifredo Lam* (Barcelona: Ediciones Poligrafa, 1976); rev. ed., Paris: Cercel d'art, 1989), pp. 188–89.

51. Irving Sandler, *The Triumph of American Painting: A History of Abstract Expressionism* (New York: Praeger, 1979), p. 67.

52. Lam had met Césaire while he was temporarily detained on Martinique coming from Marseilles to Havana.

53. *VVV*, nos. 2–3 (March 1943), p. 36.

54. Ibid., pp. 88–89. There is also a notice on p. 137 that *Fata Morgana* was being sold at Peggy Guggenheim's Art of This Century Gallery.

55. *VVV*, no. 4 (February 1944), p. 27.

56. *VIEW*, series V, no. 2 (May 1945).

57. *Tiger's Eye* no. 6 (December 1948), p. 23.

58. *Instead*, no. 2 (March 1948).

59. *Instead*, nos. 5–6 (November 1948).

60. Ann Eden Gibson, *Issues in Abstract Expressionism: The Artist-run Periodicals* (Ann Arbor/London: U.M.I. Press, 1990), p. 45.

61. Lam, in a statement prepared for the Gorky exhibition at the Guggenheim in 1980. I am grateful to Lou Lam for making this available to me.

62. See Dore Ashton, *Isamu Noguchi: East and West* (New York: Alfred A. Knopf, 1992), p. 73; Jennifer L. Boyles and Evan M. Maurer, *Gerome Kamrowski: A Retrospective Exhibition* (Ann Arbor: University of Michigan Museum of Art, 1983); Fouchet; Per Hovdenakk, "Wifredo Lam y el expresionismo abstracto en Estados Unidos y Europa," in *Sobre Wifredo Lam* (Havana: Editorial Letras Cubanas, 1986), pp. 129–37; Antoñio Nuñez Jimenez, *Wifredo Lam* (Havana: Editorial Letras Cubanas, 1982). Additional information about Lam's contacts in New York have been provided by Lou Lam, David Hare, and Ann Gibson.

63. Thomas B. Hess," Spotlight on Lam," *Art News* 47 (May 1948) p. 37.

64. Lam, in an unpublished interview with an individual notated as "P.," probably done in Cuba in the 1970s, from the archives of the Wifredo Lam catalogue raisonné in Paris.

65. Pierre Mabille, "The Ritual Painting of Wifredo Lam," *Magazine of Art* 42 (May 1949), p. 188.

66. See *Cobra, 1945–1951*, exh. cat., Musée d'Art Moderne de la Ville de Paris (1982), pp. 44–46.

67. See Angliviel de la Beaumelle, "Cobra," in *Paris/Paris, 1937–1957*, exh. cat., Centre Georges Pompidou (Paris, 1981), pp. 149–52, and *Cobra, 1945–1951*, p. 91.

68. For example, for each of the ten issues of the *Cobra* magazine the editorial direction was given over to a different group of artists in different countries and published in their different languages. It was an audacious internationalist sensibility that is only now beginning to be seen again in the art world.

69. See *Le surréalisme en 1947: Exposicion internationale du surréalisme*, presented by André Breton and Marcel Duchamp, exh. cat., Editions Pierre a fue, Maeght Editeur (Paris, 1947), pp. 135–38.

70. Ibid., p. 136. See also Isadore Ducasse, *Oeuvre complets* (Paris: Librairie Generale Française, 1963). It is interesting to note that the author of this novel of sensual obsession was born in Montevideo, Uruguay, cementing the Latin American roots of Surrealism.

71. Geri Trotta, "Wifredo Lam Paints a Picture," *Art News* (September 1950), pp. 42–44, 51–52.

72. Ibid., p. 51.

73. See H. H. Arnason, *Robert Motherwell*, preface by Bryan Robertson (New York: Harry N. Abrams, 1977), pp. 25–30.

74. *Robert Motherwell*, exh. cat., Smith College Museum of Art (Northampton, Mass., 1963), n.p., caption for no. 16.

75. Trotta, p. 81.

76. Fouchet, pp. 45, 48.

77. Luc Zangrie, "Pour un nouveau totemisme," *Cobra (Revue internationale de l'art experimental)*, no. 10 (September 1951), pp. 22–23.

78. Ibid., p. 23.

79. See Judith E. Tolnick, "The Painting—A Background," *Flying Tigers, Painting and Sculpture in New York, 1939–1946*, intro. by Kermit S. Champa, essays by Nancy R. Versaci, Judith E. Tolnick, and Ellen Lawrence, exh. cat., Bell Gallery, Brown University (Providence, R.I., 1985), pp. 15–16. It is interesting that Lam as an Afro-Chinese Cuban did not face the exclusion from the art world experienced by African-American artists, or a Chinese artist such as Yun Gee in the 1940s. This was undoubtedly due to Lam's association with Breton, which helped open doors to Lam when he came to the United States in the second half of the 1940s. Also, Lam would have been perceived as a Latin American, and his reception would have been, as has been discussed, predicated on interest in that area at that time. For a discussion of the situation of African-American abstract artists, gays, and women in the 1940s, see Ann Gibson's forthcoming publication, from Yale University Press, which is tentatively titled *Abstract Expressionism Recast*.

80. See Jan van de Marck, "Milan in the 1950s: An Authentic Avant Garde," in *Baj, Fontana, Manzoni* (New York: Marisa del Re Gallery, 1989), n.p.

81. See Peter Wollen, "Bitter Victory: The Art and Politics of the Situationist International," in *On the Passage of a Few People Through a Rather Brief Moment in Time: The Situationist International, 1957–1972*, Elizabeth Sussman, ed. (Cambridge, Mass. and London: The MIT Press, 1989), pp. 20–61.

Façade of the house where Wifredo Lam was born in
Sagua La Grande, Cuba

Lam Yam, the artist's father. Sagua La Grande,
Cuba. ca. 1920

Wifredo Lam at age twelve. Sagua La Grande,
Cuba. 1914

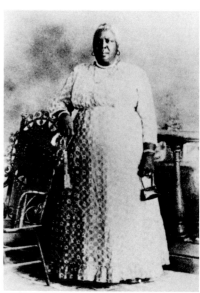

Wifredo Lam's godmother, Mantonica Wilson.
Sagua La Grande, Cuba. 1900

Chronology

Compiled by
GIULIO V. BLANC
JULIA P. HERZBERG
LOWERY STOKES SIMS

Wifredo Oscar de la Concepción Lam y Castilla was born in Sagua La Grande, Cuba, on December 8, 1902. His parentage was typical of the racial syncretism of the Caribbean: His father, Lam Yam, was born in Canton, China, and had probably gone to the United States to work on the building of the transcontinental railroad. He eventually arrived in Cuba, where he married Lam's mother, Ana Serafina, who was of mixed African and Spanish heritage. Lam was the youngest of nine children and the only son. His special talents—both artistic and intellectual—were recognized early on. His godmother, Mantonica Wilson, a priestess in the Santería religion, brought him up under the guidance of that African-based religion when he was a child. Although Lam was a devotee throughout his teens, he was never initiated as a priest. His artistic talent is evident from two pencil drawings done when he was between the ages of ten and twelve—a portrait sketch of his father and a view of the Sagua La Grande landscape. In 1916, at the age of fourteen, Lam was sent to Havana, where he lived with relatives while continuing his studies. Although his family wanted him to pursue law, Lam became increasingly involved in art, often spending time sketching in the botanical gardens. His family finally relented, and in 1918 Lam entered the Academia San Alejandro, where he worked until 1923. At the age of twenty-one, he sailed to Madrid, with the intention of studying art with the academic painter and then director of the Prado Fernando Alvarez de Sotomayor. Lam soon became dissatisfied with the academic program and began to frequent the Academia Libre in the Paseo de Alhambra, where he came into contact with modernist ideas. He continued to go to the Prado, and was particularly attracted to the work of Goya and El Greco and to that of the Flemish painters Hieronymus Bosch and Pieter Brueghel. He also visited the Archaeological Museum. With his funds depleted, Lam

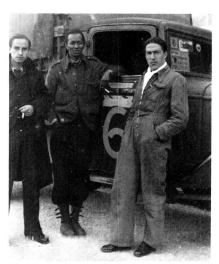

Wifredo Lam and friends in Madrid. 1936

accepted the invitation of his friend Fernando Muñoz to go to the small mountain town of Cuenca, where he spent most of his time between 1924 and 1929, supporting himself doing society portraits, touristic scenes of Spain, and decorative inter-

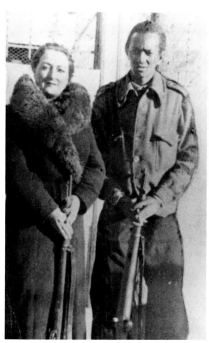

Balbina Barrera and Wifredo Lam in Madrid. 1936

iors. A group of precisely rendered portraits of Spanish peasants survives from this period, and they seem to indicate a burgeoning social consciousness. In 1929, Lam met Eva Piriz, whom he married the following year. By this time, he was once again living in Madrid. His first child, Wifredo, was born in 1931; soon afterward both the infant and Eva died of tuberculosis. During this time Lam's work shows an early experimentation with a Surrealist style. By 1934 it had begun to show the influence of Matisse, and simultaneously a segmentation into window panes that has been attributed to the presence of the Uruguayan modernist artist Joaquín Torres García in Madrid between 1932 and 1934. In 1936, Lam saw the exhibition of Picasso's work that had been organized in Barcelona. It was a fateful encounter, and his work over the next few years shows a slow but steady absorption of the lessons of Cubism. Meanwhile, Lam had become involved in Republican politics, and with the outbreak of the Civil War he was asked to do propaganda posters. Eventually, he was actively involved in the defense of Madrid, working in a munitions factory as well as fighting on the barricades during the siege of Madrid by the Nationalist forces in 1937–38. He was incapacitated in 1938 and sent to a hospital near Barcelona. There he met Helena Holzer, who was working as a researcher in neurobiology at the Gorky hospital in Barcelona, and Manolo Hugué, a Catalan sculptor who had been close to Picasso during the first two decades of the century. As the military pressure on Catalonia, the last stronghold of Republicanism, was increasing, Lam left for Paris with a letter of introduction to Picasso from Hugué.

The following chronology details the events in Lam's life, in the art world, and in the world at large between 1938 and 1952. It was during this time of turmoil that Lam achieved his artistic maturity and cemented his international reputation.

1938

Paris

January–February. "L'Exposition Internationale du Surréalisme" opens at the Galerie des Beaux Arts.

May. Picasso's *Guernica* is exhibited at the pavilion of Republican Spain in the "Exposition des Arts et Techniques de 1937."

May 22. Wifredo Lam arrives in Paris after having lived in Spain for fifteen years. He finds lodging in the Hôtel de Suède at 8 quai Saint-Michel. Later he has a studio at 8 rue Armand Moisant. Through a letter of introduction from the Catalan artist Manolo Hugué, Lam meets Picasso, who becomes a spiritual mentor, friend, and sponsor, providing Lam with needed painting materials. During 1938 and 1939 Picasso introduces Lam to Michel Leiris, Pierre Loeb, Daniel-Henry Kahnweiler, Paul Eluard, Georges Braque, Marc Chagall, Fernand Léger, Henri Matisse, Joan Miró, Tristan Tzara, Christian Zervos, and others. Lam forms a close friendship with Oscar Dominguez.

Hans Bellmer arrives in Paris from Berlin. He befriends Paul Eluard and Yves Tanguy and has contact with Arp, Breton, Duchamp, Ernst, and May Ray.

Jacques Hérold joins the Surrealist group.

Asger Jorn visits Paris for the third time.

Mexico

March 30. André Breton leaves France for Mexico. He stays with Diego Rivera and Frida Kahlo, and meets Leon Trotsky. He returns to Paris August 1.

World Events

March 11. Hitler's armies occupy Austria.

March 16–18. German forces bomb Barcelona.

December 23. Nationalist armies begin advance on Barcelona.

1939

Paris

January. Helena Holzer arrives in Paris and moves in with Lam. Picasso sends Zervos and Loeb to see Lam in his studio on the quai Saint-Michel, and Loeb purchases work for "Wifredo Lam Peintures," Lam's first exhibition in Paris, which is held at the Galerie Pierre, June 30–July 14. It is to be Lam's last exhibition in the Loeb gallery until after the end of World War II.

Summer. Dora Maar introduces Lam to André Breton.

New York

November 13–December 2. The Perls Gallery exhibition "Drawings by Picasso and Gouaches by Wifredo Lam" shows Lam's work in New York for the first time.

The Museum of Modern Art in New York purchases Lam's *Mother and Child*.

A retrospective exhibition, "Picasso: Forty Years of His Work," opens at The Museum of Modern Art and tours the United States for two years (1939–41).

Matta arrives in New York.

World Events

January 26. Barcelona falls to Nationalist forces. There is a mass flight of refugees to the French border.

April 1. Franco announces the end of the Civil War in Spain.

September 1. Germany invades Poland.

September 3. Britain and France declare war on Germany.

1940

Paris

Lam meets Sebastiá Gasch.

March–April. Helena Holzer and Katie Perls (mother of New York dealer Klaus Perls) are interned by Nazis for six weeks.

June 14. German troops enter Paris. Lam flees Paris, leaving his canvases

with Picasso after being photographed with them in his studio. He walks almost all the way to Bordeaux and continues on to Marseilles. Helena Holzer joins him there in early July.

Marseilles

Lam is reunited with many friends and acquaintances from Paris, including Pierre Mabille, René Char, Max Ernst, Victor Brauner, Oscar Dominguez, Sylvain Itkine, André Masson, Benjamin Péret, and others. He receives support in Marseilles from the Centre Américain de Secours under the direction of Varian Fry, which was supported with funds from the Emergency Rescue Committee (in the United States).

Lam and Holzer regularly visit the Villa Bel-Air, where Breton is staying. They participate in Surrealist discussions, the collective drawing activities—*Cadavres exquis*—and the card game *Le Jeu de Marseilles*. The face cards are designed by André Breton and Jacqueline Lamba (Breton), Victor Brauner, Jacques Hérold, André Masson, Oscar Dominguez, and Lam, who is from this time on accepted as one of their group.

December 3. André Breton finishes the poem *Fata Morgana*.

New York

April 16–May 7. First exhibition of Matta's work in New York is held at Julian Levy Gallery.

September. Publication of first issue of *VIEW*, founded by Charles Henry Ford.

October. Kurt Seligmann arrives in New York.

Denmark

April 9. Denmark is occupied by Germany. Asger Jorn is active in the resistance. His experiences lead him to his conviction that art should be grounded in the history and traditions of each

country. This became one of the main principles of the CoBrA group.

World Events

Progressive Cuban constitution of 1940 outlaws segregation and calls for socio-political reforms.

Fulgencio Batista is elected president of Cuba.

Trotsky is assassinated in Mexico.

Roosevelt is elected President of the United States for a third term.

1941

Marseilles

January and February. Lam illustrates Breton's poem *Fata Morgana* with Surrealist imagery.

March 10. Five copies of *Fata Morgana* are printed. Full publication is stopped by Marseilles censors.

March 24 or 25. Lam, Breton, Victor Serge, and more than 300 artists and intellectuals leave Marseilles on the boat *Capitaine Paul-Lemerle*, destined for Martinique.

Martinique

End of April. Lam and comrades arrive in Martinique and are lodged in a former leper hospital on Trois Isles for forty days. Breton and Lam meet the Martinican black poet Aimé Césaire, who had just published the first issue of the journal *Tropiques: Revue Trimestrielle*.

May 16. Lam and Holzer, Breton and Jacqueline Lamba and their daughter Aube, and Victor Serge and his son Vlady leave Martinique, stopping in Guadeloupe, St. Thomas, and Santo Domingo in the Dominican Republic. Breton and family stay in Santo Domingo for a few days before departing for New York, where they arrive at the end of July.

Lam and Holzer stay there for about a month before departing to Cuba, where they arrive in late July or early August.

Havana

Lam and Holzer set up household on Calle Enna 402, Luyanó, in Havana.

December. Lam meets Lydia Cabrera, Cuban writer and ethnologist.

New York

Drawing by Lam appears in *VIEW* (October–November 1941).

Mario Carreño has his first one-man exhibition in New York at Perls Gallery.

Helena Holzer and Wifredo Lam in Havana. 1947

Mexico

June–August. Matta visits Mexico with Robert Motherwell.

World Events

Cuba declares war on Germany and Japan.

The Manhattan project (atomic research) begins in Los Alamos, New Mexico.

1942

Havana

February. Pierre Loeb and his family arrive in Havana.

Alfred H. Barr, Jr. and Edgar J. Kaufmann, Jr. visit Cuba for The Museum of Modern Art. Through the Inter-American Fund, MoMA purchases works by Mario Carreño, Wifredo Lam, Luis Martínez-Pedro, Amelia Peláez, René Portocarrero, and Teodoro Ramos Blanco. Paintings by Cundo Bermúdez, Carlos Enríquez, and Fidelio Ponce de Leon are donated to the Museum.

Lam and Holzer move to Calle Panorama 43 in the Marianao section of Havana at the end of the year. During the next few years, Lam attends Afro-Cuban ritual dances and Ñañigo ceremonies several times with Holzer in the company of Lydia Cabrera and Alejo Carpentier, and later with Pierre Loeb and Eric Klieber. These experiences begin to be reflected in Lam's work, providing subject matter for his paintings. Holzer shares with Lam her interest on the work of Carl Jung and hermetic thought, which also becomes a source of inspiration for his work.

New York

June. First issue of *VVV*, founded and edited by David Hare, is published. Breton and Ernst serve as editorial advisors.

October 14–November 7. "Papers of Surrealism" is held at the Whitelaw Reid mansion. The only major group exhibition during the Surrealist exile in New York is sponsored by the Coordinating Council of French Relief Societies and includes work by Arp, Baziotes, Bellmer, Brauner, Calder, Chagall, Duchamp, Ernst, Frances, Giacometti, Hare, Kahlo, Kiesler, Klee, Lam, Matta, Magritte, Miró, Masson, Moore, Motherwell, Oelze, Onslow Ford, Picasso, Seligmann, and Tanguy.

October. Opening of Peggy Guggenheim's Art of this Century Gallery.

November 17–December 5. Pierre Matisse Gallery shows "Lam Paintings," his first solo exhibition in New York. André Breton writes the foreword for the catalogue.

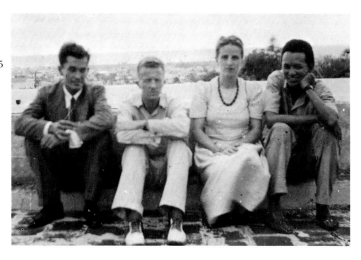

Fabian Benitez, Paul Bowles, Helena Holzer, and Wifredo Lam. ca. 1944–45

1943

Havana

January. Lam completes the painting *The Jungle*.

July. Lam participates with other Cuban modernists in a fundraising exhibition and sale of painted fans at the Lyceum. This event is for the restoration of the church of Santa María del Rosario and its paintings by the 18th-century mulatto artist José Nicolás de la Escalera.

November 11–29. "Salon Internacional de Acuarelas y Gouaches," a group show of work by Cuban modernists and Mexican artists (including Federico Cantú, Jesús Guerrero Galván, and Diego Rivera), is held at the Instituto Hispano-Cubano de Cultura, organized by José Gómez Sicre.

Lam illustrates Aimé Césaire's *Retorno al País Natal* with three drawings.

New York

March. *VVV* (nos. 2–3) reproduces Lam's 1942 gouache *La Chanteuse des poissons*.

July. Lam's work is included in the group exhibition "Summer Exhibition—Modern Pictures Under Five Hundred at the Pierre Matisse Gallery."

October 5–23. The group exhibition "Water Colors and Drawings" is held at the Pierre Matisse Gallery.

November 9–27. First one-man exhibition of the work of Jackson Pollock is held at Art of This Century Gallery.

The Latin American Collection of The Museum of Modern Art, by Lincoln Kirstein, is published. It includes a section on Cuba, in which the works acquired the previous year are illustrated.

1944

Havana

Lam marries Helena Holzer. They move to Avenida 8a in Havana.

Summer. Lam makes drawings for *Gaceta del Caribe*, an avant-garde Cuban magazine. His artistic significance is noted by the critic Guy Pérez Cisneros in the government publication *Anuario Cultural de Cuba 1943*. Mention is made of *The Jungle*.

José Gómez Sicre's *Pintura Cubana de Hoy* includes a chapter on Lam in which *The Jungle* is reproduced.

Lam joins an anti-Franco committee along with Teodoro Ramos Blanco, Carlos Enríquez, René Portocarrero, and several other artists.

November. Lam is one of the founders of the Comité de Artistas Plásticos de Ayuda al Pueblo Español.

Lam's work is included in "Colección de Pinturas de la Legación de Cuba en Moscu," a group exhibition organized by Guy Pérez Cisneros for the Cuban government. The exhibition opened in Havana and traveled to Moscow the following year.

New York

February. *VVV* (no. 4) reproduces a Lam drawing.

March–April. "Modern Cuban Painters" opens at The Museum of Modern Art, New York. Lam refuses to participate.

June 6–June 24. Lam has his second solo exhibition at the Pierre Matisse Gallery, "Lam Paintings."

October 24–November 1. First one-man exhibition of Robert Motherwell's work is held at Art of This Century Gallery.

Chicago

January 4–29. Exhibition of work of Lam and Matta is held at The Arts Club of Chicago.

World Events

August 25. Charles De Gaulle enters Paris.

Ramón Grau San Martín is elected president of Cuba.

1945

Havana

Spring. Lam illustrates the cover of *Origenes: Revista de Arte y Literatura*.

Haiti

January 18–February 4. "Les Peintres Modernes Cubains" is held at Centre d'Art Galerie, Port-au-Prince.

December. Lam visits Haiti for the first time. He is invited by Pierre Mabille, French cultural attaché, and the government of Haiti to the inauguration of the

Institute of Culture in Port-au-Prince. Breton is also invited. Lam and Holzer stay in Haiti until April 1946.

New York

André Breton publishes *Le Surréalism et La Peinture*, in which he discusses the work of Kahlo, Lam, and Matta.

May. Lam illustrates the cover of *VIEW*.

November 20–December 8. Lam has his third solo exhibition at the Pierre Matisse Gallery, "Lam Paintings." The painting *The Jungle* is bought by The Museum of Modern Art.

March 12–31. Matta's work is shown at Pierre Matisse Gallery.

Paris

December 12–December 31. Galerie Pierre mounts "Wifredo Lam," the first exhibition in Loeb's gallery after the war.

World Events

May 7. Germany surrenders to allied forces.

August 6. First atomic bomb dropped on Hiroshima. Second on Nagasaki (August 9).

1946

Haiti

January 9–30. Solo exhibition is held at Centre d'Art Galerie, Port-au-Prince. Catalogue text, *La Nuit a Haiti*, is written by André Breton.

Lam and Holzer attend vodun ceremonies for the first time with Breton and Mabille. Breton and Lam become interested in the survival of traditions from Dahomey and Guinea.

Havana

April 11–May 19. Lam has his first solo exhibition in Cuba at the Lyceum. Catalogue text is by Lydia Cabrera.

December 18–29. "Exposición de Pintura Contemporánea Cubana," a group show, is organized by the Dirección de Relaciones Culturales del Ministerio de Estado under Dr. Francisco Ichaso.

New York

January. Lam's work is included in a group show at the Pierre Matisse Gallery.

Spring. Lam's *Antillean Parade* (1945) is reproduced in *Portfolio*.

March 12–30. Pierre Matisse Gallery mounts "Paintings Gouaches Drawings."

Late June. Lam arrives in New York en route to France. He is met in New York by Jeanne Reynal and meets James Johnson Sweeny, Noguchi, Pollock, Motherwell, Archile Gorky, Marcel Duchamp, and Nicolás Calas.

July 9. Lam leaves New York for London on the Queen Mary. He goes on to France, where he visits Paris, and also Cannes, where he has been offered an apartment by Marcel Dreyfus. Lam decides not to stay in France at this time.

October 10–November 2. Lam's work is included in a group show at the Pierre Matisse Gallery.

Lam's work is included in an exhibition at The Museum of Modern Art, along with work by Picasso, Matisse, Miró, and Matta.

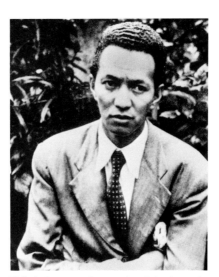

Wifredo Lam upon his arrival in Cuba during the war. 1942

Late 1946. Pollock begins painting his all-over paintings.

Paris

January. Jorn visits Paris where he meets Eduard Jacquer. He travels back and forth between Denmark and Paris several times.

May 26. Breton returns to Paris.

Lam's work is included in the exhibition "Les Peintres de Paris" at UNESCO Headquarters.

Communist group including Aragon, Eluard, Sadoul, and Tzara mounts an offensive against Surrealists.

London

November 5–30. The London Gallery shows "The Cuban Painter Wifredo Lam."

Mexico

June. Lam exhibits in the government-sponsored "Exposición de Pintura Cubana Moderna" at the Palacio de Bellas Artes, Mexico City. President Lázaro Cardenas and Diego Rivera praise the exhibition. Academic Cuban artists protest their exclusion and are rebuffed with a manifesto signed by Lam and other modernists.

1947

Havana

Winter. Lam illustrates the cover of *Origenes: Revista de Arte y Literatura*.

New York

Spring. Peggy Guggenheim closes Art of This Century Gallery and returns to Europe.

Lam's work is included in a group show, "Blood Flames," organized by Nicolás Calas at the Hugo Gallery.

Lam and Holzer come to New York. They see Noguchi, Jeanne Reynal, David and Jacqueline Barr, Motherwell, Pierre and Teeny Matisse. They stay in the Matisse apartment on East 72nd Street, and visit Lee Krasner and Jackson

Wifredo Lam with Lou Laurin-Lam and sons Jonas, Timour, and Eskil, at 23 Boulevard Beausejour, Paris. 1971

Pollock on Long Island.

Paris

April 11. Lecture by Tzara at the Sorbonne "Le Surréalisme et l'Après Guerre," is interrupted by Breton.

July–August. Galerie Maeght shows "Exposition Internationale du Surréalisme." Lam participates in the last major group show of the Surrealist movement, organized by Breton and Duchamp, with works of eighty-seven artists from twenty-four countries.

Fall. Karel Appel and Corneille to go Paris and meet Constant.

Belgium

Christian Dotremont, later to be one of the prime movers of the CoBrA group, founds the group Surréalistes Révolutionnaires in Belgium.

World Events

The Marshall Plan to aid the rebuilding of Europe is announced.

Franco declares Spain a monarchy and himself Regent for Life.

1948

Havana

November. Lam is one of the founders of the Agrupación de Pintores y Escultores Cubanos, an association of modernists.

New York

March–November. Matta and Lionel Abel publish the magazine *Instead*. Drawings by Lam appear in issue no. 2, and in issue nos. 5–6.

April 20–May 8. Fourth solo exhibition is held at Pierre Matisse Gallery. Lam stays in Cuba. Helena Holzer comes to New York for the exhibition.

May 18–June 5. Lam's work is included in a group show at Pierre Matisse Gallery.

June 8–July 2. Lam's work is included in Pierre Matisse Gallery's "Summer Exhibition."

Lam and Holzer come to New York and stay with Jeanne Reynal and Erwin Nuringer on 11th Street.

December. Lam's *L'Arbre aux miroirs* is reproduced in the New York magazine *Tiger's Eye*.

Paris

Lam meets Asger Jorn and shares a studio with him in Paris. He is in contact with the CoBrA group.

October 25. Matta returns to Europe. He is excluded from the Surrealist group.

November 8. Victor Brauner is excluded from the Surrealist group.

Avignon

June 27–September 30. Lam's work is included in the group show "Exposition de Peintures et Sculptures Contemporaines" at the Palais des Papes.

London

Lam's work is included in a group show at The Institute of Contemporary Art, "Forty Years of Modern Art 1907–1947: A Selection from British Collections."

November. Lam's work is included in "40,000 Years of Modern Art: A Comparison of Primitive and Modern" at The Institute of Contemporary Art.

Belgium

July 16. The CoBrA group is founded in the home of Constant.

Copenhagen

November. Exposition of work of CoBrA artists is held in Copenhagen (Nov. 9–Dec. 5), including work by Jorn, Peterson, Constant, and Corneille.

1949

Havana

July. Lam participates in a group show, "Agrupación de Pintores y Escultores Cubanos," at the Lyceum.

New York

May 23–June 18. Lam's work is shown in Pierre Matisse Gallery's "Summer Exhibition: Paintings Gouaches Drawings Sculptures."

Denmark

March. First issue of *CoBrA* magazine

is published in Denmark.

August. Members of the CoBrA group participate in a collective project at Bregnerod, north of Copenhagen: a mural at the week-end house for architectural students at the university. The project affirms the group's commitment to collectivity, and to the involvement of art in everyday life.

Sweden

October. Lam participates in a group show of Cuban modernists at the Lilijevalchs Galleries, Stockholm.

Netherlands

November 3–28. "L'Exposition Internationale d'Art Experimental" (CoBrA) is held at Stedelijk Museum in Amsterdam, organized by Willem Sandberg.

group show at the Sidney Janis Gallery, "XX Century Young Masters."

May 2–May 20. Pierre Matisse Gallery shows "Lam Paintings."

September. *Art News* article by Geri Trotta describes Lam's painting method.

1951

Havana

Lam is commissioned to paint a mural in the Esso Bulding (Esso Standard Oil Company, Cuba). Other Cuban artists who are commissioned to paint murals there are Peláez, Portocarrero, Enríquez, Jorge Rigol, Carmelo González, and Enrique Moret.

Lam wins first prize at the Salón Nacional de la Habana.

Jacques Hérold severs ties to the Surrealist group.

Liège

October 6–November 6. Last group exhibition of experimental art group—including work by Lam, Miró, Giacometti, and Bazine—is held at Palais des Beaux Arts. Lam's painting *Peinture* (1950) is illustrated in Luc Zangrie, "Pour un Nouveau Totemisme," *CoBrA* (*Revue Internationale de l'Art Experimental*) no. 10. This issue also includes a catalogue listing of the Liège exhibition.

New York

May 28. Helena Holzer divorces Lam.

1952

Havana

Lam illustrates the cover of *Origenes: Revista de Arte y Literatura*, vol. 9.

Paris

Lam moves back to Paris to take up permanent residency there at the age of fifty.

May–June. Lam participates in a group show at the Musée National d'Art Moderne, "Les Oeuvres du XX Siècle: Peintures-Sculptures."

London

Solo exhibition is held at the Institute of Contemporary Art, with catalogue text by E. L. T. Mesens.

World Events

Fulgencio Batista overthrows Prío in Cuba and declares himself head of state.

Gabriel García Marquez, Wifredo Lam, and René Portocarrero in Havana. June 1977

1950

Havana

October 2–15. "Lam: Obras Recientes 1950," a solo exhibition of Lam's work, is held at Parque Central, organized by the Ministry of Education.

New York

April 24–May 20. Lam is included in a

April. "Lam y Nuestro Tiempo: Paris 1938–Habana 1951" is shown at the gallery Sociedad Nuestro Tiempo.

Paris

February–March. Lam is included in "Art Cubain Contémporain," a group show held at the Musée National d'Art Moderne.

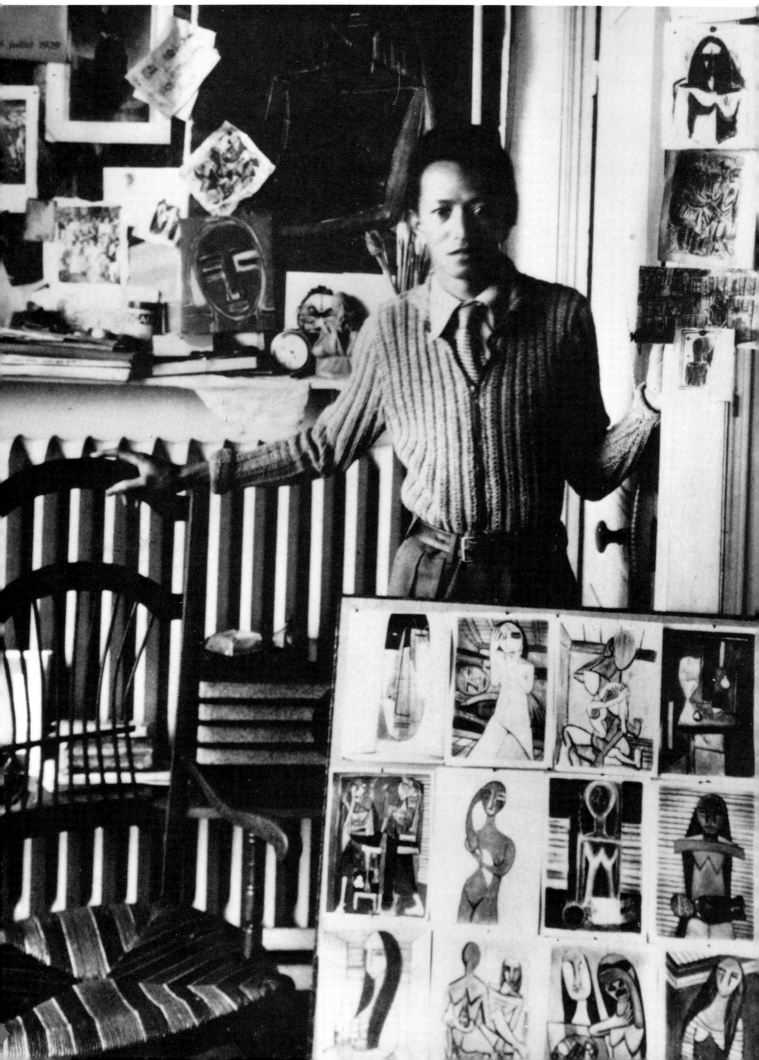

Checklist of the Exhibition

In the following listing, dimensions are given in inches and centimeters; height is followed by width, which is followed, when necessary, by depth. Works marked with the symbol ■ are not illustrated in this volume.

WIFREDO LAM

1. **Deux personnages** 1938
Tempera on paper
43 x 31½ in. (110 x 80 cm)
Collection Mme Françoise Thésée, France

2. **The Family** 1938
Tempera on paper mounted on canvas
75 x 57⅛ in. (190.5 x 145 cm)
Private Collection, Paris

3. **Personnage assis [La Lettre]** 1938
Gouache on paper
39¾ x 27⅝ in. (101 x 70.2 cm)
Private Collection, Miami

4. **Mother and Child** 1939
Gouache on paper
41⅞ x 29½ in. (106.4 x 74.9 cm)
The Museum of Modern Art, New York

5. **Woman Holding Her Hair** 1939
Oil on wood panel
50 x 36 in. (127 x 91.4 cm)
Private Collection

6. **Hector, Andromache and Their Son Astyanax** 1940 ■
Pastel and ink on paper
12¼ x 16½ in. (31 x 41.5 cm)
CDS Gallery, New York

7. **Marseilles notebook** (preparatory drawings for **Fata Morgana**) 1940–41
(36 unframed drawings, unmounted in portfolio, approx. 8 x 5½ in. each)
Collection Gerald J. Millstein, M.D.

8. Untitled (from **Cadavre Exquis, Marseilles**) 1941 ■
Colored pencil on paper
5 x 8 in. (12.7 x 20.3 cm)
Private Collection, Paris

9. **Figure** 1942
Tempera and pastel on paper
41⅞ x 33⅛ in. (106.5 x 84 cm)
Artcurial, Paris

10. **Nu dans la nature** 1942 ■
Oil on paper mounted on canvas
70⅞ x 47¼ in. (180 x 120 cm)
Musée National d'Art Moderne, Centre Georges Pompidou, Paris

11. **Femme** 1942
Gouache on paper
40½ x 31½ in. (102.9 x 80 cm)
Private Collection

12. **La Cortina** 1942
Tempera on paper mounted on board
42 x 33 in. (106.7 x 83.8 cm)
Courtesy M. Gutierrez Fine Arts, Miami

13. **Déesse avec feuillage** 1942
Gouache on paper
41½ x 33½ in. (105.4 x 85.1 cm)
Private Collection

14. **Les Yeux de la grille** 1942
Gouache on paper
41½ x 33 in. (105.4 x 83.8 cm)
Private Collection

15. Untitled 1942
Gouache on paper
40½ x 32¼ in. (102.9 x 81.9 cm)
Collection Dr. Alberto Martinez-Piedra, Bethesda, Maryland

16. **L'Homme à la vague** 1942
Gouache
105 x 84 in. (266.7 x 213.4 cm)
Private Collection

17. **Anamú** 1942
Oil on canvas
48¼ x 58 in. (122.6 x 147.3 cm)
Museum of Contemporary Art, Chicago. Gift of Joseph and Jory Shapiro

18. **Woman with Fan** ca. 1942 ■
Gouache on paper
41 x 32 in. (104.1 x 81.3 cm)
Courtesy M. Gutierrez Fine Arts, Miami

19. Untitled (Ñañigo) ca. 1942 ■
Charcoal and wash on paper
40 x 31 in. (101.6 x 78.7 cm)
Private Collection, Miami

20. Untitled (Seated Woman) ca. 1942 ■
Gouache on paper
39½ x 30 in. (100.3 x 76.2 cm)
Private Collection, Miami

21. **The Jungle** 1943
Oil on reinforced paper
94¼ x 90½ in. (239.4 x 229.9 cm)
The Museum of Modern Art, New York. Inter-American Fund

22. Untitled (Ñañigo) 1943
Oil and tempera on paper mounted on linen
77¼ x 48½ in. (197 x 124 cm)
Private Collection, Paris

23. Untitled ca. 1943
Ink and pastel on paper
9 x 12 in. (22.9 x 30.5 cm)
Lowe Art Museum, University of Miami

24. **Caimán comiendose un elefante (Caiman Eating an Elephant)** ca. 1943 ■
Ink and watercolor on paper
9¼ x 6 in. (23.5 x 15.2 cm)
Lowe Art Museum, University of Miami

25. **Homenaje a jicotea (Homage to Jicotea)** ca. 1943
Ink and pastel on tracing paper
6¾ x 8¼ in. (17.2 x 21 cm)
Lowe Art Museum, University of Miami

26. **Angel** ca. 1943 ■
Ink and pastel on tracing paper
5½ x 4½ in. (14 x 11.4 cm)
Lowe Art Museum, University of Miami

27. Untitled 1944
Oil on paper mounted on board
25¾ x 37⅞ in. (65.4 x 96.2 cm)
Collection M/M Knyper, Aspen, Colorado

28. **Autel pour Elegguá (Altar for Elegguá)** 1944 ■
Mixed media on paper mounted on canvas
57⅞ x 36⅝ in. (147 x 93 cm)
Courtesy Galerie Lelong, Paris

29. **Woman (Femme)** 1944
Oil on paper
48 x 36 in. (121.9 x 91.4 cm)
Collection Richard S. Zeisler, New York

30. **Portrait of H. H. (Retrato de H. H.)** 1944
Gouache on paper mounted on board
40½ x 30½ in. (102.9 x 77.5 cm)
Collection Jorge C. Gruenberg, Lima, Peru

31. **The Fascinated Nest** 1944
Oil on canvas
32 x 22 in. (81.3 x 55.9 cm)
Private Collection, Paris, courtesy Christie's

32. **Oiseau lumière** 1944
Oil on paper mounted on canvas
29½ x 37½ in. (74.9 x 95.3 cm)
Courtesy Galerie H. Odermatt—Ph. Cazeau, Geneva

33. **Femme nue** 1944 ■
Oil on paper mounted on canvas
29¾ x 24 in. (75.6 x 61 cm)
Private Collection

34. **Deux figures** 1945
Oil on canvas
25⅝ x 21 in. (65.1 x 53.3 cm)
The Menil Collection, Houston

Lam with his paintings in his Studio at 8, rue Armand Moisant. Paris, 1940

36. **Personnages** 1945
Oil on canvas
24 x 24 in. (61 x 61 cm)
Heinz K. Vaterlaus, courtesy
Arnold Herstand & Co.

37. **Les Oiseaux voiles** 1945
Oil on canvas
43¾ x 49¾ in. (111.1 x 126.4 cm)
Collection M/M Knyper, Aspen, Colorado

38. **Sur les traces** 1945
Oil on canvas
61 x 49¼ in. (154.9 x 125.1 cm)
Collection M/M Knyper, Aspen, Colorado

39. Untitled 1945
Oil on canvas
61½ x 49½ in. (156.2 x 125.7 cm)
Galerie Lelong, Paris

40. **Butinantes** 1945
Oil on canvas
31¾ x 32 in. (80.7 x 81.3 cm)
Collection M/M Knyper, Aspen, Colorado

41. **The Triangle** 1947
Oil on canvas
24¼ x 58¼ in. (61.5 x 148 cm)
Collection Mrs. Yolanda Santos
de Garza Laguera

42. **Personage** 1947
Oil on burlap
43⅛ x 36 in. (109.5 x 91.4 cm)
Santa Barbara Museum of Art.
Gift of Wright S. Ludington

43. **Figure** 1947
Oil on canvas
50 x 43¾ in. (127 x 111.1 cm)
Collection Mrs. Dolores Smithies

44. **Cuarto fambá** 1947
Oil on canvas
26½ x 32 in. (67.3 x 81.3 cm)
Private Collection, Miami

45. **The Dream (Le Rêve)** 1947
Oil on canvas
30¼ x 40⅛ in. (76.8 x 101.9 cm)
Hirshhorn Museum and Sculpture Garden,
Smithsonian Institution, Washington, D.C.
Joseph H. Hirshhorn Bequest, 1981

46. **Exodo** 1948
Oil on burlap
62 x 50½ in. (157.5 x 128.3 cm)
Howard University Gallery of Art,
Washington, D.C.

47. **I Am Leaving** 1948 ■
Oil on burlap
12 x 18 in. (30.5 x 45.7 cm)
Collection Mrs. Josefina Pinedo,
courtesy M. Gutierrez Fine Arts, Miami

48. **L'Esprit aveugle (Blind Soul)** 1948
Oil on canvas
28½ x 33½ in. (72.4 x 85.1 cm)
Indianapolis Museum of Art.
Gift of the Joseph Cantor Collection

49. **Pasos miméticos** 1951
Oil on canvas
46 x 56 in. (117 x 142 cm)
Collection Daniel B. and Marcia G. Kraft,
Potomac, Maryland

50. **Lisamona** 1950
Oil on canvas
51 x 38 in. (130 x 97 cm)
Collection Steven M. Greenbaum,
Goffstown, New Hampshire

51. **Femme cheval** 1950
Oil and charcoal on linen
39 x 32 in. (99.1 x 81.3 cm)
Private Collection, courtesy
Galeria Arvil, Mexico

52. **Femme magique** 1951
Oil on canvas
32 x 28 in. (81.3 x 71.1 cm)
Collection M/M Knyper, Aspen, Colorado

53. Untitled 1951 ■
Oil on canvas
25¾ x 39⅞ in. (64.1 x 101.3 cm)
Collection Jorge C. Gruenberg, Lima, Peru

54. **Reflets d'eau** 1952
Oil on canvas
103 x 23 in. (262 x 58 cm)
Courtesy M. Gutierrez Fine Arts, Miami

NEW YORK SCHOOL / COBRA ARTISTS / OTHER CONTEMPORARIES

55. Karel Appel
Trois personnages 1950
Gouache on paper
19½ x 30 in. (49.5 x 76.2 cm)
Museum of Art, Fort Lauderdale. Gift of
Dr. and Mrs. Meyer B. Marks

56. William Baziotes, Gerome Kamrowski,
Jackson Pollock
Collective Painting 1940–41
Oil and enamel on linen
19¼ x 25½ in. (48.9 x 64.8 cm)
Collection Mary Jane and Gerome Kamrowski

57. Hans Bellmer
Portrait of Wifredo Lam ca. 1964
Pencil, pen, and black ink, heightened with
cream paint, on composition board
28⅜ x 26⅜ in. (72 x 67 cm)
The Art Institute of Chicago.
Worcester Sketch Fund

58. Victor Brauner
The Snake Charmer (La Psylle miraculeuse) 1943 ■
Encaustic on canvas
25⅝ x 21¼ in. (65.1 x 54 cm)
The Museum of Modern Art, New York.
Gift of Mr. and Mrs. Nathan L. Halpern

59. Constant
Untitled 1949
Gouache on paper
17¾ x 20 in. (45.1 x 50.8 cm)
Museum of Art, Fort Lauderdale. Gift of
Dr. and Mrs. Meyer B. Marks

60. Oscar Dominguez
Nostalgia of Space (Nostalgie de l'espace) 1939 ■
Oil on canvas
28¾ x 36⅛ in. (73 x 91.8 cm)
The Museum of Modern Art, New York.
Gift of Peggy Guggenheim

61. Arshile Gorky
The Betrothal II 1947
Oil on canvas
50¾ x 38 in. (128.9 x 96.5 cm)
Whitney Museum of American Art

62. Adolph Gottlieb
Forgotten Dream 1946
Oil on canvas
24 x 30 in. (61 x 76.2 cm)
Herbert F. Johnson Museum of Art, Cornell
University. Gift of Albert A. List

63. Adolph Gottlieb
T 1950
Oil on canvas
48 x 31 in. (121.9 x 78.7 cm)
The Metropolitan Museum of Art. Purchase,
Mr. and Mrs. David M. Solinger Gift

64. Asger Jorn
Untitled 1952 ■
Oil on panel
12¾ x 15½ in. (32.4 x 39.4 cm)
Museum of Art, Fort Lauderdale. Gift of
Dr. and Mrs. Meyer B. Marks

65. Asger Jorn
Untitled 1959 ■
Gouache and drawing on paper
26¾ x 41⅜ in. (68 x 105 cm), framed
Private Collection, Paris

66. André Masson
Constellation II 1943
Tempera and sand on canvas
12¾ x 10½ in. (32.4 x 26.7 cm)
Vassar College Art Gallery

67. Matta (Roberto Sebastian Matta Echaurren)
Et At It 1944
Oil on canvas
33¼ x 96½ in. (84.5 x 245.1 cm)
Collection Richard S. Zeisler, New York

68. Matta (Roberto Sebastian Matta Echaurren)
Composition 1951
Oil on canvas
46¾ x 68¼ in. (118.8 x 173.4 cm)
Collection M/M Knyper, Aspen, Colorado

69. Robert Motherwell
Collage 1946
Collage and oil on paperboard
40 x 30 in. (101.6 x 76.2 cm)
David Winton Bell Gallery, Brown University.
Gift of the Albert A. List Family Collection

70. Robert Motherwell
Western Air 1946–47 ■
Oil on canvas
72 x 54 in. (182.9 x 137.2 cm)
The Museum of Modern Art, New York.
Purchase

71. Jackson Pollock
Burning Landscape 1943
Oil on canvas
36 x 28⁷⁄₁₆ in. (91.4 x 72.3 cm)
Yale University Art Gallery.
Gift of Peggy Guggenheim

72. Jackson Pollock
Water Figure 1945
Oil on canvas
72 x 29 in. (182.9 x 73.7 cm)
Hirshhorn Museum and Sculpture Garden,
Smithsonian Institution, Washington, D.C.
Gift of Joseph H. Hirshhorn, 1966

73. Richard Pousette-Dart
Abstract Eye 1941–43 ■
Oil on canvas
21 x 16½ in. (53.3 x 41.9 cm)
Collection of the artist

74. Richard Pousette-Dart
Figure 1944–45
Oil on linen
79⅞ x 50 in. (202.9 x 127 cm)
Collection of the artist

75. Kurt Seligmann
The Offering 1946
Oil on canvas
42 x 56 in. (106.7 x 142.2 cm)
The Washington County Museum
of Fine Arts, Maryland

76. Kurt Seligmann
Baphomet 1948
Oil on canvas
48¼ x 58⅛ in. (122.6 x 147.6 cm)
Museum of Contemporary Art, Chicago.
Gift of Joseph and Jory Shapiro

77. Maria Helena Vieira da Silva
The City 1950–51 ■
38⅜ x 51 in. (97.3 x 129.4 cm)
The Museum of Modern Art, New York.
Gift of Mrs. Gilbert W. Chapman

CUBAN MODERNISTS

78. Cundo Bermúdez
The Balcony 1941
Oil on canvas
29 x 23⅛ in. (73.7 x 58.7 cm)
The Museum of Modern Art, New York.
Gift of Edgar Kaufmann, Jr.

79. Cundo Bermúdez
Barber Shop 1942
Oil on canvas
25⅛ x 21⅛ in. (63.8 x 53.7 cm)
The Museum of Modern Art, New York.
Inter-American Fund

80. Cundo Bermúdez
Musicians 1943
Oil on canvas
31⅛ x 41⅛ in. (79.1 x 104.5 cm)
Collection Mrs. Dolores Smithies

81. Mario Carreño
The Tornado 1941
Oil on canvas
31 x 41 in. (78.8 x 104.1 cm)
The Museum of Modern Art, New York.
Inter-American Fund

82. Mario Carreño
Sugar Cane Cutters 1943
Pen and ink with brown wash and white
33⅜ x 22⅛ in. (84.8 x 56.2 cm)
The Museum of Modern Art, New York

83. Mario Carreño
Afro-Cuban Dance 1944
Gouache on paper
23½ x 19 in. (59.7 x 48.3 cm)
Art Museum of the Americas, OAS,
Washington, D.C.

84. Mario Carreño
El palmar (The Palm Grove) 1947
Oil on canvas
30 x 36 in. (76.2 x 91.4 cm)
Private Collection, Miami

85. Roberto Diago
Still Life ca. 1946 ■
Oil on cardboard
21 x 19½ in. (53.3 x 49.5 cm)
Private Collection, Miami

86. Roberto Diago
Birds 1946
Ink and watercolor on paper
19 x 25 in. (48.3 x 63.5 cm)
Collection Mr. and Mrs. Ramón Cernuda

87. Roberto Diago
Head 1946
Pen and ink on paper
11⅝ x 8¼ in. (29.5 x 21 cm)
The Museum of Modern Art, New York

88. Carlos Enríquez
Landscape with Wild Horses 1941
Oil on composition board
17½ x 23⅜ in. (44.5 x 60 cm)
The Museum of Modern Art, New York.
Gift of Dr. C. M. Ramirez Corria

89. Carlos Enríquez
Cuban Outlaw 1943
Oil on canvas
47¾ x 34⅞ in. (121.3 x 88.6 cm)
Collection Mr. and Mrs. Ramón Cernuda

90. Carlos Enríquez
**La caoba en el Jardin (The Mahogany Tree
in the Garden)** 1946
Oil on canvas
21⅛ x 16⅛ (53.7 x 41 cm)
Courtesy M. Gutierrez Fine Arts, Miami

91. Víctor Manuel García
Carnival ca. 1940
Oil on canvas
24 x 19 in. (61 x 48.3 cm)
Collection Mr. and Mrs. Ramón Cernuda

92. Víctor Manuel García
Landscape (Paisaje) ca. 1950
Oil on canvas
16 x 20 in. (40.6 x 50.8 cm)
Collection Emeterio Zorrilla, Miami

93. Víctor Manuel García
Muchacha Guajira ca. 1950
Oil on canvas
24 x 30 in. (61 x 76.2 cm)
Collection Emeterio Zorrilla, Miami

94. Luis Martínez-Pedro
Giadrunama and the Bird 1945
Ink on paper
16 x 11 in. (40.6 x 27.9 cm)
Private Collection, Miami

95. Luis Martínez-Pedro
At the Beach of Jibacoa 1946
Watercolor and gouache on cardboard
37¼ x 27¾ in. (31.7 x 23.8 cm)
The Museum of Modern Art, New York

96. Amelia Peláez del Casal
Diablito 1937 ■
Oil on canvas
19 x 9½ in. (48.3 x 24.1 cm)
Private Collection, Miami

97. Amelia Peláez del Casal
Still Life in Red 1938 ■
Oil on canvas
27¼ x 33½ in. (69.3 x 85.1 cm)
The Museum of Modern Art, New York.
Inter-American Fund

98. Amelia Peláez del Casal
Fishes 1943
Oil on canvas
45½ x 35⅛ in. (115.6 x 89.2 cm)
The Museum of Modern Art, New York.
Inter-American Fund

99. Amelia Peláez del Casal
Fruit Dish 1947
Oil on canvas
44½ x 47⅞ in. (112.8 x 120.3 cm)
Collection Mr. and Mrs. Ramón Cernuda

100. Fidelio Ponce de Leon
First Communion 1935 ■
Oil on canvas
35 x 39 in. (88.9 x 99.1 cm)
Collection Mr. and Mrs. Ramón Cernuda

101. Fidelio Ponce de Leon
Saint Ignatius of Loyola ca. 1940
Oil on canvas
34½ x 34½ in. (87.6 x 87.6 cm)
Collection Mr. and Mrs. Ramón Cernuda

102. René Portocarrero
Interior del Cerro (Cerro Interior) 1943
Oil on canvas
31 x 25½ in. (78.7 x 64.8 cm)
Private Collection

103. René Portocarrero
The Happy Family 1944
Oil on panel
34½ x 29 1/16 in. (87.6 x 73.9 cm)
Private Collection, Miami

104. René Portocarrero
Brujo 1945
Oil on canvas
27 x 23¾ in. (68.6 x 60.3 cm)
Private Collection, Miami

105. René Portocarrero
Mythological Personage 1945
Gouache
37¼ x 27¾ in. (94.6 x 70.5 cm)
The Museum of Modern Art, New York

106. Teodoro Ramos Blanco
Old Negro Woman 1939 ■
Acana wood
11⅛ in. (28.3 cm) high
The Museum of Modern Art, New York.
Inter-American Fund

107. Teodoro Ramos Blanco
Head of Langston Hughes n.d. ■
Plaster
12½ x 8 x 5 in. (31.8 x 20.3 x 12.7 cm)
Art & Artifacts Division, Schomburg Center for
Research in Black Culture, The New York Public
Library, Astor, Lenox and Tilden Foundations

108. Mariano Rodríguez
The Cock 1941 ■
Oil on canvas
29¼ x 25⅛ in. (74.3 x 63.8 cm)
The Museum of Modern Art, New York. Gift of
the Comisión Cubana de Cooperación Intelectual

109. Mariano Rodríguez
Cockfight 1942
Oil on canvas
30 x 25 in. (76.2 x 63.5 cm)
Private Collection, Miami

110. Mariano Rodríguez
Figures in a Landscape 1942
Watercolor on paper
23 x 28 in. (58.4 x 71.1 cm)
The Museum of Modern Art, New York

Objects

111. Ibo male shrine figure, n.d.
Wood
69 in. (175.3 cm) high
Courtesy M. Gutierrez Fine Arts, Miami
(formerly collection Wifredo Lam)

112. New Guinea (East Sepik province,
Karawari River) hunting and war figure, n.d.
Wood
81 in. (205.7 cm) high
Private Collection, Florida, courtesy
M. Gutierrez Fine Arts
(formerly collection Wifredo Lam)

113. Amulet
Leaves and ribbon on paper
3 x 5 in. (7.6 x 12.7 cm)
Private Collection, Paris

**Books with illustrations by Lam
and/or his contemporaries**

114. André Breton
Fata Morgana. Marseilles: Editions du
sagittaire, 1941
The Museum of Modern Art Library,
Special Collections

115. André Breton
Martinique: Charmeuse de serpents
Paris: Jean-Jacques Pauvert, 1972
(First edition 1941)
Illustrations by André Masson
The Museum of Modern Art Library,
Special Collections

116. Aimé Césaire
Retorno al país natal 1943
Preface by Benjamin Peret, illustrations
by Lam. Translation by Lydia Cabrera
Colección de Textos Poeticos
Numbered 260 or 300
Estate of Pierre Matisse, New York

117. **Le Jeu de Marseilles** (playing cards
designed by Lam)
The Museum of Modern Art Library,
Special Collections

118. *Instead* magazine, nos. 5–6,
November 1948

Bibliographic materials

119. Baragaño, J. A. **Wifredo Lam**. Havana:
Sociedad Colombista, 1948.
Collection Nereyda García-Ferraz, Chicago

120. Alfred H. Barr, "Modern Cuban Painters,"
Museum of Modern Art Bulletin April 1944
Private Collection

121. Victor Landaluze
Tipos y Costumbres de la Isla de Cuba
Havana: Miguel de Villa, 1881
Private Collection

122. Pierre Loeb
Voyages à travers la peinture
Paris: Editorial Bordas, 1945
Private Collection

123. Ortíz, Fernando. **Wifredo Lam y su
obra vista a tráves de significados críticos.**
Havana: Ministerio de Educación, 1950.
Estate of Pierre Matisse, New York

Note: Cat. no. 35 is not in the exhibition.

The Catalogue

1
Deux personnages. 1938
Collection Mme Françoise Thésée, France

2
The Family. 1938
Private Collection, Paris

3

Personnage assis [La Lettre]. 1938
Private Collection, Miami

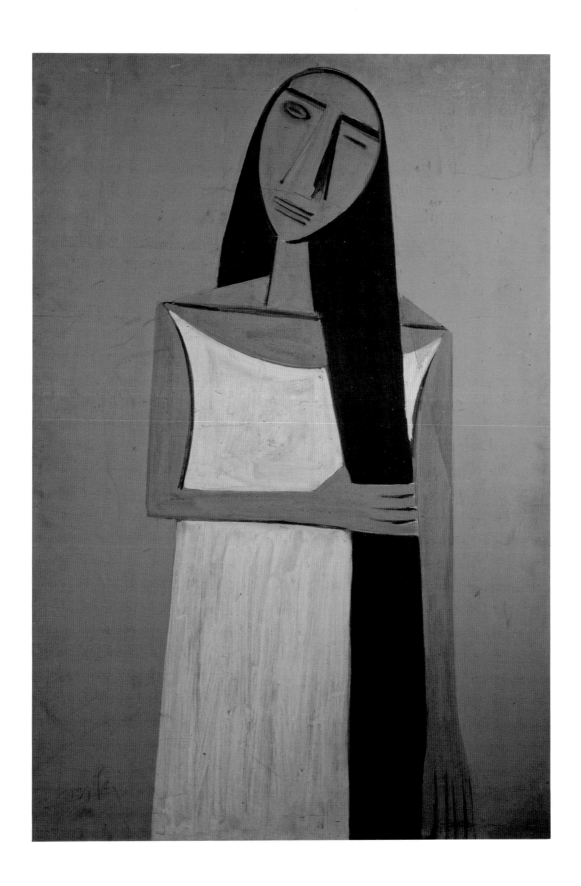

5
Woman Holding Her Hair. 1939
Private Collection

9
Figure. 1942
Arteurial, Paris

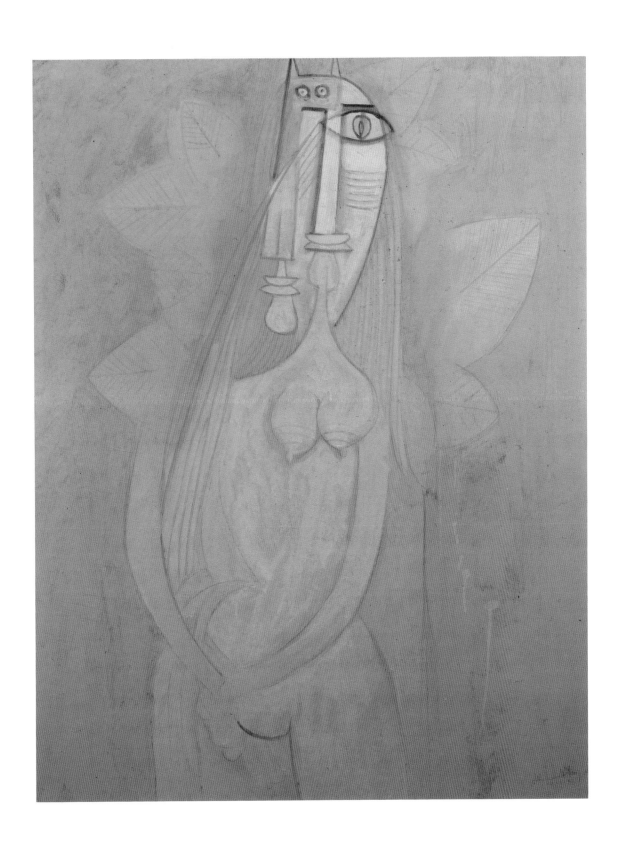

11
Femme. 1942
Private Collection

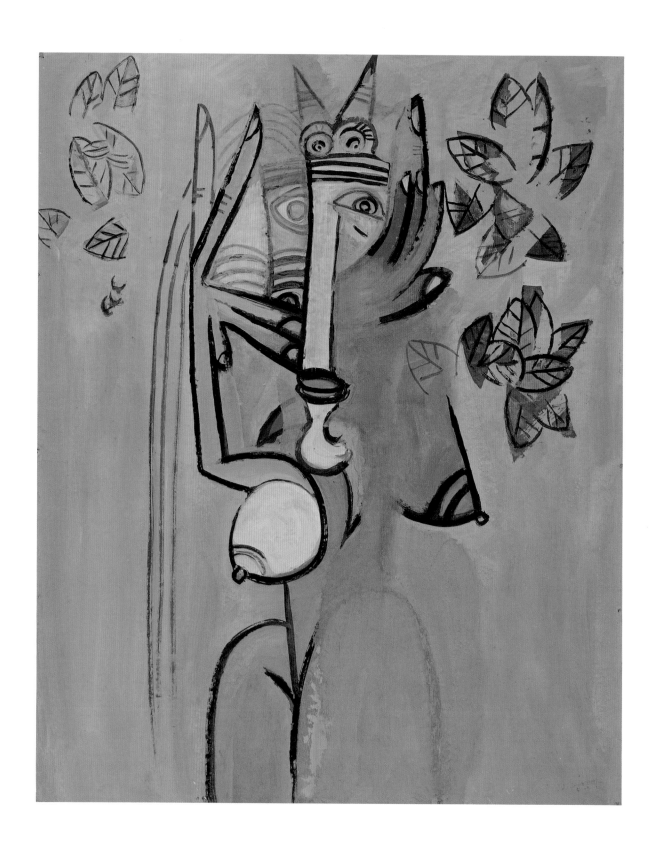

13
Déesse avec feuillage. 1942
Private Collection

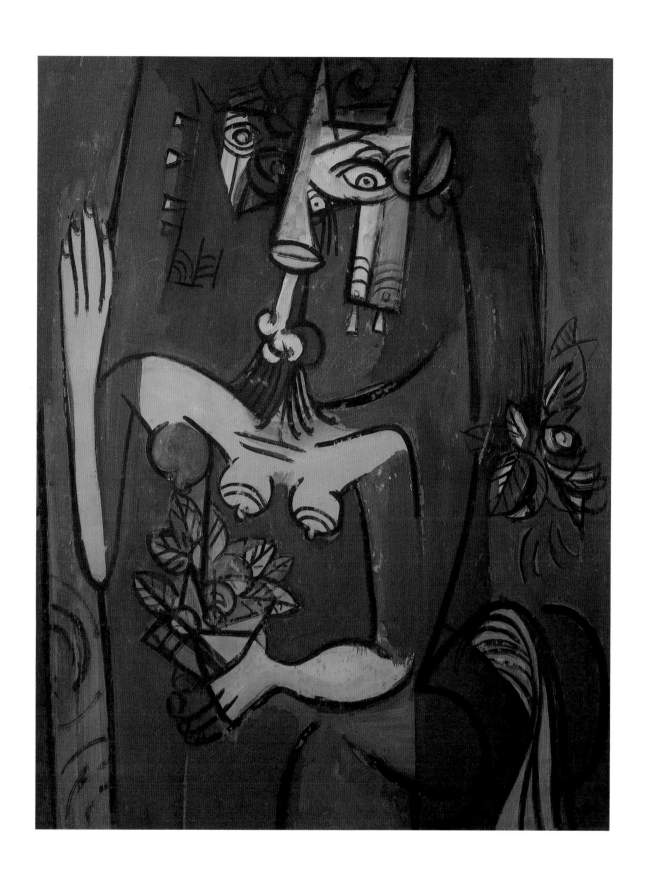

14
Les Yeux de la grille. 1942
Private Collection

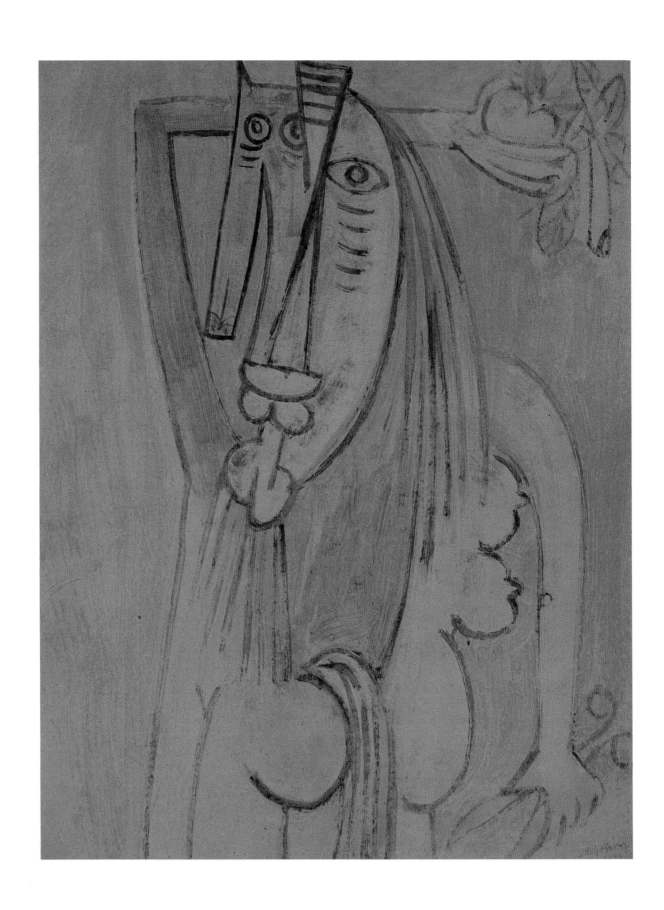

15
Untitled. 1942
Collection Dr. Alberto Martinez-Piedra, Maryland

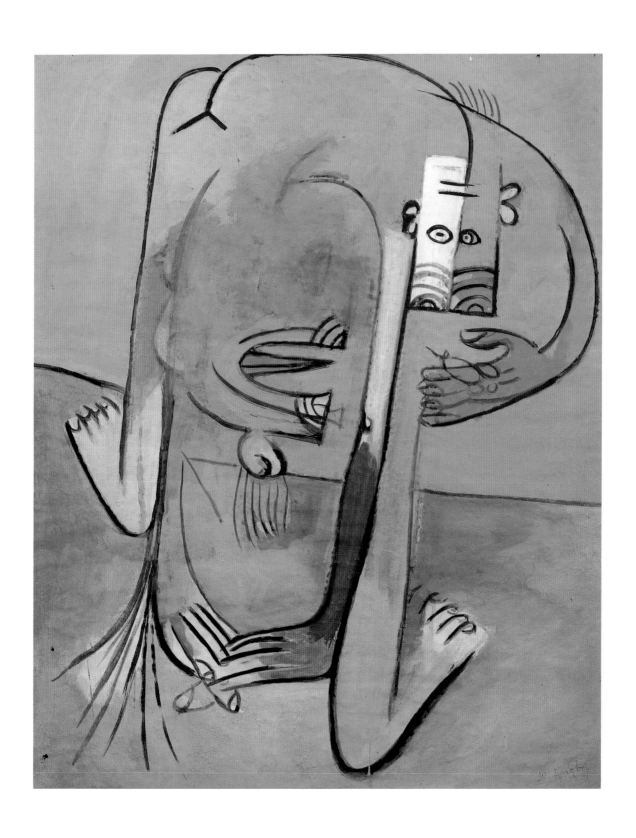

16
L'Homme à la vague. 1942
Private Collection

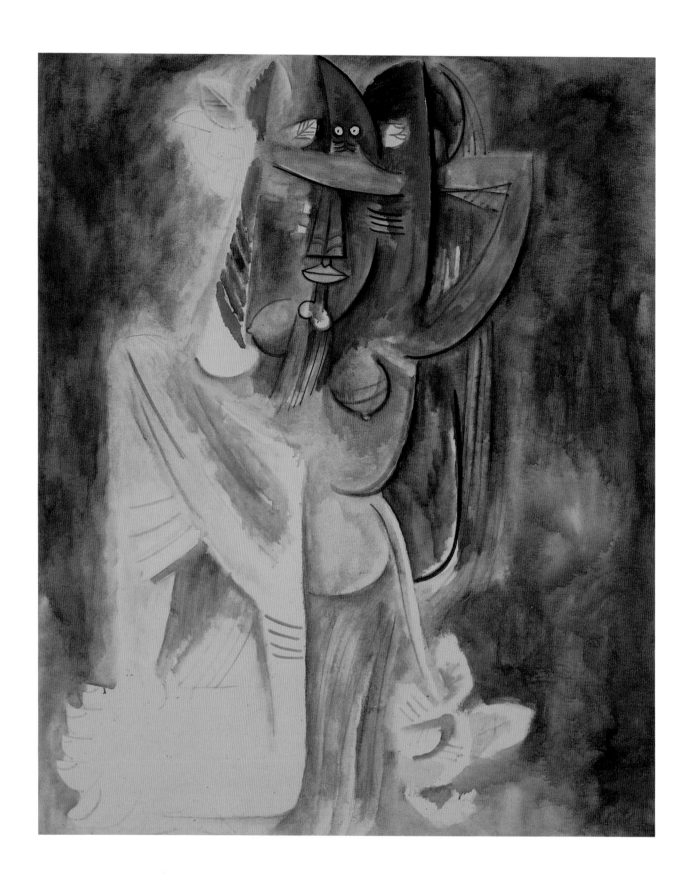

17
Anamú. 1942
Museum of Contemporary Art, Chicago

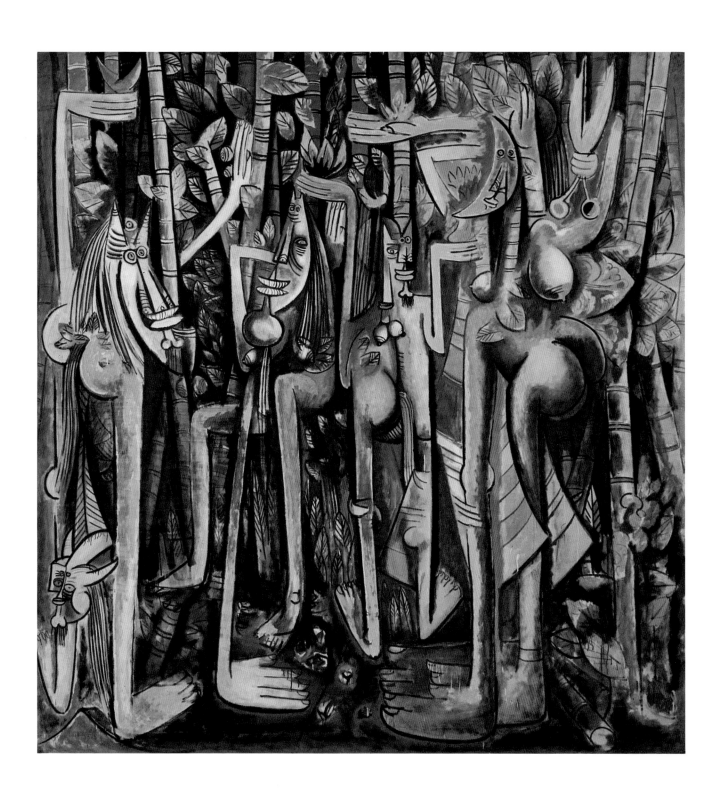

21
The Jungle. 1943
The Museum of Modern Art, New York

27
Untitled. 1944. Collection Mr. and Mrs. Melvin W. Knyper,
Aspen, Colorado

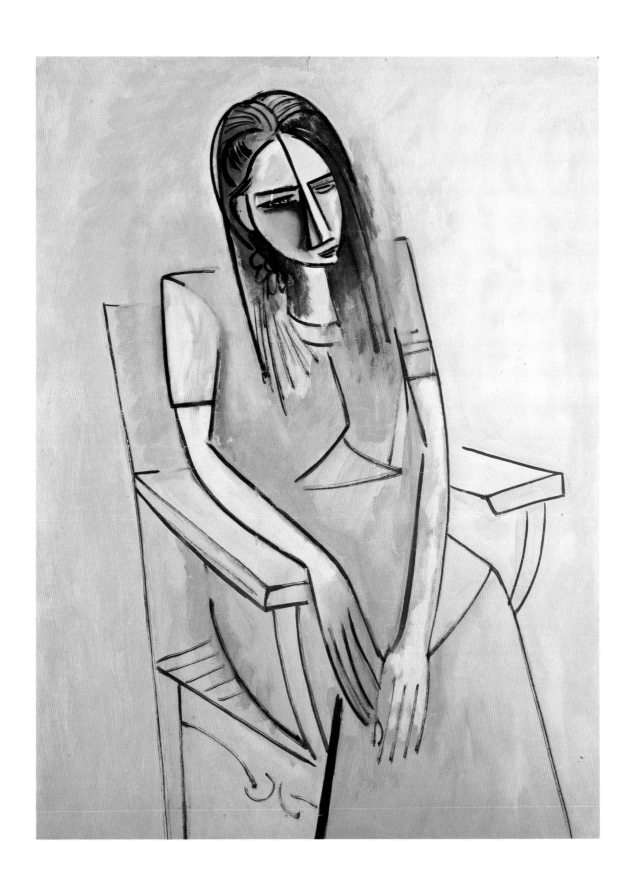

30
Portrait of H.H. 1944
Collection Jorge C. Gruenberg, Peru

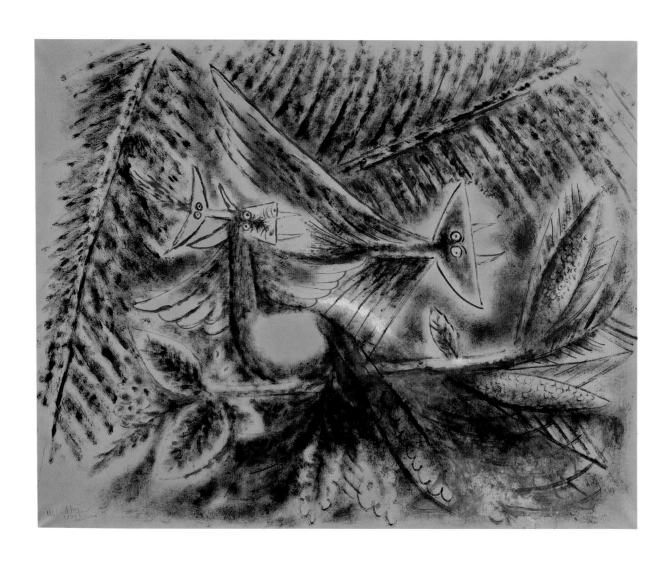

32
Oiseau lumière. 1944
Courtesy Galerie H. Odermatt–Ph. Cazeau

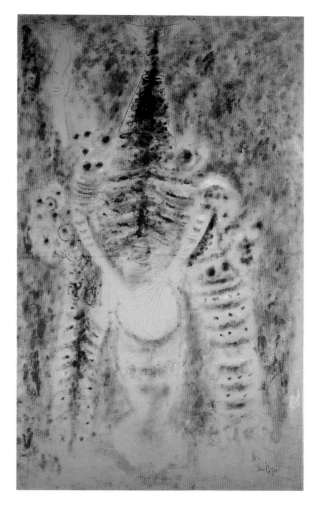

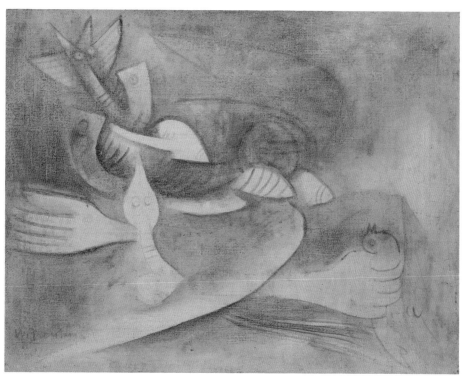

22
Untitled (Ñáñigo). 1943
Private Collection, Paris

31
The Fascinated Nest. 1944
Private Collection, Paris, courtesy Christie's

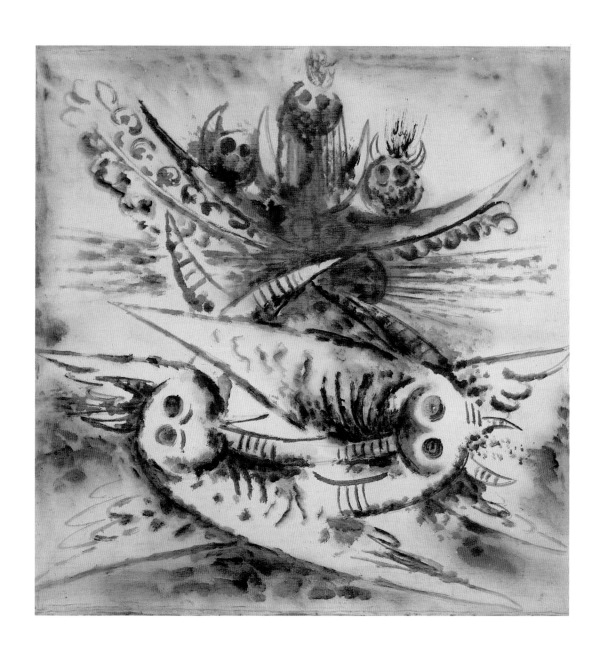

36
Personnages. 1945. Collection Heinz K. Vaterlaus, courtesy Arnold Herstand & Co.

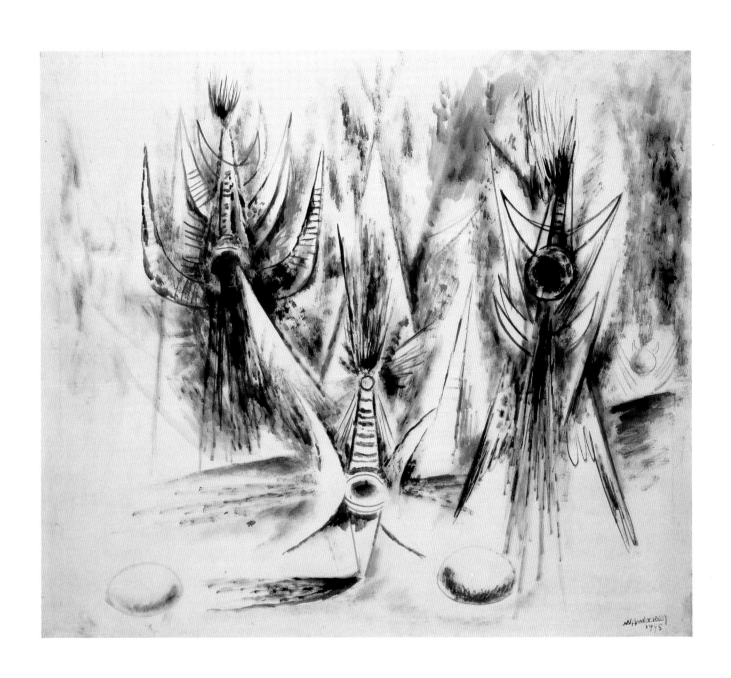

37
Les Oiseaux voiles. 1945. Collection Mr. and Mrs. Melvin W. Knyper,
Aspen, Colorado

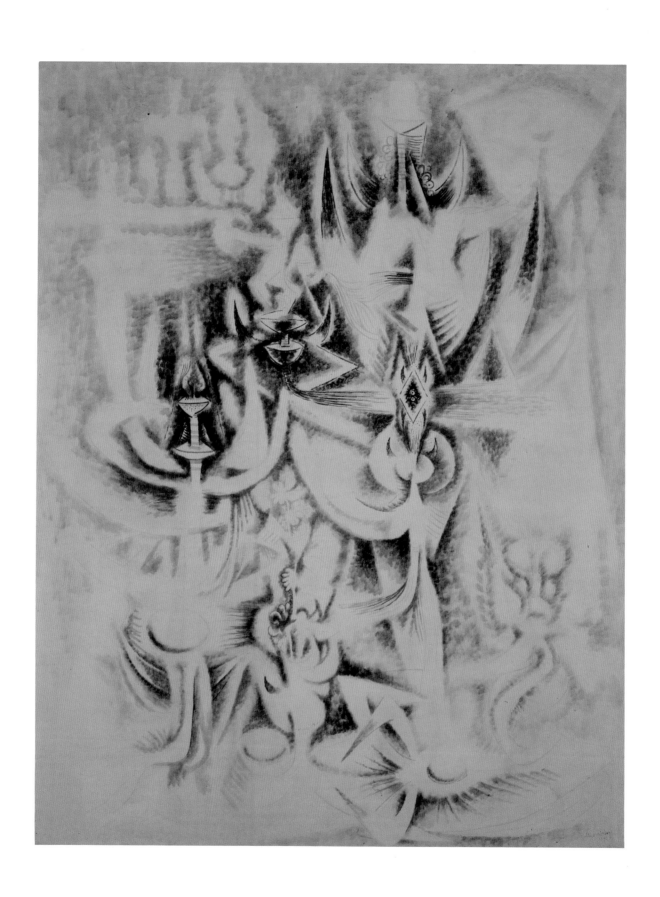

38
Sur les traces. 1945. Collection Mr. and Mrs. Melvin W. Knyper,
Aspen, Colorado

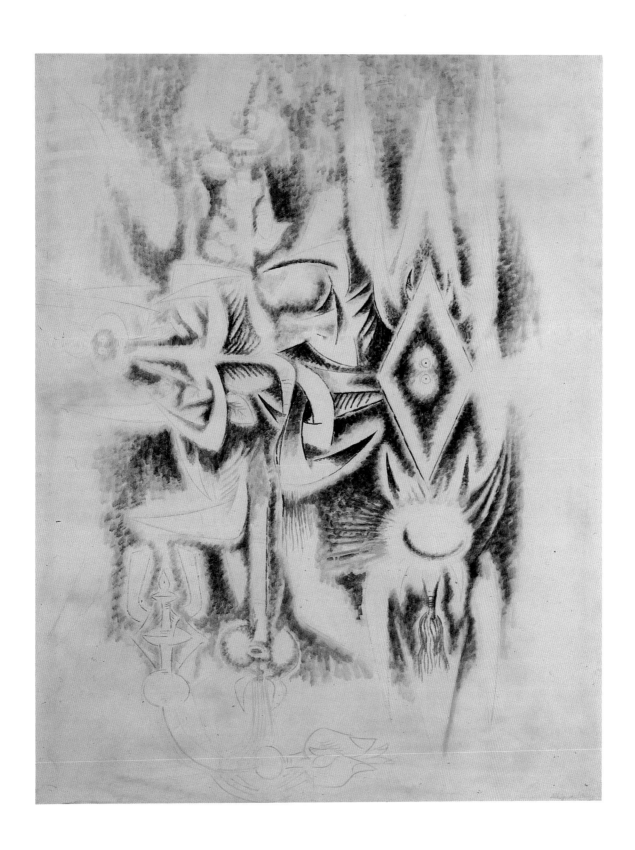

39
Untitled. 1945
Galerie Lelong, Paris

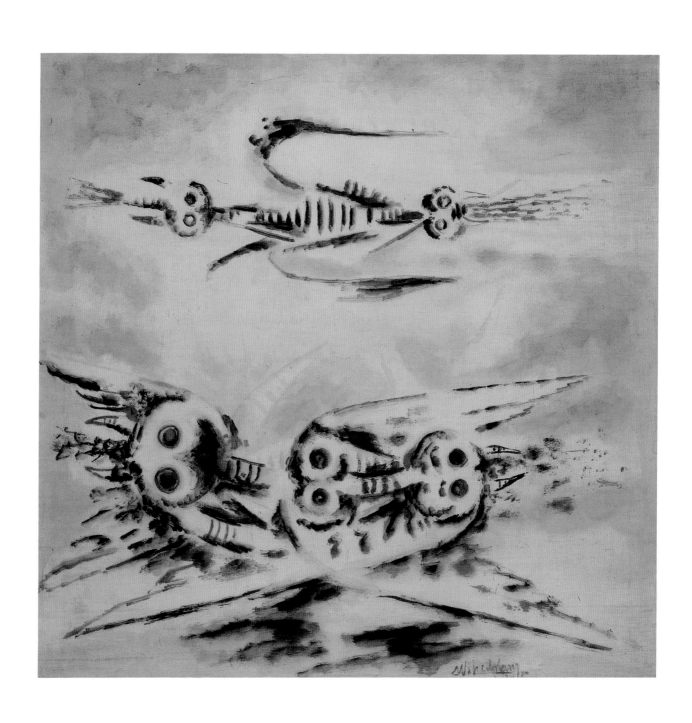

40
Butinantes. 1945. Collection Mr. and Mrs. Melvin W. Knyper,
Aspen, Colorado

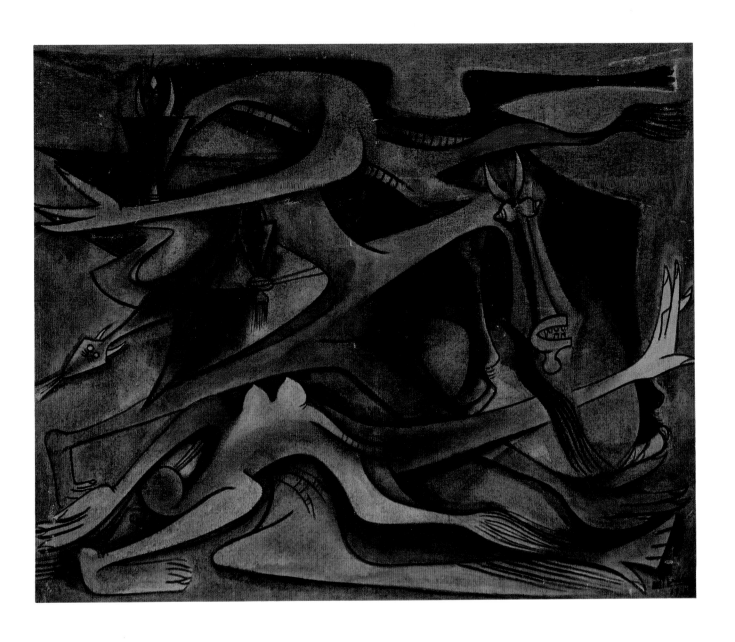

46
Exodo. 1948. Howard University Gallery of Art,
Washington, D.C.

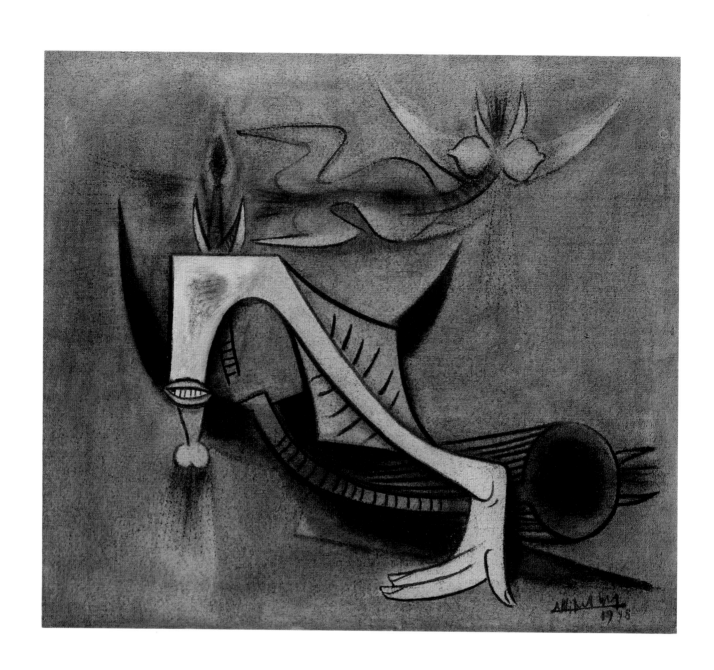

48
L'Esprit aveugle. 1948
Indianapolis Museum of Art

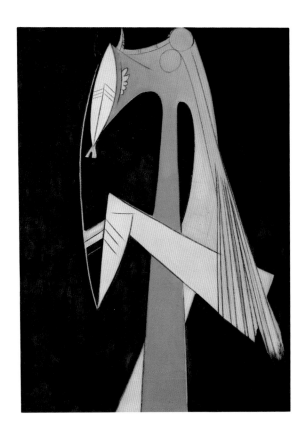

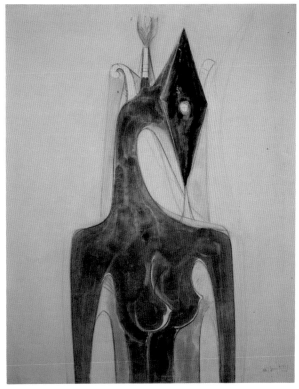

50
Lisamona. 1950
Collection Steven M. Greenbaum, New Hampshire

51
Femme cheval. 1950
Private Collection, courtesy Galería Arvil, Mexico

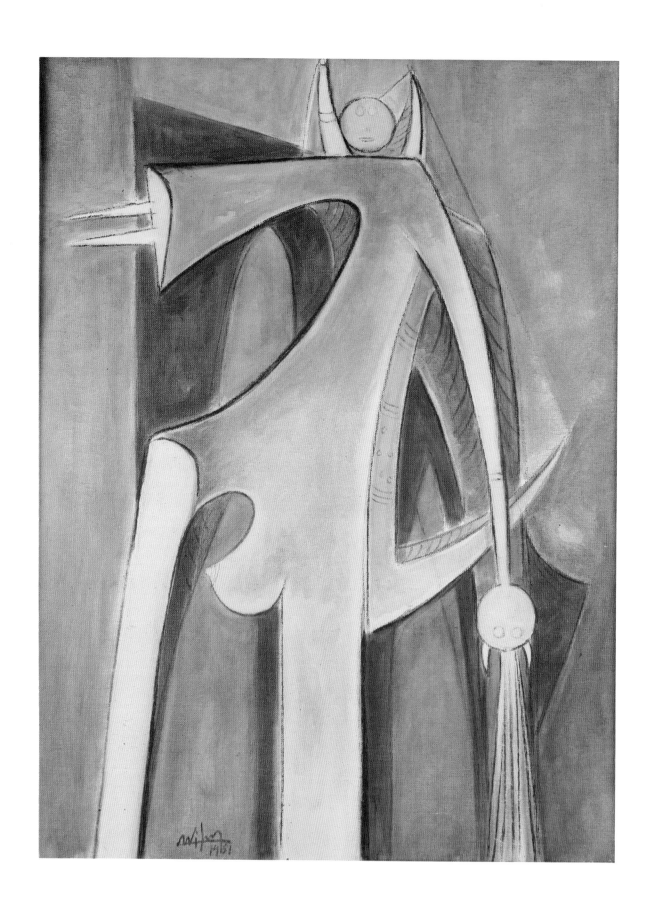

52
Femme magique. 1951. Collection
Mr. and Mrs. Melvin W. Knyper, Aspen, Colorado

67
Matta. **Et At It.** 1944
Collection Richard S. Zeisler, New York

68
Matta. **Composition.** 1951. Collection
Mr. and Mrs. Melvin W. Knyper, Aspen, Colorado

74
Richard Pousette-Dart. **Figure.** 1944–45
Collection of the artist

56
William Baziotes, Gerome Kamrowski, and Jackson Pollock
Collective Painting. 1940–41
Collection Mary Jane and Gerome Kamrowski

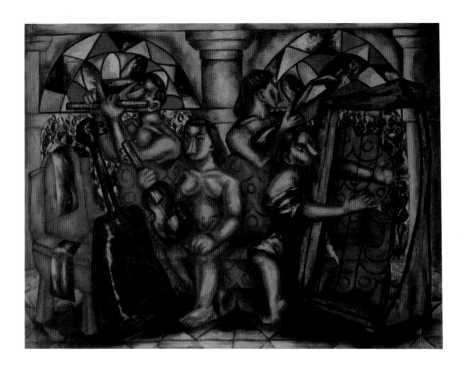

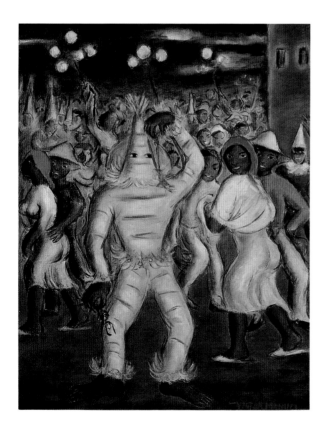

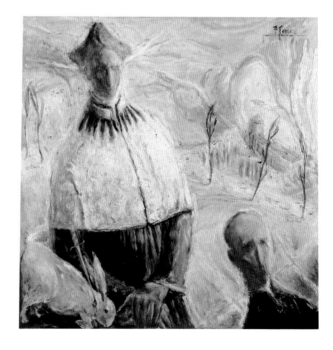

80
Cundo Bermúdez. **Musicians.** 1943
Collection Mrs. Dolores Smithies

91
Victor Manuel García. **Carnival.** ca. 1940
Collection Mr. and Mrs. Ramón Cernuda

101
Fidelio Ponce de Leon. **St. Ignatius of Loyola.** ca. 1940
Collection Mr. and Mrs. Ramón Cernuda

109
Mariano Rodríguez. **Cockfight.** 1942
Private Collection, Miami

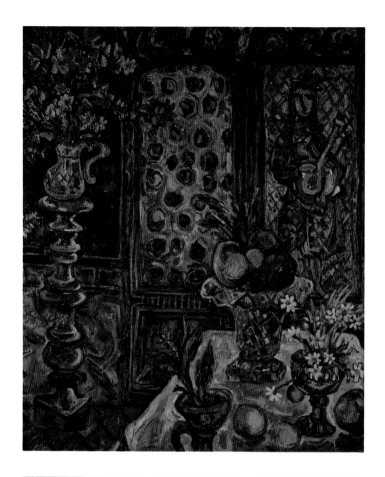

102
René Portocarrero. **Interior del Cerro.** 1943
Private Collection

99
Amelia Peláez del Casal. **Fruit Dish.** 1947
Collection Mr. and Mrs. Ramón Cernuda

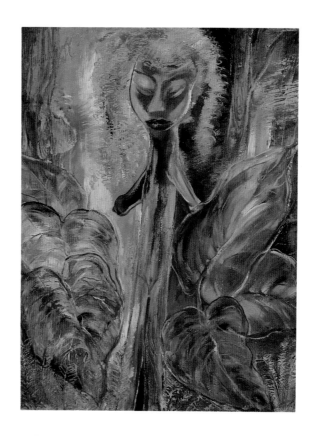

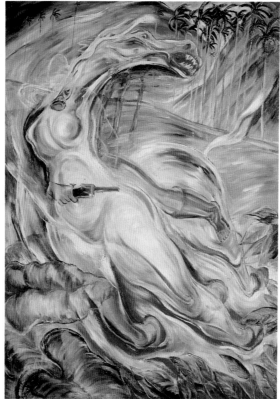

90
Carlos Enriquez. **La caoba en el jardin.** 1946
Courtesy M. Gutierrez, Fine Arts, Miami

89
Carlos Enriquez. **Cuban Outlaw.** 1943
Collection Mr. and Mrs. Ramón Cernuda

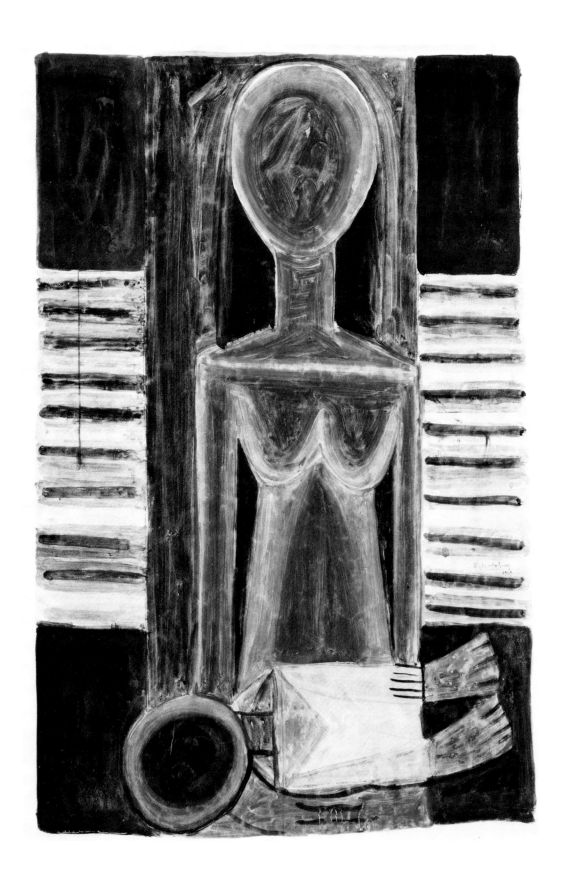

4
Mother and Child. 1939
The Museum of Modern Art, New York

7
Marseilles notebook (Preparatory drawings for
Fata Morgana) 1940–41
Collection Gerald J. Millstein, M.D.

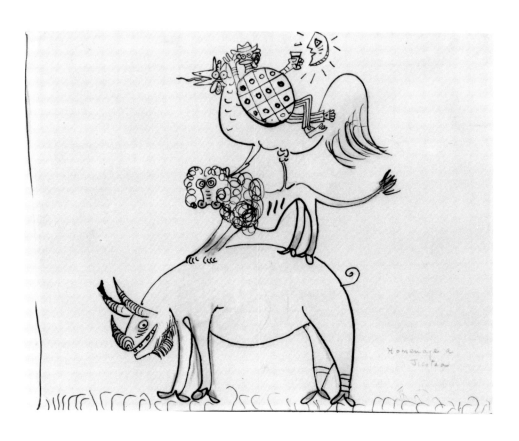

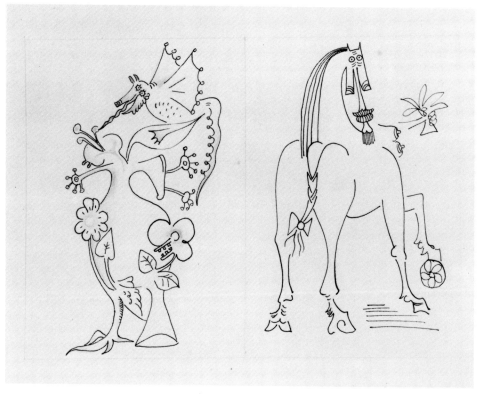

25
Homenaje a jicotea. ca. 1943
Lowe Art Museum, University of Miami

23
Untitled. ca. 1943
Lowe Art Museum, University of Miami

29
Woman. 1944
Collection Richard S. Zeisler, New York

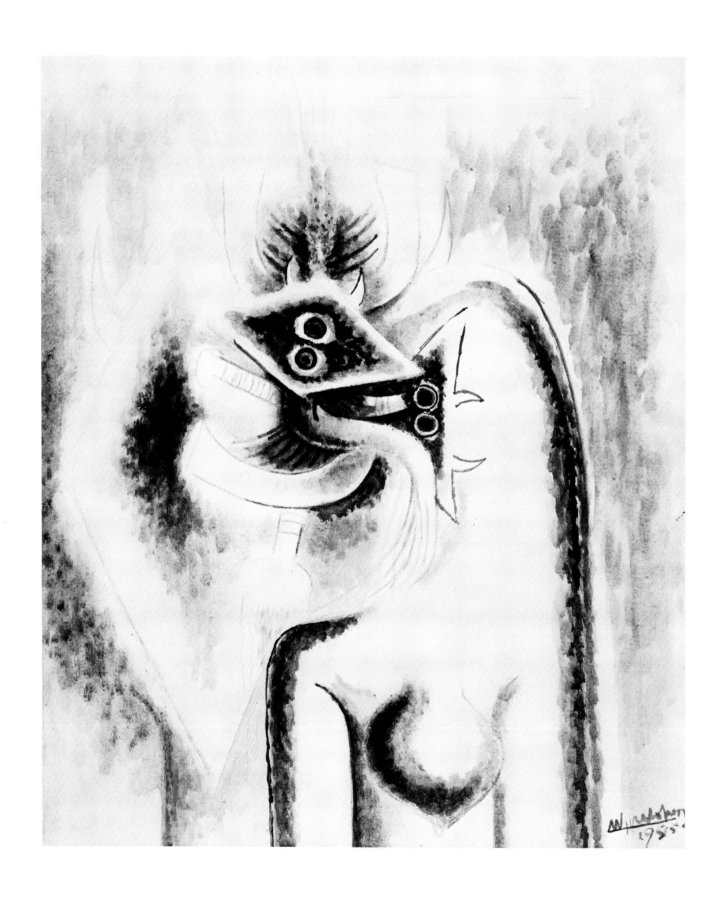

34
Deux figures. 1945
The Menil Collection, Houston

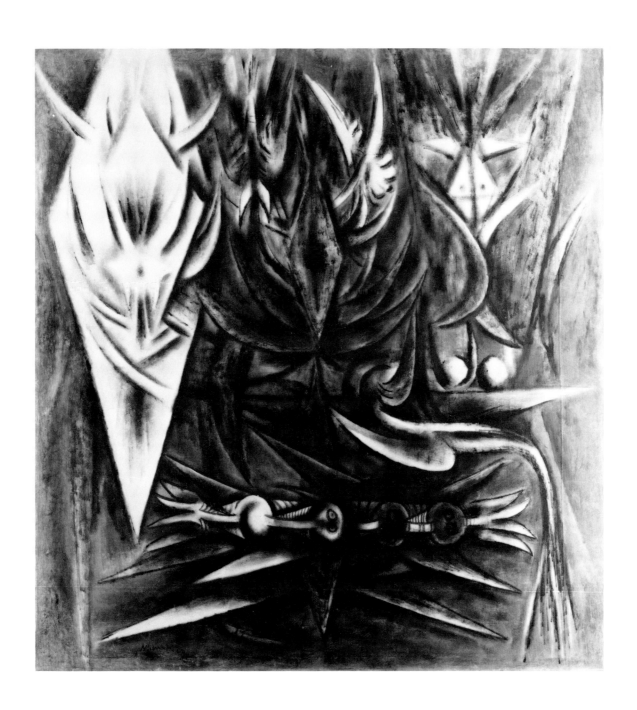

41
The Triangle. 1947. Collection Mrs. Yolanda Santos
de Garza Laguera

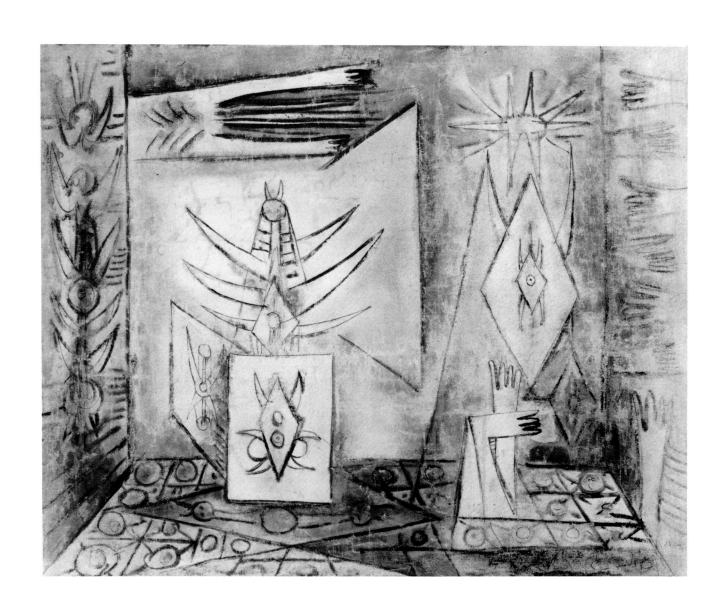

44
Cuarto fambá. 1947
Private Collection, Miami

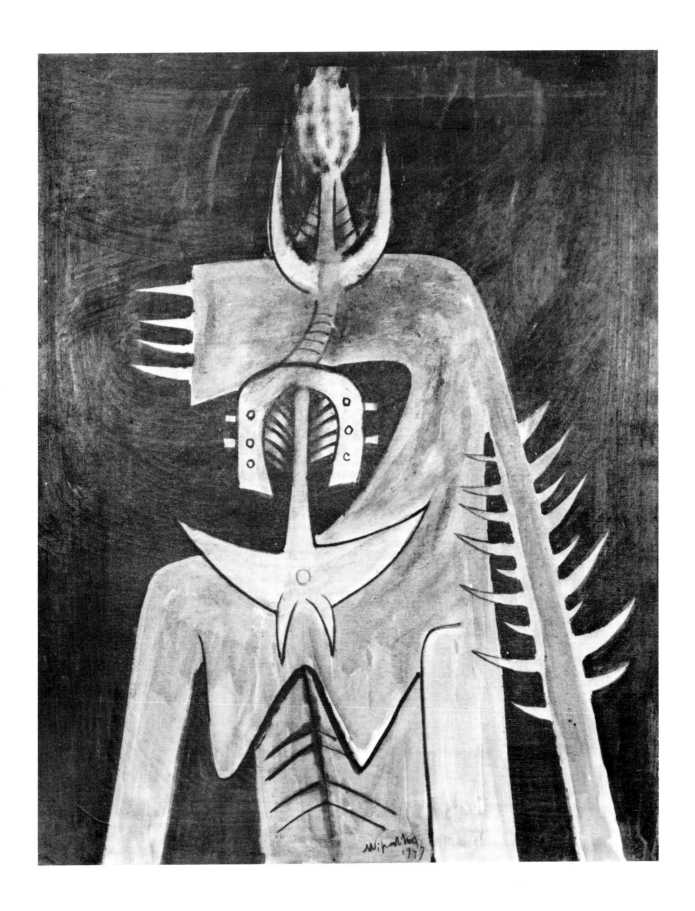

43
Figure. 1947
Collection Mrs. Dolores Smithies

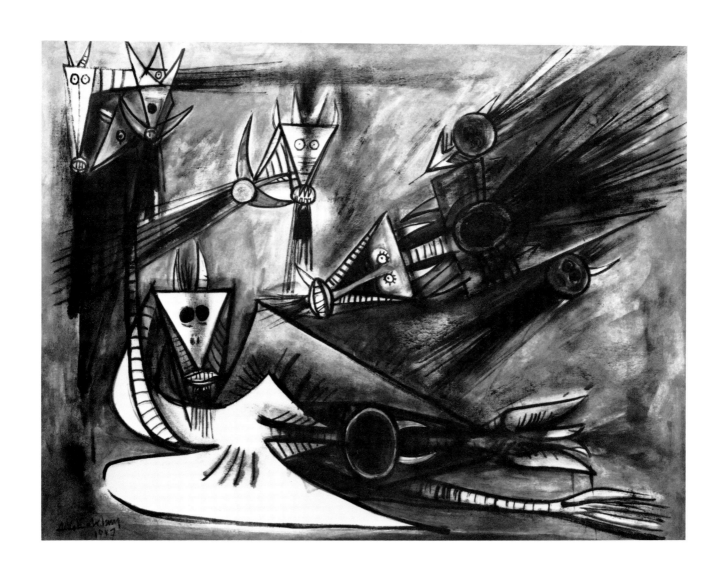

45
Le Rêve. 1947. Hirshhorn Museum and Sculpture Garden,
Smithsonian Institution

54
Reflets d'eau. 1952
Courtesy M. Guttierez Fine Arts, Miami

55
Karel Appel. **Trois personnages.** 1950
Museum of Art, Fort Lauderdale

59
Constant. Untitled. 1949
Museum of Art, Fort Lauderdale

61
Arshile Gorky. **The Betrothal II.** 1947
Whitney Museum of American Art

62
Adolph Gottlieb. **Forgotten Dream.** 1946
Herbert F. Johnson Museum of Art, Cornell University

63
Adolph Gottlieb. T. 1950
The Metropolitan Museum of Art

69
Robert Motherwell. **Collage.** 1946
David Winton Bell Gallery, Brown University

71
Jackson Pollock. **Burning Landscape.** 1943
Yale University Art Gallery

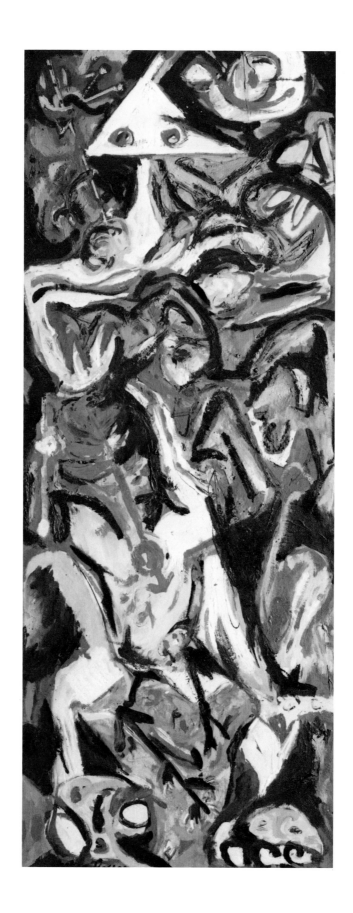

72
Jackson Pollock. **Water Figure.** 1945
Hirshhorn Museum and Sculpture Garden, Smithsonian Institution

66
André Masson. Constellation II. 1943
Vassar College Art Gallery

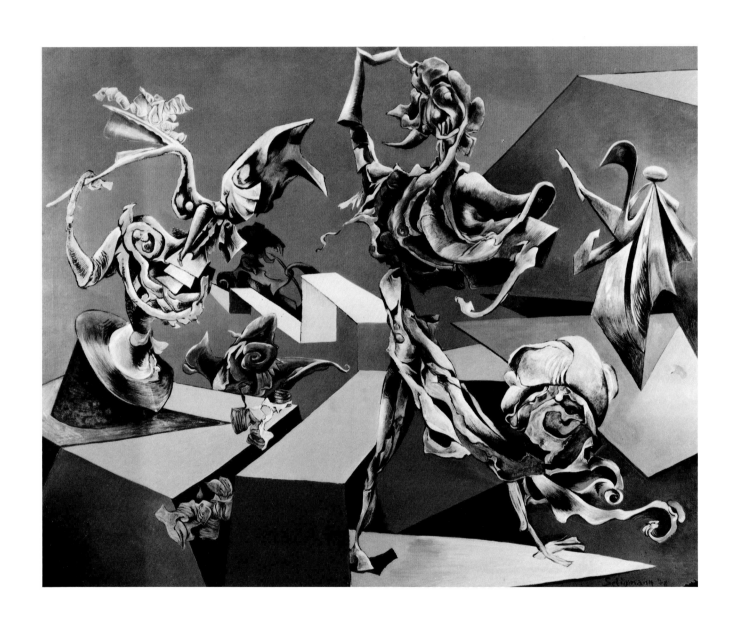

76
Kurt Seligmann. **Baphomet.** 1948
Museum of Contemporary Art, Chicago

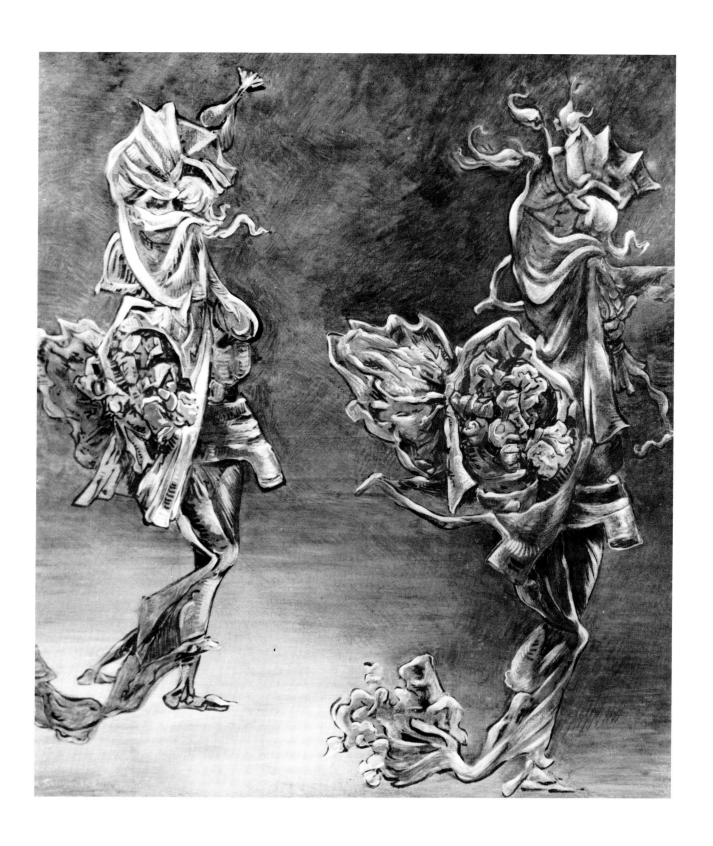

75
Kurt Seligmann. **The Offering.** 1946
The Washington County Museum of Fine Art, Maryland

78
Cundo Bermúdez. **The Balcony.** 1941
The Museum of Modern Art, New York

79
Cundo Bermúdez. **Barber Shop.** 1942
The Museum of Modern Art, New York

81
Mario Carreño. **The Tornado.** 1941
The Museum of Modern Art, New York

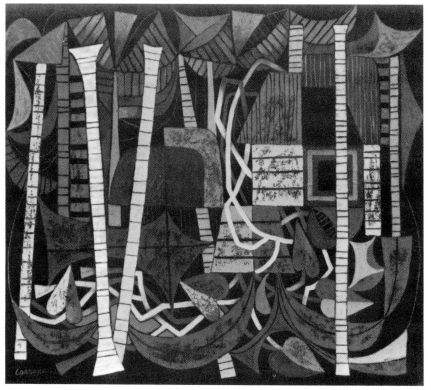

83
Mario Carreño. Afro-Cuban Dance. 1944
Art Museum of the Americas, OAS, Washington, D.C.

84
Mario Carreño. **El Palmar.** 1947
Private Collection, Miami

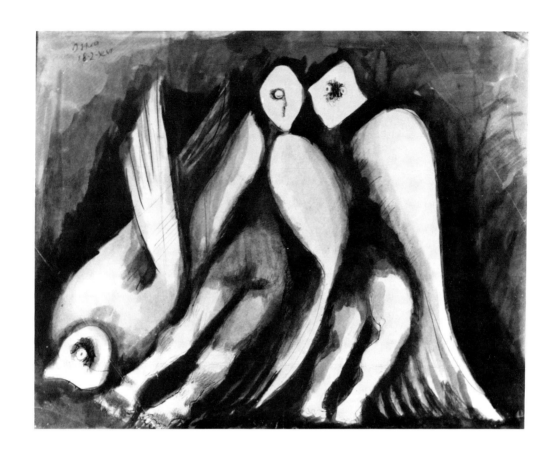

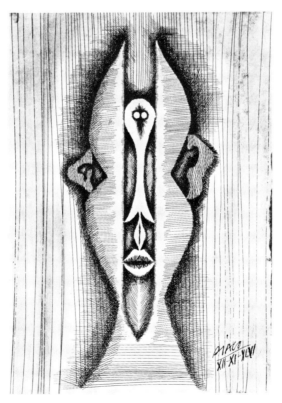

86
Roberto Diago. **Birds.** 1946
Collection Mr. and Mrs. Ramón Cernuda

87
Roberto Diago. **Head.** 1946
The Museum of Modern Art, New York

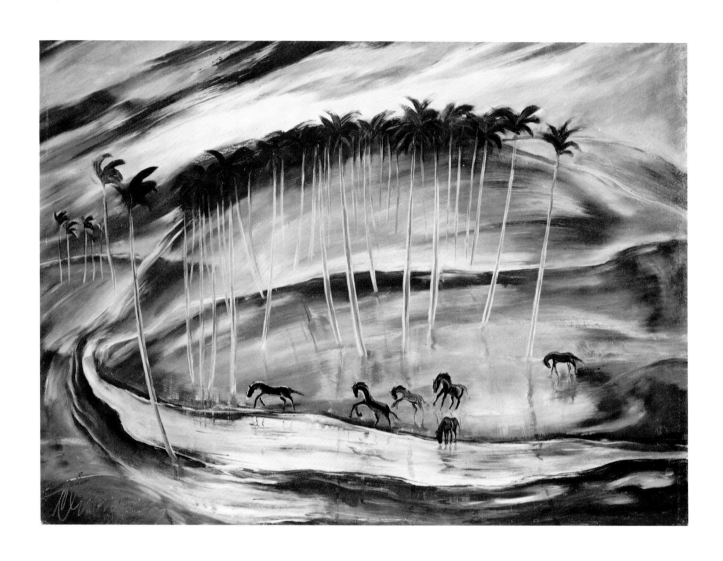

88
Carlos Enriquez. **Landscape with Wild Horses.** 1941
The Museum of Modern Art, New York

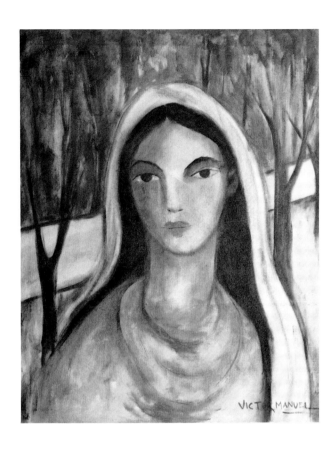

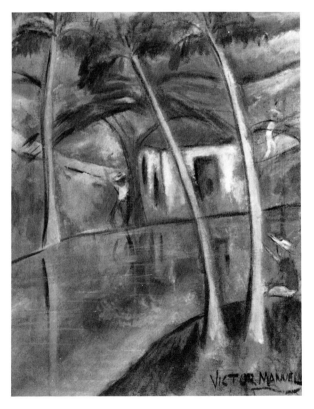

93
Víctor Manuel García. **Muchacha Guajira.** ca. 1950
Collection Emeterio Zorrilla, Miami

92
Víctor Manuel García. **Landscape.** ca. 1950
Collection Emeterio Zorrilla, Miami

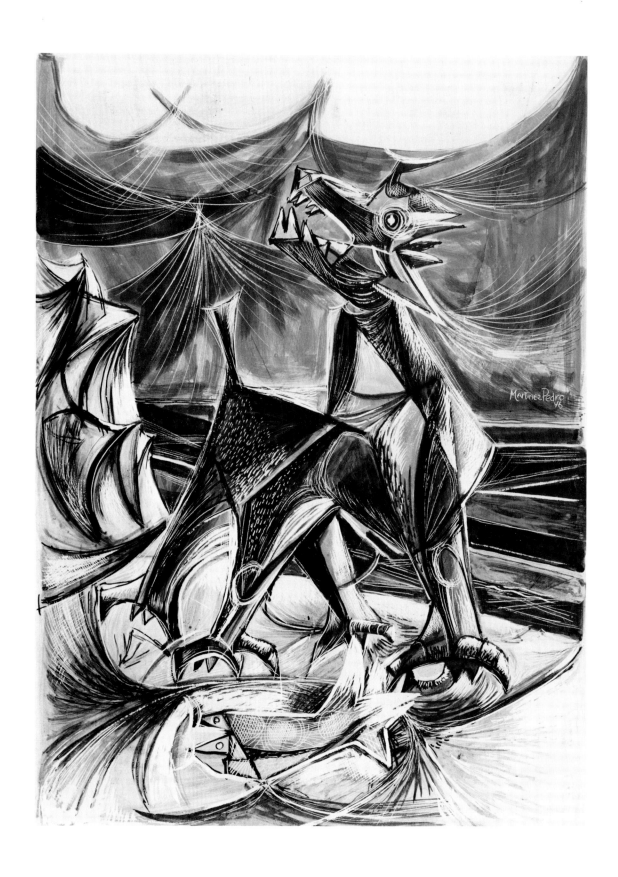

95
Luis Martínez-Pedro. **At the Beach of Jibacoa.** 1946
The Museum of Modern Art, New York

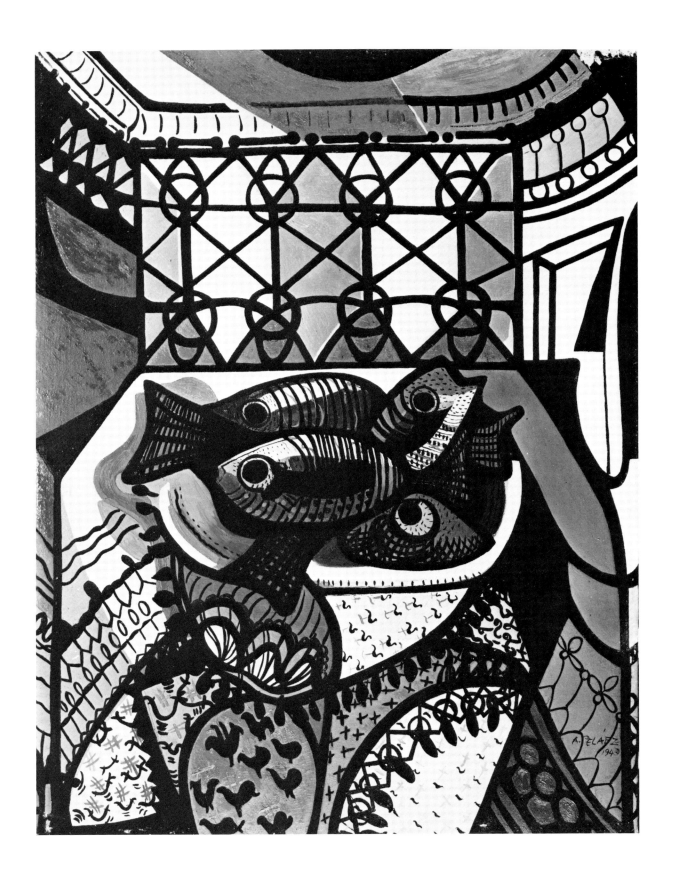

98
Amelia Peláez del Casal. **Fishes.** 1943
The Museum of Modern Art, New York

103
René Portocarrero. **The Happy Family.** 1944
Private Collection, Miami

110
Mariano Rodríguez. **Figures in a Landscape.** 1942
The Museum of Modern Art, New York

94
Luis Martínez-Pedro. **Giadrunama and the Bird.** 1945
Private Collection, Miami

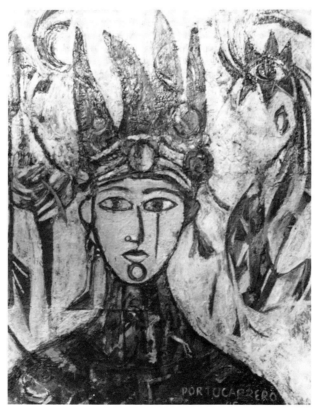

105
René Portocarrero. **Mythological Personage.** 1945
The Museum of Modern Art, New York

104
René Portocarrero. **Brujo.** 1945
Private Collection, Miami

112
New Guinea hunting and war figure. n.d.
Private Collection, courtesy M. Guttierez Fine Arts, Miami

111
Ibo male shrine figure. n.d.
Courtesy M. Guttierez Fine Arts, Miami

Helena Holzer Lam and the first
eight pieces of African art
Wifredo Lam brought back from
Paris in early 1947. This photo-
graph was taken in March 1947
in her home at Avenida 8a
(Marianao), Havana

Lenders to the Exhibition

Mario Amiguet
Artcurial, Paris
The Art Institute of Chicago
Art Museum of the Americas, OAS, Washington, D.C.
Mr. and Mrs. Ramón Cernuda, Miami, Florida
CDS Gallery, N.Y.
David Winton Bell Gallery, Brown University, Providence, R.I.
M. Gutierrez Fine Art, Miami, Florida
Galeria Arvil, Mexico, D.F.
Nereyda García-Ferraz, Chicago
Steven M. Greenbaum, New Hampshire
Jorge C. Gruenberg, Lima, Peru
Herbert F. Johnson Museum of Art, Cornell University, Ithaca, N.Y.
Hirshhorn Museum and Sculpture Garden, Smithsonian Institution, Washington, D.C.
Howard University Gallery of Art, Washington, D.C.
Indianapolis Museum of Art, Indiana
Daniel B. and Marcia G. Kraft, Maryland
Mr. and Mrs. Melvin W. Knyper, Aspen, Colorado
Mary Jane and Gerome Kamrowski, Ann Arbor, Michigan
Maurice Landsberg
Galerie Lelong, New York
Galerie Lelong, Paris
Lowe Art Museum, The University of Miami, Coral Gables, Florida
Dr. Alberto Martinez-Piedra, Maryland
Pierre Matisse Foundation, New York
The Menil Collection, Houston
The Metropolitan Museum of Art, New York
Gerald J. Millstein, M.D., Fort Lauderdale, Florida
Museum of Contemporary Art, Chicago
Musée National d'Art Moderne, Centre Georges Pompidou, Paris
Museum of Art, Fort Lauderdale, Florida
The Museum of Modern Art, New York
Museum Tower Editions, New York
Galerie H. Odermatt–Ph. Cazeau, Paris
Richard Pousette-Dart, New York
Santa Barbara Museum of Art, California
Mrs. Yolanda Santos de Garza Lagüera, Monterrey, Mexico
Schomburg Center for Research in Black Culture, New York
Mrs. Dolores Smithies, Key Biscayne, Florida
Mme Françoise Thésée, Chatillon, France
Vassar College Art Gallery, Poughkeepsie, New York
Heinz K. Vaterlaus
The Washington County Museum of Fine Arts, Hagerstown, Maryland
Whitney Museum of American Art, New York
Yale University Art Gallery, New Haven, Connecticut
Richard S. Zeisler, New York
Emeterio Zorrilla

Private Collections, Florida
Private Collections, Paris

Hans Bellmer
Portrait of Wifredo Lam.
ca. 1964
The Art Institute of Chicago
cat. no. 57

Selected Bibliography

WIFREDO LAM

Allyón, José, et al. *Exposición Antológica: Homenaje a Wifredo Lam, 1902–1982.* Madrid: Museo Nacional de Arte Contemporaneo; Paris: Musée d'Art Moderne de la Ville de Paris; Brussels: Musée d'Ixelles, 1982.

Breton, André: *Lam.* New York: Pierre Matisse Gallery, 1942.

———. *Le Surréalisme et la Peinture.* Paris: Ed. Gallimard, 1965.

———. "La Nuit en Haiti." Haiti: Centre d'Art, Fort-de-France, 1946. Reprinted in *Cahiers d'Art* 20–21 (1945–46): 360–61.

Breton, André, et al. "Wifredo Lam." *Derriere le Miroir* 52 (February 1953).

Carpentier, Alejo, et al. *Lam.* Caracas: Museo de Bellas Artes, 1955.

Centro Wifredo Lam. *Sobre Wifredo Lam: Ponencias de la Conferencia Internacional,* I Bienal de la Habana. Havana: Editorial Letras Cubanas, 1986.

Césaire, Aimé. "Wifredo Lam." *Cahiers d'Art* 20–21 (1945–46): 357–59.

Daniel Garrigues, Suzanne. "The Early Works of Wifredo Lam, 1941–1945." Doctoral dissertation, University of Maryland, 1983. Reprint. Ann Arbor, Michigan: UMI Research Press, 1991.

Fletcher, Valerie. "Wifredo Lam." In *Crosscurrents of Modernism: Four Latin American Pioneers: Diego Rivera, Joaquín Torres-García, Wifredo Lam, Matta.* Washington, D.C.: Hirshhorn Museum and Sculpture Garden, Smithsonian Institution, 1992.

Fouchet, Max-Pol. *Wifredo Lam.* Barcelona: Ediciones Poligrafa, S.A. 1976. Rev. ed. Paris: Cercle d'Art, 1989.

García Barrio-Garsd, Marta. "Wifredo Lam et l'Alchimie." In *Wifredo Lam: Dessins–Gouaches–Peintures, 1938–1950.* Paris: Galerie Albert Loeb, 1987.

Gasch, Sebastiá. *Wifredo Lam à Paris.* Barcelona: Ediciones Polígrafa/Galería Joan Prats, 1976.

Gaudibert, Pierre, and Jacques Leenhardt. *Wifredo Lam: Oeuvres de Cuba.* Paris: Librarie Séguier for La Maison de L'Amerique Latine, 1989.

Herzberg, Julia P. "Wifredo Lam." *Latin American Art,* vol. 2, no. 3 (summer 1990): 18–24.

———. "Wifredo Lam: The Return to Havana and the Afro-Cuban Heritage," *Review: Latin American Literature and Arts* 37 (January–June) (1987): 22–30.

Lam, Wifredo. "Oeuvres Récentes de Wifredo Lam." *Cahiers d'Art* 26 (1951): 181–89.

Leiris, Michel. *Wifredo Lam.* Milan: Fratelli Fabbri, 1970.

Loeb, Albert. *Wifredo Lam: Oeuvres de 1938 a 1946 en Hommage a Pierre Loeb.* Paris: Galerie Albert Loeb, 1974.

Mosquera, Gerardo. *Exploraciones en la Plástica Cubana.* Havana: Editorial Letras Cubanas, 1983.

Ortíz, Fernando. *Wifredo Lam y su obra vista a través de significados críticos.* Havana: Ministerio de Educación, 1950.

Rubin, William S. *Dada, Surrealism and Their Heritage.* New York: Museum of Modern Art, 1968.

Sims, Lowery S. "In Search of Wifredo Lam." *Arts Magazine* 63 (December 1985): 21–25.

Sweeney, James Johnson. *Wifredo Lam.* Urbana, Illinois, 1961.

Xuriguera, Gérard. *Wifredo Lam.* Paris: Ediciones Filipacchi, 1974.

Zervos, Christian. "Wifredo Lam—Peintures Recontes." *Cahiers d'Art* 18 (1953): 154–221.

LAM'S CUBAN CONTEMPORARIES

Barr, Alfred H. "Modern Cuban Painters." *The Bulletin of The Museum of Modern Art* 11 (1944): 2–14.

Blanc, Giulio V. "Amelia Peláez: The Artist as Woman." *Art Nexus* 5 (1992): 72–75.

Blanc, Giulio V. et al. *Amelia Peláez: A Retrospective.* Miami: Cuban Museum of Art and Culture, 1988.

Cabrera, Lydia. *La Sociedad Secreta Abakuá.* Miami: Ediciones C.R., 1970.

Carreño, Mario. *Mario Carreño: Cronología del Recuerdo.* Santiago: Editorial Antartica, 1991.

Gómez Sicre, José. *Pintura Cubana de Hoy.* Havana: Maria Luisa Gómez Mena, 1944.

Hurtado, Oscar et al. *Pintores Cubanos.* Havana: Ediciones R, 1962.

Kirstein, Lincoln. *The Latin American Collection of The Museum of Modern Art.* New York: Museum of Modern Art, 1943.

Luis, Carlos M. *Cundo Bermúdez.* Miami: Cuban Museum of Art and Culture, 1987.

Martínez, Juan. *Cuban Art and National Identity: The Vanguardia Painters, 1920s–1940s.* Doctoral dissertation, Florida State University, 1992.

———. "Afrocuban and National Identity: Modern Cuban Art 1920s–1940s." *Athanor* XI (1992): 70–73.

Ministerio de Cultura. *Pintura Española y Grabados Cubanos del Siglio XIX.* Madrid: Museo del Prado, 1983.

———. *René Portocarrero.* Madrid: Museo Español de Arte Contemporaneo, 1984.

Museo Nacional. *Mariano: Uno y Multiple.* Santa Cruz de Tenerife: Sala de Exposiciones Centro Cultural Cajacanarias, 1988.

Pogolotti, Graciella et al. *Víctor Manuel.* Havana: Museo Nacional, 1969.

———. *Carlos Enríquez, 1900–1957.* Havana: Museo Nacional, 1979.

Sánchez, Juan. *Fidelio Ponce.* Havana: Editorial Letras Cubanas, 1985.

Thomas, Hugh. *Cuba, or the Pursuit of Freedom.* London: Eyre and Spottiswoode, 1971.

de la Torriente, Loló. *Estudio de las Artes Plásticas en Cuba.* Havana: 1954.

The Studio Museum in Harlem is grateful for permission
to illustrate the works of artists whose copyright is represented
as follows:

All works by Wifredo Lam © 1992 SPADEM, Paris/Artists
Rights Society (ARS), New York

*Photographs have been supplied by lenders and those
listed below:*

Mrs. Helena H. Benitez
Isabel Castellanos
Christie's, New York
The Lloyd Kreeger Foundation, Washington, D.C.
Mary-Anne Martin Fine Art, New York
Sotheby's, New York
Musée de L'Homme, Paris
Museum of Art, Rhode Island School of Design
Solomon R. Guggenheim Museum, New York
United States Holocaust Memorial Museum,
 Washington, D.C.
Schomburg Center for Research in Black Culture,
 The New York Public Library
Lowery Stokes Sims
Private Collections

Photo Credits:

Colten, New York
Jonas Lam, Paris
Douglas Baz, Poughkeepsie, New York
Laura Cohen, Mexico, D.F.
André Gomes, Paris
Kay Bell, New York
Elio Penso, Florida
Lee Stalsworth, Virginia
Gerald Heidersberger, Florida
Rafael Salazar, Florida
Ramón Guerrero, Florida
Constantino Arias, Cuba
Valdir Cruz, New York
Lynton Gardiner, New York
Robert E. Mates, New York
Irving Penn
J. Hyde, Paris
Robert Murray, New York
André Morain, Paris
Nathan Rubin, N.Y.
Lezcano, Cuba

Edited by Jessica Altholz
Designed and produced by Leon Auerbach
Typography by Unbekant Typographers Inc.
Printing by Jaylen Lithographers Inc.